THE ART OF
WILLIAM SIDNEY MOUNT

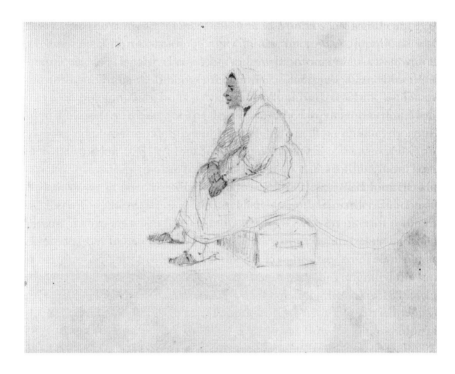

William Sidney Mount, *Figure Sketch: Black Woman with Hat*, 1831. *The Long Island Museum of American Art, History, and Carriages Collection.*

2023

For Ann Becker

THE ART OF
WILLIAM SIDNEY MOUNT

LONG ISLAND PEOPLE
OF COLOR ON CANVAS

*with admiration
and best wishes,
Katherine Kirkpatrick*

KATHERINE KIRKPATRICK &
VIVIAN NICHOLSON-MUELLER

THE
History
PRESS

Published by The History Press
Charleston, SC
www.historypress.com

Front cover: Detail from *Eel Spearing at Setauket (Recollections of Early Days— "Fishing Along Shore")* by William Sidney Mount, 1845. *Collection of the Fenimore Art Museum, Cooperstown.* Gift of Stephen C. Clark. Photograph by Richard Walker. N0395.1955.

Back cover: *The Power of Music (The Force of Music)* by William Sidney Mount, 1847. *The Cleveland Museum of Art.* Leonard C. Hanna Jr. Fund. 1991.110.

Photographs of the works herein are used by permission of the owners.

First published 2022

Manufactured in the United States

ISBN 9781467152235

Library of Congress Control Number: 2022937896

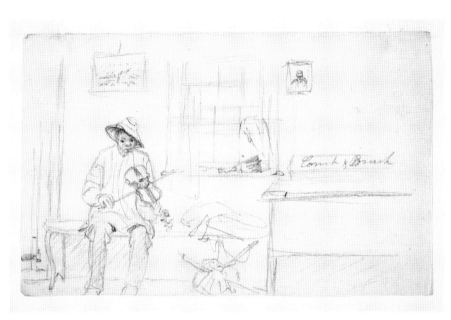

William Sidney Mount, *Boy Playing Violin*, not dated. *The Long Island Museum of American Art, History, and Carriages Collection.*

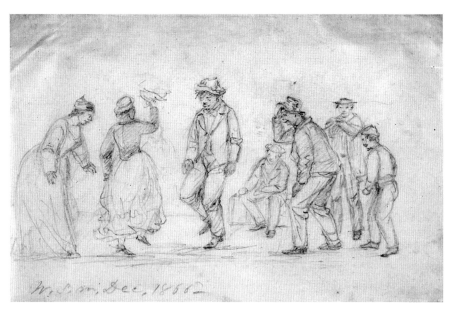

William Sidney Mount, *Dancing Couple*, 1866. *The Long Island Museum of American Art, History, and Carriages Collection.*

To the memory of my parents, Audrey and Dale Kirkpatrick,
who were proud to call Stony Brook their home.
—Katherine Kirkpatrick

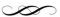

To my Brewster, Mills, Mount, Ruggles, Smith, Thompson, and Tobias ancestors:
to those who nurtured and supported William Sidney Mount from early life;
to those who inspired him to create paintings of incredibly soulful beauty;
to the one who transported his body to his grave.
—Vivian Nicholson-Mueller

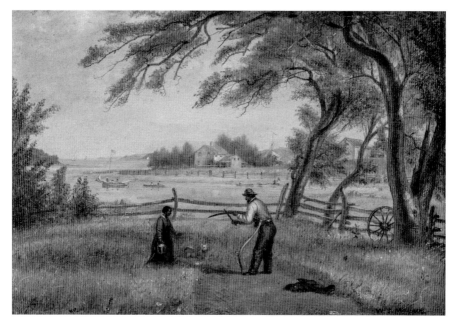

William Sidney Mount, *The Mower*, 1866–1867. *The Long Island Museum of American Art, History, and Carriages Collection.*

CONTENTS

ACKNOWLEDGEMENTS

This work would not be possible without the contributions of many individuals and organizations.

We thank The History Press for publishing the book. We are especially appreciative of J. Banks Smither, Acquisitions Editor, who guided us through the book's many stages, and for Abigail Fleming, Production Editor, who copy edited the work.

We are most grateful to the Long Island Museum of American Art, History, and Carriages in Stony Brook under the leadership of Neil Watson, Executive Director, for allowing us to reproduce the majority of the William Sidney Mount paintings in this book, as well as Mount's sketches, letters, and other assorted images. For their expertise, guidance, and generosity of time, our thanks go to Jonathan Olly, Curator, and Joshua Ruff, Deputy Director, Director of Collections and Interpretation. We appreciate Jonathan's and Joshua's review of our manuscript in draft form, as well as helping us in a hundred other ways. Thanks also to Andrea Squeri, Collections Manager; Lisa Unander, Director of Education; Emma Backfish, Public Programs Coordinator; and Megan Witalis, Gift Store and Visitor Services Manager.

Barbara M. Russell, Brookhaven Town Historian, gave us a wealth of information, much helpful advice, and also read a draft of the book. Karen Martin also provided invaluable resources and greatly contributed to our fuller understanding of local history. Without her this book would not have been possible.

The Three Village Historical Society provided research and much assistance. We thank Steve Healy, former President; Jeff Schnee, President; Mari Irizarry, Director; and Beverly Tyler, Historian.

Caren Zatyk, Librarian at the Richard H. Handley Collection of Long Island Americana (also known as The Long Island Room) at the Smithtown Library, furnished us with many helpful articles. We also thank Andrea Squeri, former Collections Curator at the Smithtown Historical Society, for her part in searching for photos.

The Ward Melville Heritage Organization provided us with access to its sites and was helpful in a variety of other ways. Thanks go to Dr. Richard Rugen, Chairman; Gloria Rocchio, President; Gabrielle Lindau-Mitchell, Director of Development; Deborah Boudreau, Education Director; Mike Colucci, Supervisor, Facilities; and Carmen Silano, Executive Assistant Office Manager.

Margo Arceri took us to cemeteries and many other places and gave us her lovely photo of the Thompson House. Leighton H. Coleman III provided us with photographs and research and took us on a delightful annotated tour of the local area. Anna Lombardi McCarroll and Bob McCarroll, John T. Strong and Patricia Strong, and Dr. Richard Rugen and Linda Barnes brought us on special tours of their own.

Thanks also go to David Acker, owner of Harmony Vineyards, and Allison J. Cruz, Executive Director of the Smithtown Township Arts Council, Mills Pond Gallery, for access to the historic properties. A big thank-you goes to Zachary N. Studenroth, Municipal Historian for the Town/Village of Southampton, and Christopher N. Matthews, Chairperson, Anthropology at Montclair State University, for going the extra mile to provide photographs.

We credit a number of books from which we gathered essential content. *William Sidney Mount* by Alfred Frankenstein, an enormous compendium of Mount's diaries, letters, sketches, and paintings, with informative notes by Frankenstein, served as the quintessential reference book. Edward Payson Buffet's "William Sidney Mount, a Biography," serialized in the *Port Jefferson Times* from December 1, 1923, to June 12, 1924, in fifty-six installments, gave us the names of many of Mount's models. *American Genre Painting: The Politics of Everyday Life* by Elizabeth Johns and *William Sidney Mount: Painter of American Life* by Deborah J. Johnson, editor and contributing author, greatly aided in our understanding of Mount. We quoted from these excellent scholarly works extensively. We also credit several other important works for their substantial contributions: *Catching the Tune: Music and William Sidney*

Mount published by the Museums at Stony Brook (now the Long Island Museum), *The Creolization of American Culture: William Sidney Mount and the Roots of Blackface Minstrelsy* by Christopher J. Smith, and *William Sidney Mount: Family, Friends, and Ideas* published by the Three Village Historical Society. We appreciate Bradley Harris's excellent research published online by the Mills Pond Gallery.

We thank our families, especially Jennifer Kirkpatrick and Simira Tobias, for taking the journey with us and offering much help in a variety of ways. Jennifer Kirkpatrick not only spent a week in Stony Brook to help with research and to take numerous photographs for this book, but she also created our beautiful map. Thanks to John Tait for support at the home front, a listening ear, tech help, occasional copy editing, and gift of a new iPad.

We thank Cindy Kane for her enormous editorial help and guidance.

We thank our writer friends for encouragement, support, and the reading of rough writing in progress. Thanks to Madeleine L'Engle's Circle of Friends Wednesday group: Patricia Barry, Stephanie Cowell, Jane Mylum Gardner, Pamela Leggett, Andrea Simon, and Sanna Stanley. Thanks to the Write Tribe: Mira Martinovic, Stefan McIntyre, Janet O'Leary, Elizabeth Sharpe, Rishabhkumar Skukla, and Rasa Tautvydas. Thanks to Diane Amison-Loring, proofreader extraordinaire. Thanks to Alice D'Amico and to Carol Sue Janes. A big thank-you to Shirley Litwak for reading several drafts and helping with the selection of images.

Heartfelt appreciation goes to all.

Katherine Kirkpatrick
Vivian Nicholson-Mueller

Shepard Alonzo Mount, *Profile of a Woman Smoking*, not dated. *The Long Island Museum of American Art, History, and Carriages Collection.*

INTRODUCTION

William Sidney Mount (1807–1868) was one of America's first, and best, genre painters. Most famous for his rural scenes of the North Shore of Long Island, New York, Mount was born and died in Setauket. He never married and lived most of his life with relatives in Setauket and Stony Brook. From local people, landscapes, and music, he took his inspiration.

The artist's great gifts lay in his abilities to capture the essence of people and render their everyday activities in a lively, precise, and often humorous fashion. Nearly a dozen of Mount's most famous paintings—including a woman spearing eels from a skiff on a calm bay, a fiddler, a banjo player, a bones player, and a farmer resting from his labors—feature Black[1] individuals and those of mixed ethnicity.

This book features the people of color in the Three Village area of Long Island (Stony Brook, Setauket, and Old Field) and the nearby communities of St. James and Smithtown who posed for the artist. For those who have wondered about these previously anonymous people, this work reveals demographics: the models' names, birth and death dates, parents and children, the homesteads to which they were connected, and other identifying details. Because of New York's partial manumission acts beginning in 1799 and the state's abolition of slavery in 1827, these individuals were all free or indentured during Mount's adult life.

It's inherently problematic to use a White man's artwork to research people of color, yet Mount's paintings are treasure troves of insight into the lives of individuals for whom little documentation exists. Prior to the

Civil War, photography wasn't commonplace, and people of color almost never appeared in fine art. So, such a collection of locally made nineteenth-century paintings depicting local Black individuals with the meticulous and identifiable details that a photo might bring is extremely rare. The Three Villages may be the only community in America with a famous nineteenth-century hometown artist who made numerous images of people of color. And it's even more surprising that Mount—a Jacksonian Democrat at a time when Democrats supported states' rights to choose slavery—often (but not always) rendered individuals of color with psychological depth and sensitivity. He was one of the very few artists in America in his time to depict Black people as more than racist caricatures.

Emulating the styles, poses, and craftsmanship of Old Masters such as Rembrandt while choosing American subject matter, Mount helped create a new form of American art. Called *genre* (meaning scene) paintings, this form illustrates the activities of ordinary people, including Black people, in a storytelling manner. Art historian Deborah Johnson has researched Mount's European source material. She points out that Mount based his "fancy pictures," *Just in Tune*, *Right and Left*, *The Banjo Player*, and *The Bone Player*, on musical portraits by seventeenth-century Dutch artists such as Frans Hals.[2] The poses Mount uses and the way his figures hold their props are identical to those in Dutch works. As a part of this process, Mount inserted people of color into a tradition that had never included them. Black farm laborers from Setauket, by a trick of visual rhetoric, suddenly rose to a heroic status. What statement was the artist trying to make? It is difficult to draw conclusions.

Deborah Johnson describes the artist's political views as "enigmatic."[3] He wasn't politically progressive. Two of the paintings in this book, *Farmers Nooning* and *The Dawn of Day*, appear to convey anti-abolitionist messages. Mount voted against Abraham Lincoln in both the 1860 and 1864 elections. Mount occasionally involved himself in politics, always backing candidates who viewed racial equality as a threat to existing social systems.

And yet, Mount painted people of color with great humanity. Historian Roger Wunderlich aptly describes Mount as a "split personality" who was "artistically forward and politically backward."[4]

Mount's racially diverse paintings added to his popularity as an artist among his wealthy urban patrons. The paintings also won him honors at the National Academy of Design in Manhattan, where he studied and exhibited his work throughout his life. A number of Mount's works depicting people of color were commissioned for mass reproduction throughout Europe.

As their portrayals gained recognition, Mount's models of color remained anonymous. Mount did not record their names in his letters and diaries. Only Edward Payson Buffet, Mount's first biographer, documented some of the names of the sitters after conducting interviews in the 1920s with Mount's family members and contemporaries. But as decades passed, copies of Buffet's serialized biography of Mount in the *Port Jefferson Times* became hard to find.[5]

Coauthor Vivian Nicholson-Mueller researched the identities of the models by first looking for clues in the paintings and noting generalities such as approximate age, skin color, and whether or not the individual was of mixed ethnicity. She noted the dates on which the paintings were made. Then she corroborated Buffet's remarks and anything Mount may have said in his journal or letters about the paintings, with the Brookhaven Town portion of the U.S. Census reports, the town that encompasses the Three Villages.

Family Bible inscriptions, old maps, merchants' and doctors' journals, and church and cemetery records provided more clues. The census reports, church and other records labeled people of color as "B," or Black; "negro"; M, or "mulatto"; "Indian"; or "other" (which meant Native or Black-Native). In any census year during Mount's lifetime, there were about two hundred people of color enumerated in Brookhaven within an overall population of several thousand residents, so it was possible to narrow down the possibilities, for example, when looking for a man of mixed race of a certain age in a certain year. Typically, there would be only several candidates.

Patterns emerged within the historical documents. The people of color in Mount's paintings generally dwelled in small groups, within or adjoining the White households of Mount's siblings and extended family on Long Island. All the models of color were connected to the households Mount visited regularly. These families included the Brewsters of Setauket, related by marriage to Mount's brother Robert Nelson Mount; the Strongs in Setauket, distant cousins on Mount's father's side; the Mills in Saint James/Smithtown,[6] distant cousins on Mount's mother's side; the Seaburys in Stony Brook, the family of Mount's sister, Ruth; and the Joneses of Stony Brook, the family of Mount's paternal second cousin Shepard "Shep" Smith Jones.

Telling the stories of nineteenth-century people of color, while challenging because of the fragmentary nature of their historical records, is actually much easier in the Three Villages than in many other places in America. The area has a great number of well-preserved colonial and nineteenth-century buildings and vistas, thanks to businessman and philanthropist Ward Melville

and his wife, Dorothy, whose preservation work is carried on today by the Ward Melville Heritage Organization. Not only did the Melvilles preserve numerous old buildings in the Three Villages, but they also founded the Long Island Museum in Stony Brook, to which they gifted enough William Sidney Mount drawings and paintings to fill a large gallery and storage vault. The museum houses more than one thousand pages of Mount's journals and letters as well as artwork and correspondence of Mount's brother Shepard, several of Mount's violins and other personal effects. Ward Melville also purchased the Mount family's home, the Hawkins-Mount House, which has been restored and leased to the Long Island Museum. The Melvilles left a rich legacy indeed.[7]

But while the Melvilles and others fought to save many fine old houses by creating four historic districts in the Three Villages in the 1970s, several neighborhoods particularly known for their minority communities were not included within the historic designations at that time. Founded by Robert Lewis in 2004, the Higher Ground Intercultural and Heritage Association established the Bethel–Christian Avenue–Laurel Hill Historic District in Setauket. The district was added to the State and National Registers of Historic Places in 2017. Places within the sector include the Bethel AME Church, the Reverend David Eato's House and Laurel Hill Cemetery. In a separate endeavor in 2017, coauthor Vivian Nicholson-Mueller and her cousin Simira Tobias led a successful campaign to add Stony Brook's Old Bethel Cemetery to the State and National Registers of Historic Places as well. The Three Village area always was, and still is, a place of great cultural diversity. Public awareness of the area's ethnic heritage is growing.

The authors hope you will enjoy this book and that reading it will broaden your understanding of Mount's art and of nineteenth-century people of color. May you find this different take on local history to be illuminating and eye-opening. Thank you for reading, for listening to once-lost voices, and for sharing in the important mission of acknowledging long-forgotten lives.

WILLIAM SIDNEY MOUNT
(1807–1868)

A Biography

CHILDHOOD

Born in Setauket, Long Island, New York, in 1807 to Julia Ann Hawkins and Thomas Mount, William Sidney Mount was the second youngest of five children who survived to adulthood. His parents owned a farm and inn facing the Setauket Village Green, across from the family's church, the Setauket Presbyterian Church. Mount and his siblings—Henry Smith, Shepard Alonzo, Robert Nelson (known as Nelson), and Ruth Hawkins—all painted or played musical instruments or both. Mount was a fiddler and flutist as well as an artist.[8]

In 1814, when Mount was almost seven, his father died. Mount, his mother, and his siblings then moved into the home of his maternal grandparents, Jonas and Ruth Mills Hawkins, in Stony Brook. Jonas's home, known today as the Hawkins-Mount House (circa 1725, enlarged in 1757) has two and a half stories, twenty rooms, and seven bays. During the Revolutionary War, Jonas served as a major in the Continental army and as a messenger in the Culper Spy Ring. He operated a store and tavern within his home.

By the time Mount and his siblings moved to the house, it was probably no longer a tavern or a store, though it still served as a post office, with Jonas as postmaster for Stony Brook and Setauket. Jonas died in 1817 at age sixty-four, when Mount was nine. His widow, Ruth Mills Hawkins, lived for nearly thirty more years to the age of ninety-two.

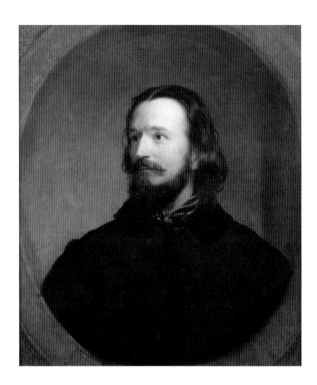

Charles Loring Elliott,
William Sidney Mount, 1848.
*The Long Island Museum of
American Art, History, and
Carriages Collection.*

The Mounts were originally from Middletown, New Jersey, and the family was among the first settlers of that region. The Hawkins family had lived on Long Island since the 1600s. As far as is known, the Mounts possibly had one enslaved person as part of their households.[9] The Hawkinses had kept multiple enslaved laborers since the late seventeenth century; one Hawkins ancestor had been a trader of enslaved individuals in Hispaniola. A number of people of color served the Hawkins-Mount household during Mount's childhood and in later years.[10]

Mount would recall childhood memories of hearing a talented fiddler named Anthony Hannibal Clapp play jigs and hornpipes. Fond associations with people of color would enter into Mount's artwork, both in subject and in the sensitivity and individuality of his portraiture. Yet in time, he'd fervently back a political party, the Jacksonian Democrats, that championed the states' rights to choose slavery.

Around age eight, Mount briefly lived in the city of New York with a maternal uncle, Micah Hawkins; his wife, Letty; and a free man of color whose name is unknown. An accomplished musician on violin, piano, and flute, as well as a composer, poet, and playwright, Micah kept a piano to entertain customers in his shop and tavern in the Five Points neighborhood

of lower Manhattan. Within a year of staying with this uncle, Mount moved back to Long Island, probably to avoid an epidemic of typhus in the city. He spent the remainder of his childhood and most of his teenage years working the farm on his grandfather Jonas's property. Members of prominent landowning White families on Long Island often performed gritty agricultural tasks alongside free and enslaved people of color during harvesttime. The multiracial farming scenes Mount would later paint likely resembled his own lived experience.

In a short autobiography that Mount began and never finished, he wrote that he became interested in art as a child through his sister, who took lessons in drawing and watercolor:

> *In the year, 1819, a Lady accomplished in water color painting, as taught at that time, gave my sister lessons in painting, and also taught her embroidery—to execute figures in colored silks and water colors combined. You could have seen me at that time a farmer boy dressed in a coarse working frock with a straw hat in my hand, watching with deep interest the manner in which the beautiful teacher was mixing her colors and directing her young pupil.*[11]

A Young Artist in the City of New York

In 1820, at age seventeen, Mount returned to the city of New York to live with his uncle Micah Hawkins once again. This time, Mount served as an apprentice in the sign and ornamental painting business of his oldest brother, Henry. His second-oldest brother, Shepard Alonzo, soon joined the other two brothers in the city. Shepard was apprenticed to a carriage manufacturer and also created decorative panels for Henry's business.

A fascinating dichotomy of experiences informed Mount's artistic vision. His uncle, the man who was like a father to him, kept his shop and tavern in Catherine Market, the very heart of the Five Points. This lower Manhattan neighborhood has infamously gone down in history as a place where recent immigrants crowded together in single rooms, diseases ran rampant, and criminal street gangs roamed. And yet, for a young artist from a quiet Long Island hamlet, the strikingly different environment must have fed his creativity.

Micah would have served free Black and biracial people as well as Irishmen in the shop and tavern while he pounded out tunes on his store's upright

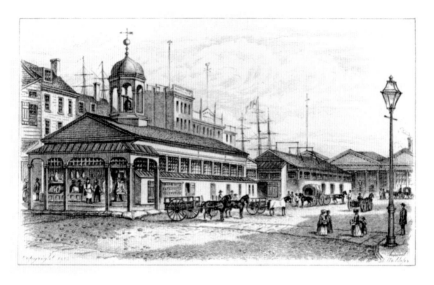

Samuel Hollyer, engraver, *Catharine Market, New York, 1850*, print made circa 1903. *Library of Congress Prints and Photographs Division.*

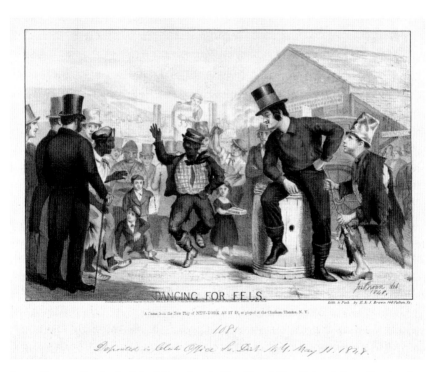

James Brown, *Dancing for Eels: A Scene from the New Play of New York as It Is, as Played at the Chatham Theatre New York*, 1848. *Library of Congress Prints and Photographs Division.*

William Sidney Mount, *The Jig*, 1866. *The Cleveland Museum of Art.*

piano. Adjacent to the shop-tavern, on Catherine's Wharf, sailors, many of them Black, sang chanties as they unloaded cargo from oceangoing vessels onto the slimy boardwalks. In the open, fishy-smelling air, Black musicians fiddled, and Black dancers jigged "juba" on wooden planks for coins or a dinner of fried clams and eels. New York newspapers printed racist cartoons depicting these activities.

One of the mementos Mount kept for life was a program from his uncle's operetta *The Saw-Mill, or a Yankee-Trick*, which was shown six times in Five Points' Chatham Garden Theatre in 1824 and 1825. The rollicking, stomping, cat-calling theater of the 1820s wasn't considered respectable by many middle- or upper-class White people, and women almost never attended the shows. This theatrical milieu of lower Manhattan helped to introduce African American music to the wider public. Often cited as the first comic opera by an American composer on an American theme, *The Saw-Mill* features popular African American tunes as well as Micah's original folk music.

Though there's no record of Micah Hawkins and the other White actors in his troupe blackening their faces, music historians describe Hawkins's operetta as an early influence on what evolved into the Blackface minstrel show. In these shows, White musicians in makeup posed as racist caricatures of people of color and performed skits, music, and dance. Years later, Blackface minstrelsy would morph into vaudeville. Mount's artwork that featured people of color, and in a few cases Black stock theatrical characters, fed into the popularization of Black people in White American entertainment.

Mount distinguished himself as an artist both in his passion for his subjects and in his technical expertise. The trio of artistic brothers—Henry, Shepard, and William Sidney—spent evenings together drawing and painting. The young artists pored through the collection of William Hogarth's engravings owned by Henry's business partner, William Inslee; Mount successfully tried his hand at copying in pencil some of Hogarth's figures. Judging by the compositions Mount would later emulate in his own work, he also had access to engravings of seventeenth-century Dutch artists and prints of British, French, and Italian works of various eras. And Mount was likely familiar with the blithe cartoons of David Claypoole Johnston, who illustrated one of Micah Hawkins's comic poems, and the illustrations of Lewis Krimmel, another American genre artist.

In 1825, at the American Academy of the Fine Arts, Mount was dazzled by the grand historical panoramas of Benjamin West, an American expatriate in London, and West's protégés. Later, Mount would also admire paintings of Scotland's David Wilkie, especially known for his genre scenes. And Mount took a great liking to the portraits of Charles Loring Elliott, an artist from Upstate New York.

In 1826, Mount and Shepard enrolled in the National Academy of Design, a newly established competitor to the American Academy, which had been founded in 1802. Setauket friend, doctor, and historian Benjamin Franklin Thompson and a son of Dr. Samuel Thompson, helped facilitate the entrance process.[12] At the Academy, Mount received instruction from Henry Inman, a well-known portrait painter, among others.

Micah Hawkins died of typhus in 1825 at age forty-eight, when Mount was eighteen, a bitter blow to the young artist. Mount continued to live with his aunt Letty until he concluded his studies about two years later. Mount mentioned in a letter that Letty burned the librettos from her husband's operetta-in-progress in the fire of her potbellied stove when he died. Fortunately, she didn't touch Micah's several hundred scores of classical and popular sheet music, which Mount received as a bequest.

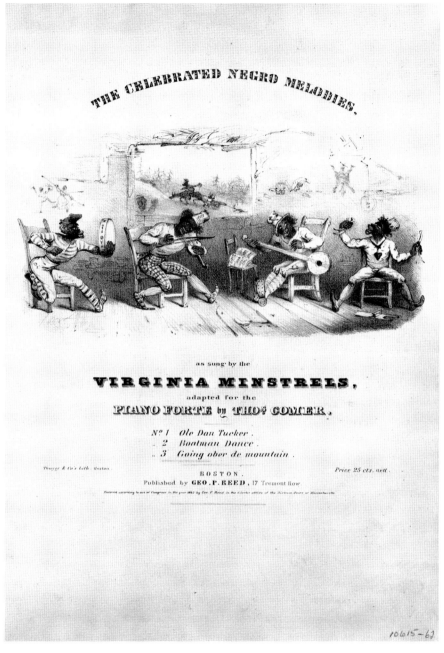

Thayer, *The Celebrated Negro Melodies*, sheet music cover showing the Virginia Minstrels performing, lithograph, 1843. *Library of Congress Prints and Photographs Division.*

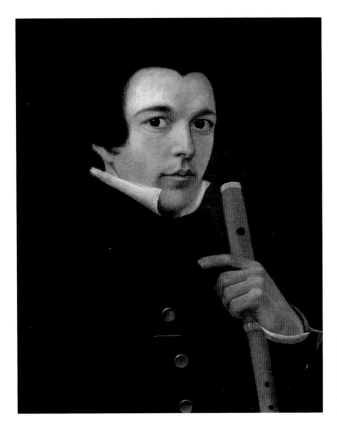

William Sidney Mount, *Self-Portrait with Flute*, 1828. *The Long Island Museum of American Art, History, and Carriages Collection.*

Mount's first self-portrait, created in 1828, shows a serious young man with dark brown hair, dark eyes, a straight nose, and a slightly angular face. He wears a high white collar and brass-buttoned jacket and holds a flute. Clearly, he regarded himself as a gentleman with genteel pursuits. Micah's collection of music included flute duets by Handel and Haydn, which uncle and nephew had likely played together.

Mount might have become an artist in the Grand Manner of European "history" painters, who depicted poetical topics on a large scale. But he wasn't able to sell those kinds of works. Mount's dramatic paintings on Biblical and Shakespearean themes, which he exhibited at the National Academy of Design in 1828 and 1829, represent a short-lived phase of his career.

In nineteenth-century America, painting portraits was the only sure way for artists to earn a living. Recognizing this, Mount and his brother Shepard opened a portrait studio in lower Manhattan. Lacking clientele, they closed their business within months. At the age of twenty-two, perhaps disillusioned with urban life, Mount returned to Long Island. Shepard soon followed.

EARLY SUCCESSES

The large family home in Stony Brook, which had sheltered the Mount children during a time of great change in the past, would always be there for them in their adult lives when they needed it. Mount's mother and grandmother, both widows, managed the domestic and farming operations. And across the street, a short distance away, lived his sister, Ruth, wife of Charles Saltonstall Seabury, a piano manufacturer. In time, Ruth would become a mother of seven children.

Though Mount often boarded elsewhere—generally with one sibling or another—it's clear from his writings that he returned to the Hawkins-Mount House with some frequency. There, working in his third-floor bedroom attic studio, where the rays of the sun filtered into the room through a skylight, or sometimes outdoors, with "the canopy of heaven as my paint room,"[13] he produced works that would bring him great fame.

Mount's first genre painting, *Rustic Dance After a Sleigh Ride* (1830), is a sprightly scene of two couples dancing in a crowded country tavern to a Black fiddler's tunes. It marked a turning point in his career. He won a prize for the work at the National Academy of Design's annual art show in 1830. Subsequently, Mount directed his efforts to painting rural scenes and developed a clientele for them. In 1832, the National Academy gave him the honor of becoming a full member, or Academician, of their institution. Only fifty artists could hold these honorary lifetime appointments.

Mount didn't just develop a clientele for fine art of American bucolic scenes; he created the demand. Luman Reed, one of the wealthiest merchants in the city and an important patron of the arts, purchased Mount's 1835 paintings *Bargaining for a Horse (Farmers Bargaining)* and *The Truant Gamblers (Undutiful Boys)*. More rich businessmen, such as Henry Breevort Jr., Edward L. Carey, Charles Augustus Davis, Gouverneur Kemble, Charles Mortimer Leupp, Robert Gilmore Jr. and Jonathan Sturges, would follow Reed's example of wanting Mount's genre scenes in their collections. Like Reed, some of Mount's patrons had grown up on farms.[14]

It was the America of Andrew Jackson's presidency, which saw the emergence of a commercial middle class and a belief in the democratic equality of the "common man." These concepts were ones that Mount held in high esteem. In this pre–Civil War era, the population of New York and other cities grew, industry expanded, and the economy shifted away from agriculture. The Yankee symbolized democracy and came to represent all that was good in the country. The Yankee farmer even appeared on dollar

A rare, undated photo of William Sidney Mount's studio in the Hawkins-Mount House attic. *The Long Island Museum of American Art, History, and Carriages Collection.*

bills. The most circulated of Mount's works, his *Long Island Farmer Husking Corn* (1833–1834), was engraved and used on multiple state and local bank notes from the late 1830s to the 1860s.[15]

Mount's major works of the 1830s include *Dancing on the Barn Floor* (1831), *Long Island Farmer Husking Corn* (1833–1834), *Bargaining for a Horse (Farmers Bargaining)* (1835), *Bar-room Scene* (1835), *The Sportsman's Last Visit* (1835), *Farmers Nooning* (1836), *The Painter's Triumph (Artist Showing His Own Work)* (1838), and *Catching Rabbits (Boys Trapping)* (1839). Some paintings, like *Bargaining for a Horse*, contain verbal puns; Mount was comically illustrating the phrase "horse trading," which for viewers in the know referred to politicians who made false promises to supporters.

The National Academy's annual art shows continued to attract patrons for Mount. Never poor but also never wealthy, Mount took a relaxed view toward his genre commissions. When using oils, he worked slowly and in great detail. Sometimes he did not paint for months at a time. He might take up to two years to start a work he'd promised a client, and he tended

28

to undercharge them. More than once, patrons gave him more than his asking price.

Like his brother Shepard, an Academician and an extremely talented artist in his own right, Mount almost never turned away local portrait commissions. Mount enjoyed his "bread and butter" portrait work, except he abhorred the common nineteenth-century practice of sketching the recently deceased in order to memorialize them. A wide network of cousins and second cousins, especially the Smiths in Stony Brook, the Millses in Smithtown, and the Strongs of Strong's Neck, Setauket, provided a core clientele for both brothers. Family friends, such as the Thompsons, Williamsons, and Satterlys, extended from that core.

Though better known as a portraitist, Shepard also created exquisite landscapes. Closely linked in both personal and professional ways, the careers of Shepard Mount and William Sidney Mount ran parallel to each other for four decades.

Middle Years and International Recognition

Sadly, the eldest in the trio of artistic brothers, Henry Smith Mount (1802–1841), died of consumption—tuberculosis—at the age of thirty-nine. He left a wife and six children who ranged in age from two to fourteen; one of them, Evelina, would eventually become an artist. It was a devastating time for Mount. A few months after Henry died, his mother passed on. His grandmother had died the previous year. For the rest of Mount's life, from his mid-thirties, he became preoccupied with his own health and the health of other family members.

Mount also developed an interest in spiritualism and attended séances at the home of distant cousins, the Hadaways, in Stony Brook.[16] Mount believed that he'd received messages from his uncle Micah, who in turn relayed messages from Mount's mother and deceased brother, Henry. During two séances, the medium relayed messages for Mount from a spirit identified as Rembrandt, who advised him on artistic technique.

Other members of the Mount family may have also taken an interest in spirits. Edward Payson Buffet, Mount's first biographer, began his serialized biography with an anecdote about a violin Mount had built. As the story goes, the family believed that whenever a family member was about to die, the segments of the violin became unglued and the instrument fell apart.[17]

From the early 1840s on, along with his brothers Shepard and Robert Nelson and Mary, Henry's widow, Mount shared ownership of the Hawkins-Mount House. Various combinations of family members would live in it. At one point, Mount, Shepard and his wife and four children, and Henry's widow and her many children, all dwelled together.

Mount was the only one of his four siblings not to marry. Whatever love interests he may have had, his career took precedence. The fact that Mount never settled down for long in one place seems to relate to an artistic urge for new venues. In a journal entry on November 17, 1852, he wrote: "A true painter should have no home" and that moving about was preferable to "rusting out in one place."[18]

Customarily, and for practical reasons in this period on Long Island, single men did not live alone. The largely self-sustaining homesteads required many hands to farm the land and perform numerous chores. So Mount moved in with his siblings. Some years, Mount resided with Shepard and his family, who settled in Setauket. Other times, he stayed with Ruth and her family in Stony Brook. And some years he boarded with Robert Nelson

One of William Sidney Mount's tiny sketchbooks in the collections of the Long Island Museum of American Art, History, and Carriages. *Katherine Kirkpatrick.*

and his family in Setauket, next door to what we know today as the Brewster House or Joseph Brewster House. Occasionally, Mount took a room in a boardinghouse in Stony Brook.

Mount carried a sketchbook, often a tiny one. When possible, he sketched from his small sailing craft, from which he also enjoyed fishing. He visited the city of New York several times a year and debated in his journals as to whether he should move there. Periodically, he considered the idea of venturing abroad, but he never journeyed farther than Pennsylvania. Though he often remarked in his journals that Long Island was provincial and lacking in culture, he passionately loved its people and landscapes. And while he often complained about the distractions and annoyances of living with family, he invariably returned to them.

The 1840s and 1850s proved to be a fruitful time in Mount's career. Now in his thirties and forties, he continued to paint farming scenes, some with political allegories. He focused most on rural scenes involving music and dance. As a fiddler and occasional builder of violins, he portrayed his musical subjects with precision and accuracy. Sometimes, Mount fiddled for pay at dances. He composed at least two tunes, "In the Cars on the Long Island Railroad" and "Musings of an Old Bachelor." In order for his music to be heard over the din of clamorous dancing and merrymaking, he invented a hollow-backed, sound-amplifying violin he called "The Cradle of Harmony." In the 1850s, Mount obtained patents for several versions of this violin. The idea never took off as a commercial enterprise.

Some of Mount's most prominent paintings of this time were *Cider Making* (1841), *Ringing the Pig* (1842), *Dance of the Haymakers* (1845), *The Power of Music* (or *The Force of Music*) (1847), *Just in Tune* (1849), *Right and Left* (1850), *The Bone Player* (1856), and *The Banjo Player* (1856).

It was another fortuitous turning point in Mount's life when he came to know, beginning in 1848, Carl Wilhelm (William) Schaus, the New York agent for the international art dealership Goupil, Vibert & Co. (later Goupil and Co.). Mount was then forty-one. Schaus saw Mount's *The Power of Music* at the National Academy of Design's annual art exhibit and soon arranged for it to be copied for lithographic prints. Subsequently, Mount was among the first American artists to have his work reproduced through the new lithographic technologies and distributed as prints overseas. In the decade from the late 1840s to the late 1850s, Schaus—first as an agent for Goupil (and its various incarnations) and then acting as agent for his own firm—negotiated to have ten of Mount's paintings turned into lithographs. Though no specific records exist as to the number of prints that were sold,

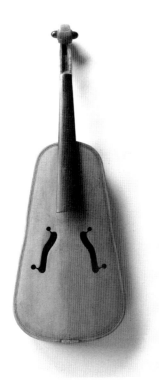

Left: James H. Ward, "Cradle of Harmony" violin, 1851–1852, designed by William Sidney Mount. *The Long Island Museum of American Art, History, and Carriages Collection.*

Below: *New York City—An Afternoon Lounge at Goupil's Art Gallery, Fifth Avenue. The Library of Congress Prints and Photographs Division.*

NEW YORK CITY—AN AFTERNOON LOUNGE AT GOUPIL'S ART GALLERY, FIFTH AVENUE. Drawn by J. N. Hyde.—See Page 203.

it's known that Mount collected royalties, which was rare for artists in his time period.

At first, Schaus contracted for paintings that Mount had already created, such as *The Power of Music* and *Dance of the Haymakers*, to be made into lithographs. But soon after knowing Mount, Schaus began commissioning original work. These images that Mount created with the lithography process in mind include three of his four "fancy pictures," or portraits of well-dressed musicians: *Right and Left*, *The Banjo Player*, and *The Bone Player*. The German émigré must have heard of the popularity of Black musicians (or those posing as Black people) in musical theater. Schaus calculated that this exotic subject matter of minstrelsy would be of great interest to European buyers.

LATER YEARS

Mount wrote a baffling assortment of political statements in his journals and letters that seem contradictory, at least to a modern audience. He occasionally used the word "nigger" in his notations to himself on sketches, though he wrote "negro" or "black" on other sketches.[19] How could the creator of such a stunning painting as *The Banjo Player* have been on the wrong side of history in voting against Lincoln (and calling the Republican Party that supported him "Lincoln-poops")?[20] There are no easy answers. Mount is a complex character. He reacted to the happenings of the day in his diaries and letters as these events occurred, and he did not have the foresight to see how history would play out.

In the last seven years of his life, the Southern states seceded, and the Civil War began and ended. Americans reacted in horror to the unprecedented violence and bloodshed of battles such as Antietam, Gettysburg, Shiloh, and Stones River. After the close of the war, slavery was abolished on a national level and America took its first halting steps toward Reconstruction. Like other northern Democrats in his party, Mount opposed civil and political rights for people of color—ostensibly as a way of placating the Southern states so that America could come together as an undivided country.

Mount created few paintings in the 1860s. Reasons for this probably include the distractions of wartime, the decline of his eyesight and perhaps his overall health, and patrons' lack of interest in his genre paintings. However, two magnificent Three Villages landscape scenes, *Long Island*

Farmhouses (1862–1863) and *Catching Crabs* (1865), show Mount's talents for harmonic compositions and color schemes and detailed accuracy in representing people, buildings, and natural scenery.

Fair Exchange, No Robbery (1865), considered Mount's last significant genre work, presents a farmer trading hats with a scarecrow. As a political work, its cryptic allegory involves President Andrew Johnson and his clash with the Radical Republicans. Another genre painting, *Catching the Tune* (1866–1867), shows a whistling man, who is perhaps racially mixed, teaching a tune to a fiddler. The generic quality of the five characters' faces suggests that Mount no longer employed models when making his art. The characters appear somewhat wooden.

In 1862, a carriage maker from Port Jefferson named Effingham Tuthill built for Mount a portable studio that Mount had designed himself. He'd conceived of his "artist wagon," as he called it, ten years earlier. The boxlike enclosure measured seven feet, eight inches high, with an interior room that measured seven by twelve feet. It had three windows and a skylight. The

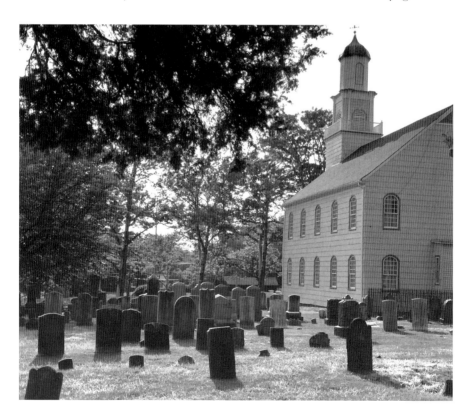

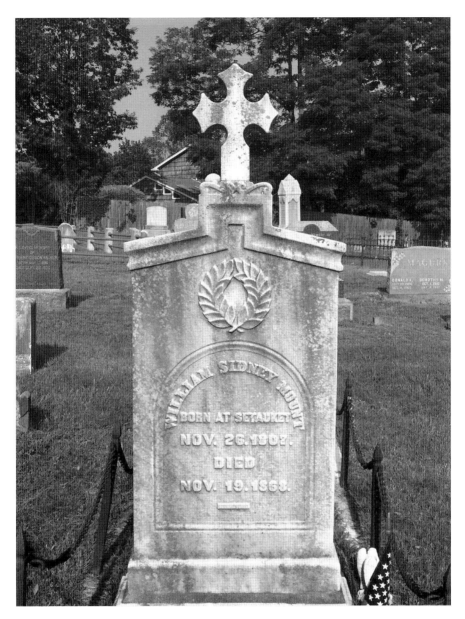

Opposite: The Setauket Presbyterian Churchyard. *Jennifer Kirkpatrick.*

Above: William Sidney Mount's grave at the Setauket Presbyterian Church. *Jennifer Kirkpatrick.*

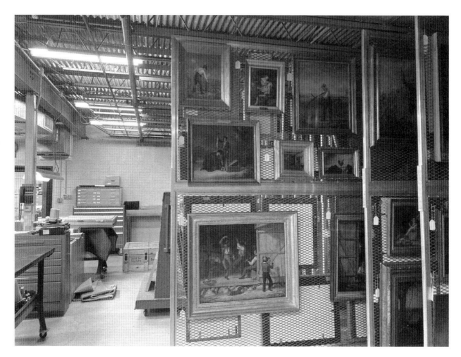

Mount paintings in the storage vault of the Long Island Museum of American Art, History, and Carriages. *Katherine Kirkpatrick.*

term *portable* is relative. In order to move it, Mount needed the assistance of two teams of horses. The bachelor artist did not own even one horse. At least several times, however, Mount relocated the wagon. Finally, he found a place for it in Port Jefferson near the harbor. In the last year of his life, 1867–1868, when boarding at the home of his brother Robert Nelson next door to the Brewster House in Setauket, Mount walked to and from his wagon every day for exercise. When he set out in the morning, he carried his lunch with him in a pail as he headed down the hill to the next town. The wagon solved the longstanding problem of finding solitude and privacy for his work while sleeping under the same roof as family.

Shepard Mount died of cholera in September 1868. A few months later, while William Sidney Mount was in Manhattan settling Shepard's estate, he fell ill with pneumonia. Soon after returning to Robert Nelson's house, Mount succumbed to his illness. He passed away on November 19, 1868, at the age of sixty.

Mount is buried in the cemetery of the Setauket Presbyterian Church, less than a quarter of a mile from where he was born. He left a legacy of about

two hundred paintings. In addition to the Long Island Museum in Stony Brook, which owns the majority of his work, Mount's paintings can be seen at the Art Institute of Chicago; the Brooklyn Museum in New York; The Cleveland Museum of Art; Fenimore Art Museum in Cooperstown, New York; The Metropolitan Museum of Art in New York; the Museum of Fine Arts, Boston; and the New-York Historical Society.

SKETCHES OF FIVE HOUSEHOLDS

The people of color who served as William Sidney Mount's models and inspirations tended to belong to the households of his extended family. These homesteads, all farms on several hundred acres of land, lay within a seven-mile radius in Stony Brook, Setauket, and Smithtown. Remarkably, all but one of the main houses, or manor houses, on these once enormous estates are still in existence.

Like those on other households on Long Island in the mid-nineteenth century, Mount's relatives grew corn, wheat, oats, and other grains, and some of them also owned apple orchards. They kept horses, cattle, chickens, geese, turkeys, pigs, and sometimes sheep. The manor house where the owners' family lived was just one of many structures, such as barns, stables, and washhouses, on the homestead.

Upkeep of these large homesteads required the work of cooks, housekeepers, farmhands, and other laborers who were often, but not always, people of color. A few of the men of color described in this book worked the land of Mount's relatives while simultaneously farming their own parcels of land. They built their own small dwellings and lived with their families. Other individuals in our story, both male and female, lived in their employers' manor houses, in attic rooms; in one rare case, the manor house was large enough to have a servants' wing. It was not unusual for the children of workers to grow up almost in sibling relationships with the children of employers. Music, as this book shows, played a special role in leveling class differences—at least temporarily, as can be seen in one of Mount's most famous paintings, *The Power of Music*.

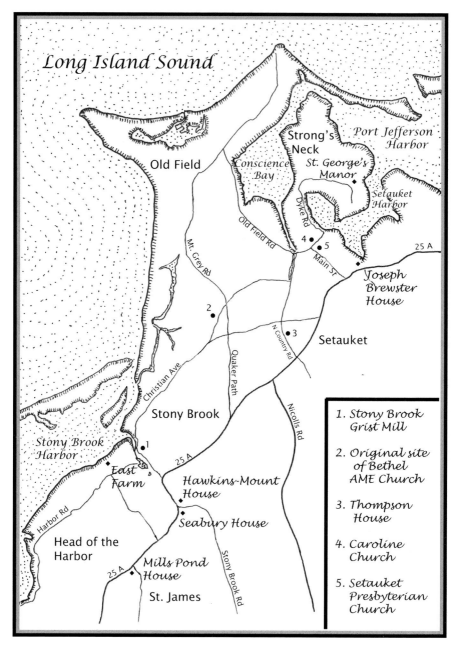

Above: Map of the Five Households. *Jennifer Kirkpatrick.*

Opposite: Shepard Alonzo Mount, *The Cabin*, not dated. This illustration shows the kind of dwelling in which many free people of color in nineteenth-century Long Island might have lived. *The Long Island Museum of American Art, History, and Carriages Collection.*

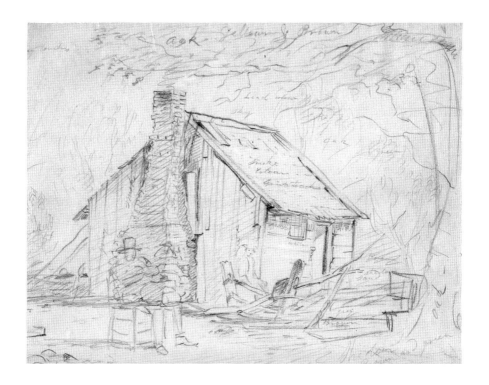

THE MOUNT HOUSE IN STONY BROOK

Today called the Hawkins-Mount House, Stony Brook's Mount House was built around 1725 and enlarged in 1757 by William Sidney Mount's great-grandfather Eleazer Hawkins. The former tavern had a storied history associated with Mount's grandfather Jonas Hawkins and with Revolutionary War patriotism long before Mount moved there as a child in 1814. The house remained in the Mount family's ownership until 1919, when it was purchased by a retired physician, Edward Payson Buffet, who became Mount's first biographer. Businessman and philanthropist Ward Melville purchased the house in 1945, and the Ward Melville Heritage Organization owns it today. The Long Island Museum maintains the house and hopes to someday open it to the public.[21]

During the years that Mount was active as a painter, his sister, Ruth, and her husband, Charles Seabury, lived across the street. Their home, which dates from the late 1700s, is now a private residence. Though the Mounts and Seaburys had separate homesteads, we include them together here as one unit.

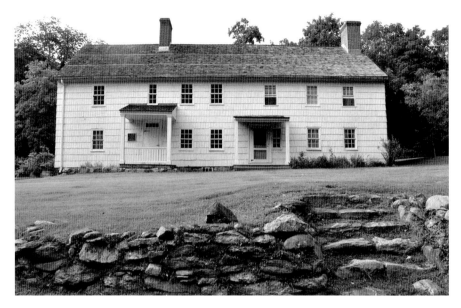

The Hawkins-Mount House, Stony Brook. *Jennifer Kirkpatrick.*

These models and other influential people of color are associated with the Mount House and the Seabury residence:

Mary Brewster
Anthony Hannibal Clapp
Hector
Philena Seabury

St. George's Manor on Strong's Neck
in Setauket

Strong's Neck in Setauket has been home to many generations of the Smith and Strong families. Native Setalcotts inhabited the area from precolonial times. In the late 1600s, through land grants and purchases, Colonel William "Tangier" Smith—a former British councilman and mayor of Tangier, Morocco, before coming to New York—acquired about eighty-one thousand acres on Long Island. He called his vast estate the Manor of St. George and, on the Setauket peninsula then known as Ye Little Neck, built the first St. George's Manor House.

Colonel William "Tangier" Smith's great-granddaughter Anna "Nancy" Smith would become legendary for her alleged role in George Washington's Culper Spy Ring. In 1750, Anna married Selah Strong, a future captain in the New York militia and delegate to the first three provincial congresses in colonial New York. After the Revolution, the Strong family purchased most of Ye Little Neck from the Smith family. Eventually, the area was renamed Strong's Neck.

Selah Brewster Strong I—a grandson of the Revolutionary War Selah Strong—built the 1844 Greek Revival home that can be seen in the background of several of William Sidney Mount's paintings. It's the third house on Strong's Neck to go by the name of St. George's Manor; the first presumably burned down, and the second was greatly damaged in the war.

The wealthiest household in the Setauket and Stony Brook area during Mount's time, it had four hundred acres, horses, milking cows, a herd of cattle, and an even larger herd of sheep. The house is still owned by members of the Strong family.[22]

William Sidney Mount and Selah Brewster Strong I were close friends as well as distant cousins descended from the William "Tangier" Smith family line.

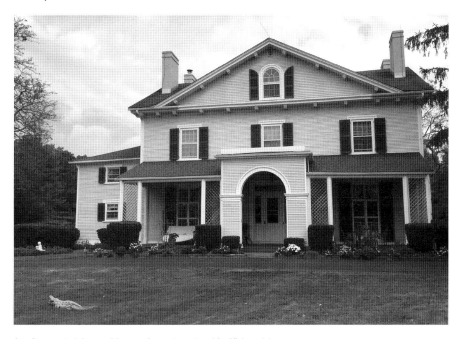

St. George's Manor House, Setauket. *Jennifer Kirkpatrick.*

This woman of color, associated with St. George's Manor, possibly modeled for Mount:

Rachael Youngs Tobias

THE MILLS POND HOUSE IN ST. JAMES/SMITHTOWN

William Sidney Mount was related to the Mills family through his grandmother Ruth Mills Hawkins. Farmer and cattle breeder William Wickham Mills I was her half brother. William Wickham Mills II, an investor in the Long Island Railroad and one of the wealthiest men on Long Island, built the two-and-a-half-story manor house that stands on the property today. Completed in 1841, the Greek Revival mansion had a central portico and five bays, thirty-four rooms, an attached kitchen, and a servants' wing. One thousand apple trees made up the apple orchard. Plum and pear trees grew on the property as well. Herds of cattle and milking cows, when not out to pasture, sheltered in an enormous, sprawling barn. Other structures on the property included a horse stable, a cider house, and a carriage house.

The Mills Pond House remained in family ownership until 1976, when three brothers, Edward H.L. Smith Jr., William Wickham Mills Smith, and

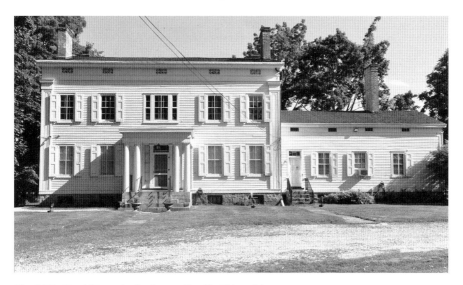

The Mills Pond House in St. James. *Jennifer Kirkpatrick.*

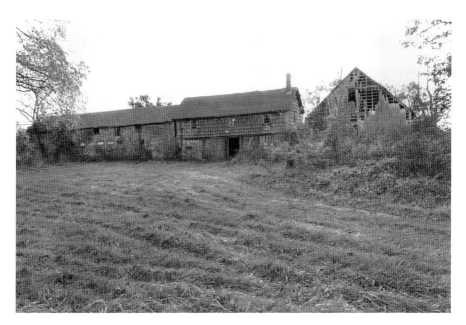

The ruins of cow barns at the Mills Pond House in 1977. *Zachary N. Studenroth.*

DuBois Tangier Smith, conveyed the house to the Town of Smithtown. Leased to the Smithtown Arts Council, it is now the Mills Pond Gallery and a multipurpose art facility.[23]

These models of color lived on or near the Mills Pond House property:

Henry Brazier
Abner Mills
Robbin Mills
Tamer Wren

The Joseph Brewster House in Setauket

The 1665 "saltbox" house, often described as the oldest house in Brookhaven, was home to six generations of the Brewster family. Lieutenant Joseph Brewster II operated a tavern and general store in the house during the Revolutionary War. While entertaining British soldiers, he may have colluded with his cousin Caleb Brewster in collecting information for the Culper Spy Ring.

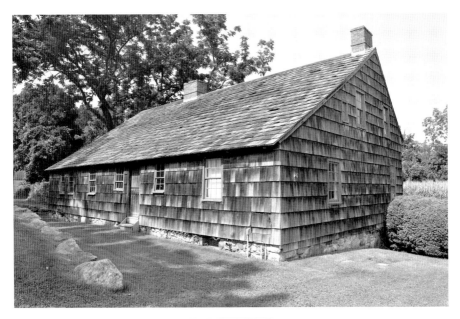

Above: The Joseph Brewster House, Setauket. *Jennifer Kirkpatrick.*

Left: The Brewster House attic. *Ward Melville Heritage Organization.*

In Mount's time, the three-room house was occupied by John Brewster and had an adjoining house located just behind it. The estate included 250 acres of woods, farmland, and waterfront property looking out to Setauket Harbor.

The friendship between the Brewsters and the Mounts was cemented when William Sidney's brother Robert Nelson Mount married John's daughter, Mary J. Thompson Brewster, in 1833 and moved into the adjoining home. The Brewster House, owned by the Ward Melville Heritage Organization, is open to the public as a museum. Robert Nelson's house, where William Sidney Mount died in 1868, is no longer in existence.[24]

These models of color are associated with the Brewster House:

Andrew Brewster
Rachel Brewster
George Freeman

EAST FARM IN HEAD OF THE HARBOR, ST. JAMES/SMITHTOWN

Richard Smith, named after his grandfather who was the original patentee of Smithtown, built the manor house around 1710. The house and land, on Harbor Road overlooking Stony Brook Harbor, was owned in Mount's time by relatives on two different sides of his family. In the mid-1800s, Lewis

The East Farm Manor House in its original location near Stony Brook Harbor. *Leighton H. Coleman III.*

Mills, son of Jedediah "Jed" Mills, lived in the house. By 1870, Shepard "Shep" Smith Jones, Mount's second cousin on his father's side, had purchased the estate and named it East Farm. Jones and Mount were close friends and often played music together.

The house, moved from its original location near the water, is now part of Harmony Vineyards and used as a tasting room for visitors.[25]

These models of color are associated with Shep Jones's household:

Ben Cato
Mathias Jones
Robbin Mills

1

ANTHONY CLAPP AND
RUSTIC DANCE AFTER A SLEIGH RIDE

The Creation of *Rustic Dance*

In the nineteenth century, the city of New York, then as now, was the pulsing heart of arts and culture in America. And in 1830, those critics and patrons at the heart of the American art scene hailed the young painter William Sidney Mount for his new work *Rustic Dance After a Sleigh Ride* and awarded him first prize at the National Academy of Design's annual art exhibition. The oil painting shows couples dancing to a Black fiddler's tune at a country inn, with an assemblage of rural characters wearing a variety of animated expressions. The work must have come as a surprising change of pace to the affluent visitors who viewed it at the National Academy. For what they saw that day in the Old Alms House in Lower Manhattan's City Hall Park wasn't a landscape, a wealthy man's portrait, or a painting with a lofty subject matter taken from the Bible, classical history, or Shakespeare. This work was altogether more earthy, provincial, backwoods—in a word, American.

Restaurant owner Edward S. Windust, who must have been one of the many top-hatted gentlemen in the crowd, purchased *Rustic Dance*. Imagine the pride and satisfaction of the twenty-three-year-old artist, bills in pocket, returning to the home of his widowed mother and widowed grandmother in Stony Brook, Long Island. This was the "backwoods" setting of the painting—a distance of about sixty miles from Manhattan. Mount would have made the day's journey by steamer, followed by a short stagecoach ride.

William Sidney Mount, *Rustic Dance After a Sleigh Ride*, 1830. *The Museum of Fine Arts, Boston.*

Mount would never again illustrate such arcane subject matters as Christ raising the daughter of Jairus from the dead or the witch of Endor summoning the ghost of Samuel in a cloud of supernatural mist. Those grand paintings of his had not sold. Clearly, the sophisticated New Yorkers wanted something altogether less sophisticated. The new U.S. president, Andrew Jackson, who'd been born into humble circumstances, was calling his presidency the "Era of the Common Man." So cultural tastes even among the rich were shifting toward new emblems of nationalism.

Mount received accolades for *Girl with a Pitcher* (1829), the simple country scene he'd exhibited with *Rustic Dance*. And it would not be long before the governing board of the National Academy made him one of their Academicians.

Mount had learned the effectiveness of good old rural charm in his art, and he embraced it.

The Message and Style of *Rustic Dance*

Art historian Deborah Johnson says that *Rustic Dance* "is about love and its narratives."[26] In the open space in the middle of the painting, two couples are our focal point. The man in the olive-colored waistcoat and trousers to the left of the woman in the red dress raises his hand to his face in either astonishment or consternation. Wearing a white gown, his sweetheart—or at least the woman he hopes will be his sweetheart—seems about to step out onto the floor with another man. We recognize the shocked onlooker as a player in the romantic drama of the painting from the valentine pinned to his cravat. The woman in white wears a valentine as well; just above her sash, it dangles from one of her long necklaces.

Compared to Mount's later work, this scene appears tight and overcrowded, and many of the faces seem alike. Still, the painting possesses warmth and vitality, and it shows Mount's talent for storytelling.

The Models of Color in *Rustic Dance*

The three people of color in *Rustic Dance*—the fiddler, the young man at the fireplace holding bellows, and the red-capped coach driver with a whip peering through the doorway—seem like caricatures rather than real people. As far as is known, Mount did not paint from models for *Rustic Dance*, as became his habit for later works. Art historian Linda Johns points out that the three Black figures are "peripheral and fundamentally comic." She writes, "Their role, as Mount represents them, is to serve, and their caricature grinning faces—like the prints of Jim Crow—suggest the happy, childlike black."[27]

Johns goes on to say that the supposed naivety and gaiety of Black people, as shown in this and other nineteenth-century paintings by White artists, perpetuated harmful stereotypes of people of color that were used as "a weapon against their freedom." These statements are perceptive. Though neither the White nor the Black faces in this work are well-rendered, the larger-than-life grins of the fiddler and the man tending the hearth make those figures appear cartoonish—unsettlingly so.

As Johns says, the Black people's place in the social order in *Rustic Dance* is clear. The three individuals of color drive the sleigh that brings the guests to the inn, provide the dance music, and pump the bellows to keep the fire burning.

Other works in this book clearly demonstrate that Mount's artistic skills improved to an astonishing degree after he painted *Rustic Dance*. In a future chapter, we discuss a painting of another fiddler of color that Mount created twenty years later, *Right and Left*.

MOUNT'S LIFE AND NINETEENTH-CENTURY LONG ISLAND IN *RUSTIC DANCE*

Nearly everyone in Mount's life on Long Island danced to fiddle music, though there were many in this period who considered both dancing and fiddling to be sinful. Mount himself both played and danced. Groups of people enjoying fiddle music became one of Mount's favorite themes.

The big room shown in the painting may have been inspired by the large first-floor room of the house of Mount's maternal grandfather, Jonas Hawkins (1752–1817). Certainly, the grandfather clock illustrated in *Rustic Dance* is the same clock that stood in that room until modern times and is now part of the Long Island Museum's collections.

The large main room in the Hawkins-Mount House, which possibly inspired the setting for *Rustic Dance After a Sleigh Ride*. *Joshua Ruff.*

Shepard Alonzo Mount, *The Slaves Grave*, circa 1850. Anthony Clapp's tombstone is the tallest one in this painting. *The Long Island Museum of American Art, History, and Carriages Collection*.

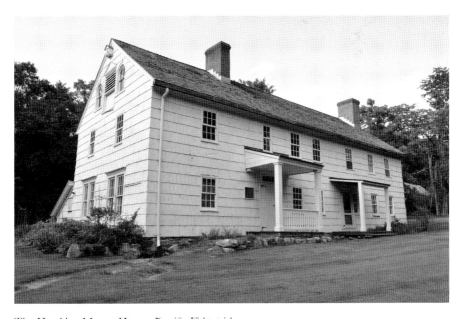

The Hawkins-Mount House. *Jennifer Kirkpatrick*.

ANTHONY HANNIBAL CLAPP

Anthony Clapp (1749–1816), also known as Toney, was born and raised in Horseneck, Connecticut, now Old Greenwich. He was enslaved by the Clapps, a Quaker family. Anthony left Connecticut for Long Island, likely as a free man, in 1779, the same year the head of the Clapp household, Thomas Clapp, died.[*] Anthony was thirty. He may have moved to Long Island for economic opportunities or to rejoin family members.

It remains a mystery how Anthony became associated with the Hawkins family. Most historians conclude that Anthony worked as a servant for Mount's grandfather Jonas Hawkins, but his tombstone specifically says he came to Setauket, not Stony Brook, in 1779.[†] So it's possible he lived elsewhere, even if he was buried in the cemetery on the Hawkins-Mount property. The 1810 census for Brookhaven mentions a free Black family of four under the household of "Jone Clap" living in Setauket next to the Dickerson and Woodhull families.[‡] Perhaps that "J" was meant to be a "T."

Could Anthony have earned a living as a traveling musician, as did a Black fiddler from Huntington named "Lige"? Was Anthony the accompanist to the dance teacher Nelson Mathewson, who taught classes at the Hawkins tavern? It's in keeping with the Hawkins family's love of music that a talented fiddler became, in one capacity or another, part of their household.

Some Mount biographers suggest that Anthony taught Mount to play the violin. It's plausible, though the window of possibility is short, as he died when Mount was nine.[§] What's more likely is that Anthony taught Mount's uncle Micah Hawkins, who taught Mount.

[*] The circumstances in which Anthony left Connecticut suggest that he could have been manumitted. He departed Horseneck (Old Greenwich) in 1779, the same year his owner, Thomas Clapp, died. Remarkably, Anthony was not passed along in ownership to either Thomas's widow, Mary, or his son, John. If the family followed the practice of many Quakers at the time, who were becoming increasingly opposed to slavery, they would have manumitted Anthony just prior to, or soon after, Thomas Clapp's death.

[†] It is often assumed that Anthony Clapp was enslaved by Jonas Hawkins because he was buried in what the Mount family referred to as "the old slave cemetery." However, Mary Brewster, a free woman of color, was interred in the same cemetery. Clearly, the burial ground, likely begun for enslaved people in the eighteenth century, included free people of color in the nineteenth century.

[‡] The 1810 census for Brookhaven mentions "Jone Clap," a free Black man and his family of four living in Setauket. And coincidentally or not, in 1820, four years after Anthony's death, the Brookhaven census lists a Tony Black (a.k.a. "Tony, a Black Man"), a possible relation of Anthony Clapp, living in Southold.

[§] Anthony Clapp is almost without a doubt the same "Toney, a black man, age 50–60," who died on January 22, 1816, according to records of the Setauket Presbyterian Church.

Edward Payson Buffet writes that Anthony Clapp was "5 feet 7 inches or 8 inches, knock knee'd but not withstand that deformity (if it may be called as such) was remarkably limber joined when young." According to Buffet, who cites Mount's brother Robert Nelson Mount as the source, the dexterous Anthony could "place a sixpence on the floor and bend over backwards and take it up with his tongue and rise without any support from his hands."¶

When Anthony died, the Hawkins family commissioned an extraordinarily large and ornate headstone for him. It was carved from red slate by Huntington artist Phineas Hill. With its lengthy epitaph and image of a violin and bow handsomely sculpted in relief, the stone shows that the family held Anthony in high esteem. Such expense was rarely paid for any person's grave in the Three Villages, let alone one for a Black man. Buffet wrote that Mount kept the violin carved on Anthony's grave "painted." As is still evident from yellow paint flecks embedded in the carving today, Mount applied pigments to the stone to decorate it. Much later, in the 1940s, finding the tombstone broken in half, Edward Payson Buffet transported the broken pieces to the Hawkins-Mount House for safekeeping. The pieces were eventually placed in the Long Island Museum, where they were cemented together.

In the long, flowery epitaph, Micah Hawkins praised Anthony for his extraordinary skills on the violin, his ability to provide the right dance music in keeping with the audience and situation, and his sunny and congenial personality despite his poverty.

ENTIRELY TONE-LESS
Honor and shame from no condition rise
Act well thy part, there all honor lies

ANTHONY HANNIBAL CLAPP
Of African descent.
Born at Horseneck Conn, 14, July 1749
came to Setauket in 1779,
Here sojourning until he died 12, Oct. 1816

¶ Buffet, biography series, "Chapter I: Determinative Factors." Also see Olly, *Long Road to Freedom*, 11–15, 99.

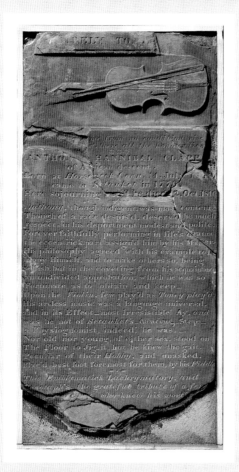

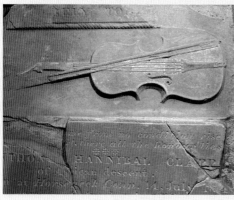

Top: Anthony Hannibal Clapp's tombstone, circa 1816. *The Long Island Museum of American Art, History, and Carriages Collection.*

Bottom: Detail of Anthony Hannibal Clapp's tombstone, circa 1816. *The Long Island Museum of American Art, History, and Carriages Collection.*

Anthony, though indigent, was most content,
Though of a race despis'd, deserv'd he much
respect—in his deportment modest and polite,
Forever faithfully performing in life's drama
the eccentrick part assign'd him by his Maker.
His philosophy agreed with his example to be
happy Himself, and to make others so, being
selfish, but in the coveting from his acquaintance
an undivided approbation, which he was so
Fortunate as to obtain and keep—
Upon the Violin, few play'd as Toney play'd,
His artless music was a language universal,
and in its Effect—most Irresistible! Ay, and
was he not of Setauket's dancing Steps
a Physiognomist, indeed; he was.

—Nor old nor young, of either sex, stood on
The Floor to Jig-it, but he knew the gait.
Peculiar of their Hobby, and unasked,
Plac'd his best foot foremost for them, by his Fiddle.

This Emblamatick Lachrymatory, and
Cenotaph's, the grateful tribute of a few of
either sex who knew his worth.**

P. Hill. Carver.

A paraphrase of this inscription might read:

We're left Tone-Less [a pun], *we're left without Toney.
There's no shame in him being born Black;
What matters is how well you play your part in life
and he honorably played his part.
He was of African descent.*

** Frankenstein, *William Sidney Mount*, 93.

*He was born in Horseneck, [Old Greenwich] Connecticut
on July 14, 1740 and came to Setauket in 1779. Here [Setauket or Stony Brook]
he stayed until his death on October 12, 1816.
Though he was not wealthy, he was content.
Though he was born of a race that many people despise, he deserves much
credit—because he carried himself modestly, was polite,
and faithfully performed his duties in life's drama
the peculiar part he was assigned by God who made him.
It was his philosophy to be happy and to make others happy.
Many (selfishly?) wanted to know him.
He was universally esteemed, and this good reputation
he was fortunate to have and to keep—
Upon the violin, few played as Toney could play.
His excellent music was a universal language all could enjoy,
the effects of this music were most irresistible! Ay, and
in terms of Setauket's dancing, he was expert in knowing what people wanted.
Young and old, male or female,
If they started to jig on the floor, he could set the right tempo for their steps.
Even though dancing was a hobby for white people
he placed his best foot forward and played for them with this fiddle.
This tribute of gratitude, on this emblematic vessel that holds tears,
and on this [possibly empty] tomb, is placed here on behalf of a few people,
both men and women, who knew his worth.*

At the same time the epitaph praises Anthony, it reflects patronizing and racist attitudes. Micah wrote that Anthony belonged to a "race despised" and played his "eccentric part" that was "assigned by his Maker." In other words, God, not man, had ordained servitude based on race, and this role was the one which Anthony was meant to play.

The young William Sidney Mount likely watched his family and friends dance in this large living room. And while the White couples hopped and stepped, bowed and curtsied, a Black fiddler named Anthony Hannibal Clapp provided the rhythm and the beat. "I have sat by Anthony when I was a child, to hear him play his jigs and hornpipes," Mount wrote of him. "He was a master in that way and played well his part."[28]

There has been much speculation among historians as to the number of free and enslaved individuals of color who worked for the Hawkins and Mount families. The first federal census wasn't taken until 1790, and the records made after that were far from complete. In addition to writing about Anthony, Mount referred in a letter to an elderly Black man named Hector who had taken him fishing as a child.

Anthony Clapp was buried in the Hawkins-Mount cemetery for people of color, which stood near the planting fields on the family's property. Shepard Alonzo Mount, one of William Sidney's brothers, made a painting of the cemetery, *The Slaves Grave* (circa 1850). Anthony's is the tallest of the tombstones shown in the work. Only two other gravestones from this cemetery still exist today. One is for an enslaved man named Cane (1737–1814), who died when Mount was seven. A built-in bench near the fireplace in the large main-floor room of the Hawkins-Mount House is familiarly known as "Cane's seat."[29]

The other remaining memorial in the cemetery is for Mary Brewster (1815–1850), a free or indentured woman who likely worked for Mount's sister, Ruth Seabury, and her husband, Charles Seabury.

The White members of the Hawkins-Mount household were buried off the property in the cemeteries of the Setauket Presbyterian Church and the Caroline Episcopal Church of Setauket, among other locations.

2

THE RACHEL OF
EEL SPEARING AT SETAUKET

THE CREATION OF *EEL SPEARING AT SETAUKET*

Look far and wide, visit every museum in the United States, and you'll not find another painting like *Eel Spearing at Setauket* (1845). One of Mount's finest works, it is one of the few American genre paintings from this period that features a woman of color.

The painting shows a relatively dark-skinned woman wearing a hat, kerchief, dress, shawl, and apron, balancing in a skiff, her arm raised as she prepares to catch an eel with her pronged spear. She intently watches the water, which is as still and reflective as a mirror. A young White boy, who holds the boat steady from the stern with his oar, also looks on with a keen expression. The boy's little terrier, its ears pointed upward, anticipates the action to come as well.

We can guess the rest of the story. Soon a cold, slimy eel—perhaps a gigantic one—will be wriggling in the boat before it's clobbered. By and by, the woman, who is probably the cook of the household, will skin the eel, bone it, and cut it into chunks. She'll likely roll the chunks in cornmeal and fry them in butter.

But at this tranquil moment, the water is calm and the air unmoving. The sky appears yellow, the dried lawns of late summer a light golden brown. Mount tells us in a diary entry that the golden colors that suffuse the landscape aren't purely artistic but evidence of a drought. A white two-story house and accompanying farm buildings emerge from behind trees

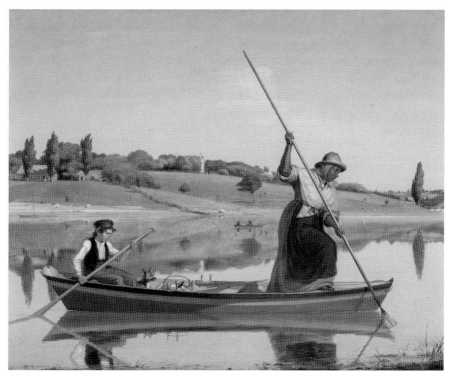

William Sidney Mount, *Eel Spearing at Setauket (Recollections of Early Days—"Fishing Along Shore")*, 1845. *Collection of the Fenimore Art Museum, Cooperstown.*

on the shore. The house, St. George's Manor, belonged to the Honorable Selah Brewster Strong I, a congressman (1792–1872, not to be confused with his grandfather Selah Strong, 1732–1815, of Revolutionary War fame).[30] Ten-year-old Judd (Thomas Shepard Strong II, 1834–1909), one of the congressman's sons, served as the model for the boy in the painting. The congressman's uncle, New York attorney George Washington Strong (1783–1855), commissioned the work.[31]

The Message and Style of *Eel Spearing at Setauket*

Like the farm scene in *Caught Napping* (1848), a later painting the attorney commissioned from Mount, *Eel Spearing at Setauket* involves one of Strong's childhood memories. He was the youngest son of Revolutionary patriots

William Sidney Mount, *St. George's Manor*, not dated. *The Long Island Museum of American Art, History, and Carriages Collection.*

Selah and Anna Smith Strong. Evidently, an enslaved woman who worked for young George's family took him fishing in the shallows near his home. Exactly what he recalled and asked Mount to paint was not put down in writing. However, in a letter to a friend, Mount recorded a fish-spearing anecdote with an enslaved older person named Hector from his own childhood. So, it seems this painting, which Mount titled *Recollections of Early Days—"Fishing Along the Shore"*, is as much about Mount's memories as it is about George Washington Strong's.

The painting was controversial in its time. In the White, male-dominated art world of the nineteenth century, to depict a Black woman as the subject of fine art would have been considered inappropriate, as well as a waste of time and precious oil paint and canvas. *Eel Spearing at Setauket* may not seem daring to a modern audience, but when Mount exhibited the painting at the National Academy of Design in New York, reviewers were baffled and uncomfortable with a "negress" taking center stage in a painting.[32] One reviewer warned Mount he was "falling off" from doing his usual good work, both in "conception and execution."[33]

THE MODEL OF COLOR IN *EEL SPEARING*

The name Rachel (or Rachael) has long been associated with the woman in the skiff; some accounts say that the enslaved woman from Strong's childhood bore that name, while other accounts say that Rachel (or Rachael) is the name of the model who posed for Mount. In the spirit of investigation—and with the intention of honoring all the Rachels of color in Setauket's past, who led brave and quietly heroic lives of hardship—we reopen the discussion. As it happens, the individuals who inspired the painting and who served as its model were likely both named Rachel (or Rachael).

The Revolutionary-era "Rachel" (if that was her name), who was enslaved by Selah and Anna Strong, isn't documented. However, this enslaved woman had a daughter named Eunice Smith Strong (1788–1863), an enslaved baby of color born into Selah Strong's household in 1788. Eunice eventually married Pierro (or Piro) Young(s) (1781–1832), a free

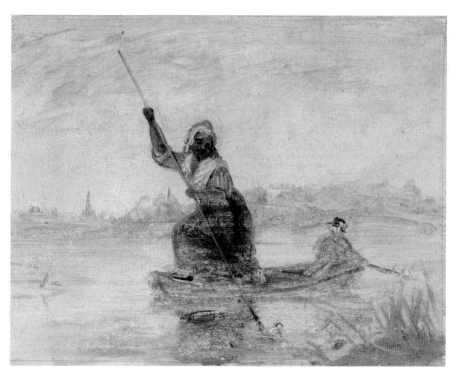

William Sidney Mount, *Study for Eel Spearing at Setauket*, not dated. *The Long Island Museum of American Art, History, and Carriages Collection.*

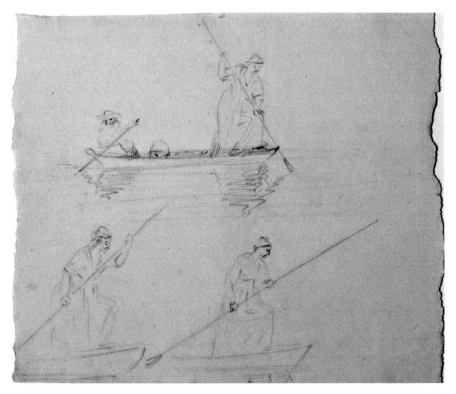

William Sidney Mount, Study for *Eel Spearing at Setauket*, 1845. *The Long Island Museum of American Art, History, and Carriages Collection.*

person of color, and had five daughters; the oldest was Rachael Youngs. It was customary in the eighteenth century among people of color for a mother to name her firstborn daughter after her own mother; it follows that Eunice's mother may have been named Rachel.

While Strong's childhood memory of the Revolutionary War–era Rachel might have inspired the subject of *Eel Spearing at Setauket*, Mount could not have used her as a model. By 1845, the Rachel of George's childhood would have been deceased, and Mount wouldn't have had any images of her to reference. Ultimately, we cannot say for sure who posed for Mount, though census, church, and family Bible records offer two compelling possibilities.

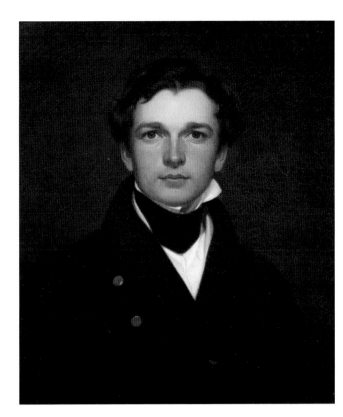

Left: William Sidney Mount, *Self-Portrait*, 1832. *The Long Island Museum of American Art, History, and Carriages Collection.*

Below: William Sidney Mount, *The Mount House*, 1854. *The Long Island Museum of American Art, History, and Carriages Collection.*

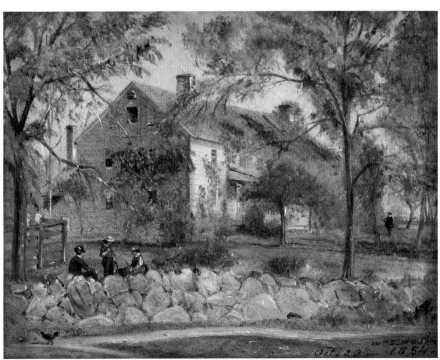

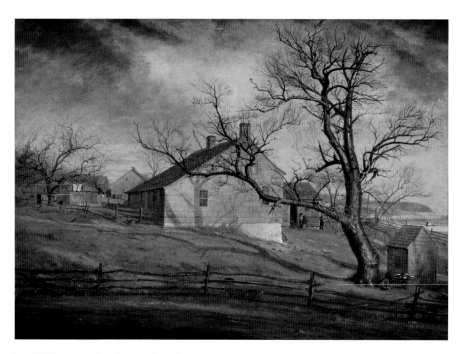

Above: William Sidney Mount, *Long Island Farmhouses*, 1862–1863. *The Metropolitan Museum of Art, New York.*

Left: William Sidney Mount, Detail for *Long Island Farmhouses*, not dated. *The Long Island Museum of American Art, History, and Carriages Collection.*

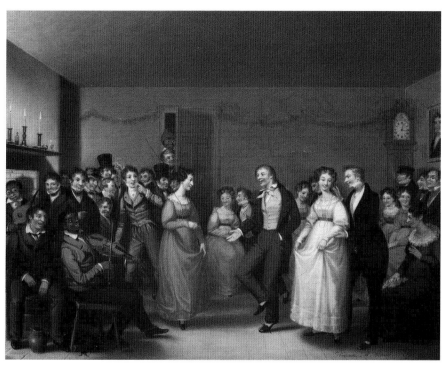

William Sidney Mount, *Rustic Dance After a Sleigh Ride*, 1830. *The Museum of Fine Arts, Boston.*

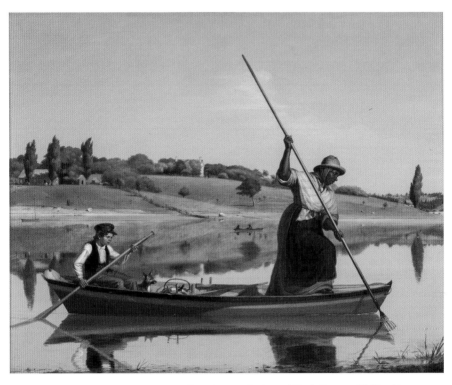

William Sidney Mount, *Eel Spearing at Setauket (Recollections of Early Days—"Fishing Along Shore")*, 1845. *Collection of the Fenimore Art Museum, Cooperstown.*

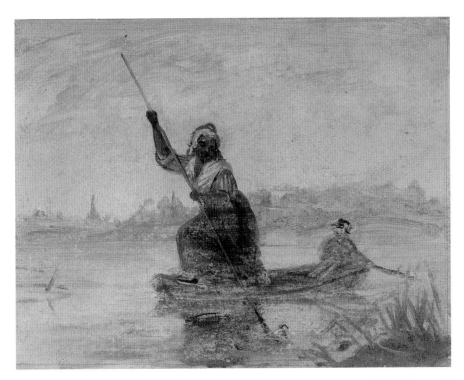

William Sidney Mount, Study for *Eel Spearing at Setauket*, not dated. *The Long Island Museum of American Art, History, and Carriages Collection.*

William Sidney Mount, *The Mower*, 1866–1867. *The Long Island Museum of American Art, History, and Carriages Collection.*

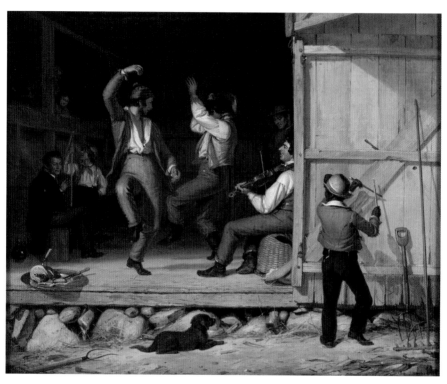

William Sidney Mount, *Dance of the Haymakers (Music Is Contagious)*, 1845. *The Long Island Museum of American Art, History, and Carriages Collection.*

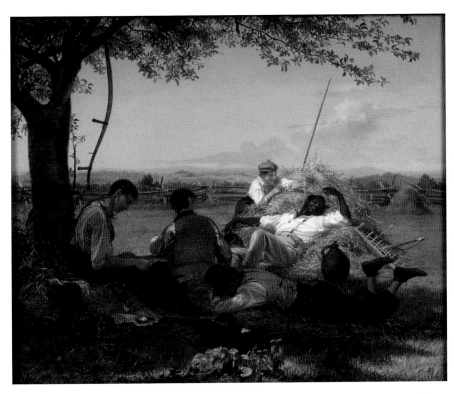

William Sidney Mount, *Farmers Nooning*, 1836. *The Long Island Museum of American Art, History, and Carriages Collection.*

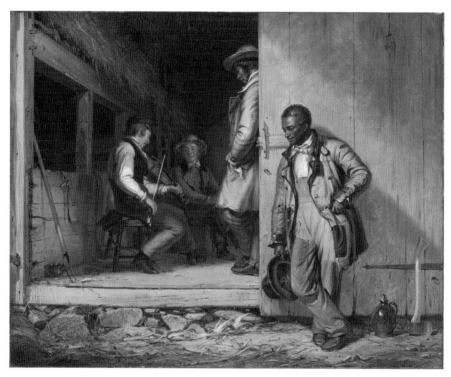

Above: William Sidney Mount, *The Power of Music*, 1847. *The Cleveland Museum of Art.*

Opposite: William Sidney Mount, Detail from *The Power of Music*, 1847. *The Cleveland Museum of Art.*

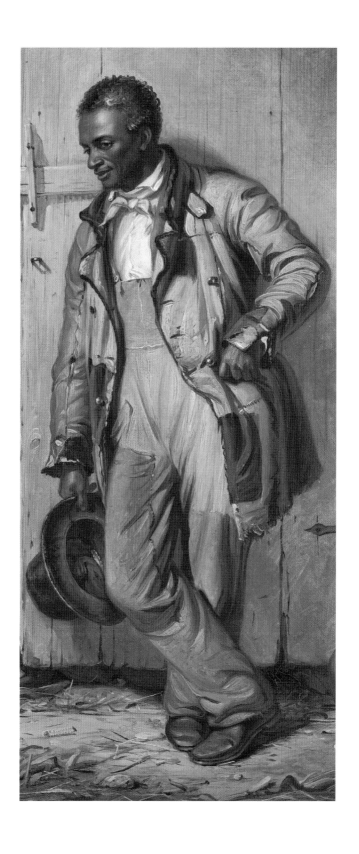

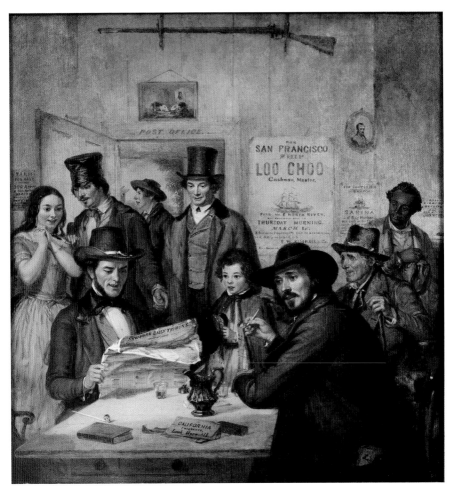

William Sidney Mount, *California News*, 1850. *The Long Island Museum of American Art, History, and Carriages Collection.*

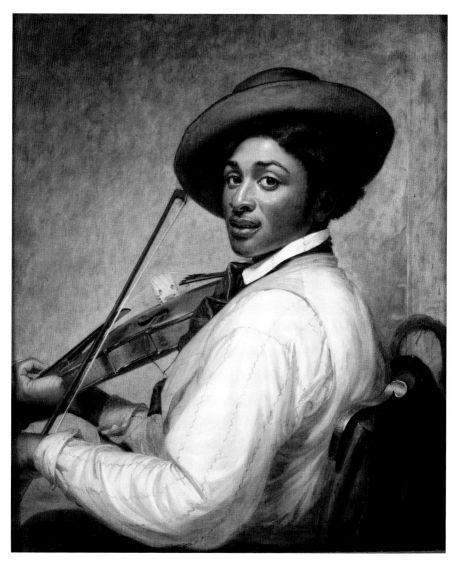

William Sidney Mount, *Right and Left*, 1850. *The Long Island Museum of American Art, History, and Carriages Collection*.

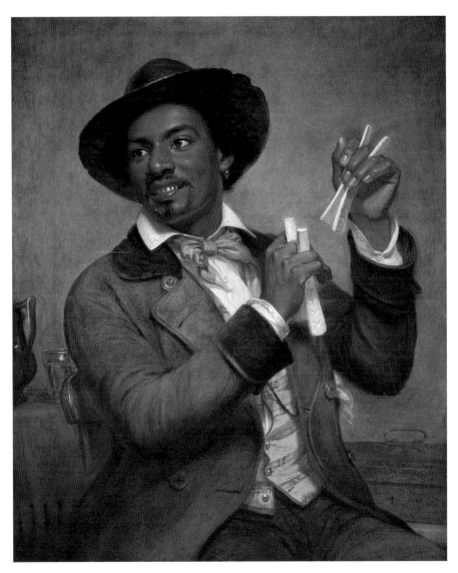

William Sidney Mount, *The Bone Player*, 1856. *The Museum of Fine Arts, Boston.*

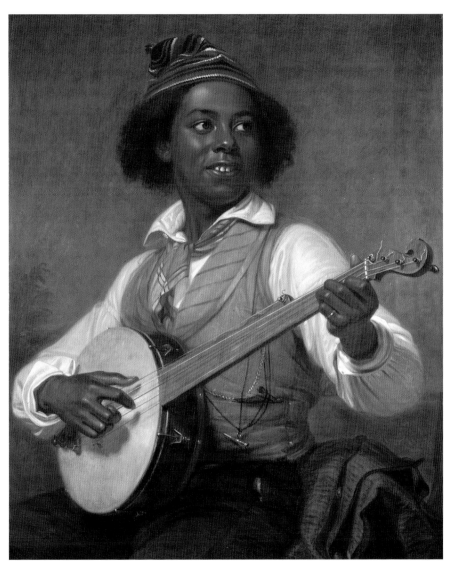

William Sidney Mount, *The Banjo Player*, 1856. *The Long Island Museum of American Art, History, and Carriages Collection.*

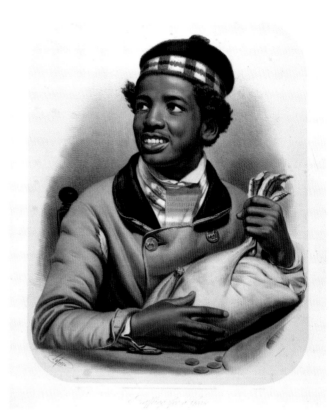

Jean-Baptiste Adolphe Lafosse, Lithograph print of *Raffling for a Goose (The Lucky Throw)*, 1851, after William Sidney Mount's painting of 1849. *The Long Island Museum of American Art, History, and Carriages Collection.*

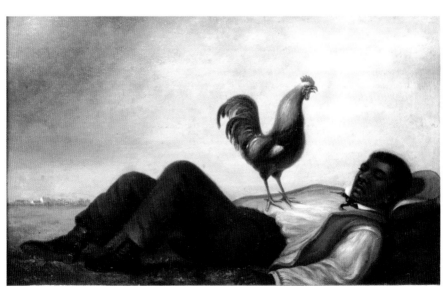

William Sidney Mount, *The Dawn of Day*, 1867. *The Long Island Museum of American Art, History, and Carriages Collection.*

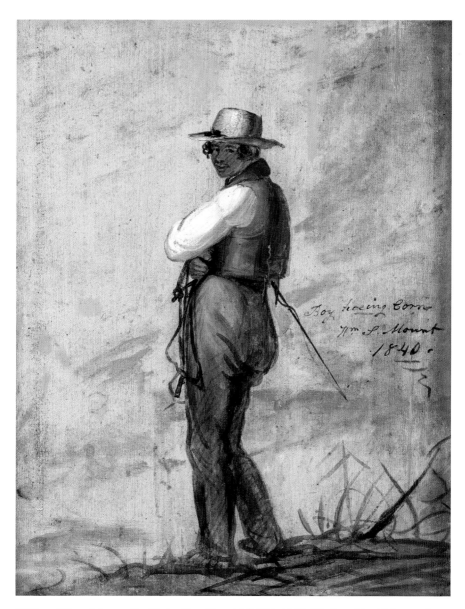

William Sidney Mount, *Boy Hoeing Corn (Boy with Bridle)*, 1840. *The Long Island Museum of American Art, History, and Carriages Collection.*

Shepard Alonzo Mount, *The Slaves Grave*, circa 1850. *The Long Island Museum of American Art, History, and Carriages Collection*.

RACHAEL YOUNGS TOBIAS

One candidate is Rachael Youngs Tobias (1805–1866), the oldest of Eunice Strong and Pierro Youngs's daughters. Rachael Youngs was forty at the time Mount painted *Eel Spearing at Setauket*. The woman in the skiff looks to be about that age.

Rachael Youngs was born into slavery in the same household as George Washington Strong, who commissioned the painting, and his older brothers, Benjamin Strong and Thomas Shepard Strong I. The parents of the three boys were Anna and Selah Strong. Rachael and her sisters (Tamar, Cealia, Ellen "Nell," and Hanna)[34] would have been like younger siblings of Anna and Selah's own children, in a way, though they were enslaved. All the children grew up together and may have eaten at the same table.

When Anna and Selah grew old, they passed along Rachael and her sisters in ownership to their eldest son, Thomas Shepard Strong I, who was given a large tract of land east of Mt. Misery Harbor, now known as Port Jefferson Harbor. Thomas manumitted Rachael and three of her sisters (the fourth was born free) in 1821, when Rachael was fourteen. According to New York State's Act for the Gradual Abolition of Slavery, the girls were required to serve their mother's owner until they were age twenty-five, though Thomas and his wife, Hannah Brewster Strong, must have released Rachael a few years earlier. When she was about twenty-three, Rachael married Jacob Tobias (1803–1869) and moved nearby, to Old Field.

Census records of 1850 show Rachael and Jacob in Old Field in a household with six sons, a daughter, and Rachael's mother, Eunice.[35] It's likely that Rachael, her sisters, and their husbands and children maintained ties with the Strongs of Strong's Neck. Several may have served them as farm laborers and "laundresses" (the term used for housekeepers). Certainly, the Strongs who lived in St. George's Manor at the time when Mount created the painting knew Rachael quite well, so it's plausible that they asked her to model for Mount.

It's also a likely scenario that Rachael Youngs Tobias fished in Setauket Harbor or nearby Conscience Bay within sight of the manor. Perhaps Mount noticed her spearing eels during one of his sketching forays. Those who lived in Old Field would have sought the protected waters off Strong's Neck rather than fish from the windy, more turbulent open areas of Long Island Sound.

Rachael died in 1866 at the age of sixty and was buried in Stony Brook in what is now known as Old Bethel Cemetery.

Rachel Brewster

Alternatively, Rachel Brewster might have served as Mount's model. According to the Brewster family Bible, she was born on November 3, 1799, to Nell Brewster, an enslaved member of the Lieutenant Joseph Brewster II household. Nell is described in her death record in 1879 at the Setauket Presbyterian Church as free and "colored"—which in nineteenth-century Long Island terminology meant that she was of mixed Black and Native American ancestry. The father of Rachel and her three younger siblings is unknown. The siblings, and possibly Rachel herself, were likely born free under New York's 1799 Act for the Gradual Abolition of Slavery.[36]

Rachel Brewster grew up in Setauket's Brewster House. About forty-five at the time of the painting, her age and the close affiliations between the Mount and Brewster families make her another good candidate for Mount's model.

As a neighbor in easy walking distance, Mount would have known Rachel and her three siblings from early childhood. Possibly they were all playmates on skiffs on the water. The Mount and Brewster families attended the same church. And the bonds between the two families strengthened in 1833, when William Sidney Mount's brother Robert Nelson Mount married Mary J. Thompson Brewster, a White member of the same Brewster household. The couple moved into a house that adjoined the main Brewster House. William Sidney Mount visited the couple frequently and boarded with them several times in his life, including his final years.

Mount's landscape painting *Long Island Farmhouses* (1862–1863) shows the Brewster property in precise detail. In back of the main house, to the left, is a partial view of another saltbox house, where Mary and Robert Nelson Mount lived. St. George's Manor appears in the distant far right across Setauket Harbor. Mount frequently made pencil drawings of this view. At least five of his sketches show tiny figures in the distance fishing with poles.

Rachel Brewster, as a young servant on the Brewster property, looked out at that same vista. Mount could have watched her spear eels. It's more likely than not that Rachel Brewster knew how to fish, as she was the daughter of a parent or parents who were all, or part, Native American.

Without a doubt, the Brewster family kept a boat and fished; when old Joseph Brewster, the first owner of the house, died, he left two eel spears in his will.

What's not known is where Rachel was living at the time *Eel Spearing at Setauket* was painted. In 1816, around age sixteen or seventeen, Rachel

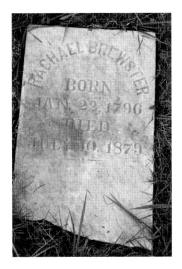

gave birth to a son, Adam Strong Brewster, at the Brewster House. The father's name isn't recorded.

Rachel doesn't reappear on census records until many years later, in 1870 and 1880, when she's living in Old Field with her son, Adam, and his family. She's enumerated as "widow" and "mother of Adam Brewster." Curiously, her tombstone in Setauket's Laurel Hill Cemetery presents her death date as 1879, a year before she is listed as alive at age eighty-six, in the census. Though her records contain incongruities, it's clear that Rachel lived to old age under the care of her son.[37]

Rachel Brewster's tombstone in Laurel Hill Cemetery, Setauket. *Jennifer Kirkpatrick.*

Rachel's brother Andrew continued to do farm work and reside at the Brewster household for most of his life. Eleven years after Mount painted *Eel Spearing at Setauket*, he used Andrew Brewster as his model for *The Bone Player* (1856). In the same period, Mount chose another Brewster farmhand, George Freeman, as his model for *The Banjo Player* (1856). Mount looked to the Brewster household for models. It follows that he could have picked Rachel Brewster as one.[38]

Native and Black Connections in Eighteenth- and Nineteenth-Century Long Island

Who might have taught the first Rachel the daring and dexterous art of hunting with a spear pole while standing in a small, tippy craft? The Native people of Long Island speared eels and showed the colonists and African Americans how to do so. In the eighteenth and nineteenth centuries, Native Long Islanders commonly intermarried with African Americans. The first Rachel may have had a parent or grandparent who was Native American, perhaps a Setalcott from Strong's Neck. Either directly from Native people, or indirectly through Native heritage passed on by other people of color, she'd mastered an age-old practice of Long Island's first inhabitants.

According to historian Lynda R. Day, nearly every Black family that can trace its roots back several generations on Long Island has Native ancestors. All the tribes on Long Island stem from the Algonquin-speaking Delaware,

also known as Lenape Indians, who originally made up much of the population from the East Coast to Canada.

Though Native populations had sharply declined on Long Island by the time of the Revolution, pockets of them remain today. Certainly in the nineteenth century, both Setalcotts and Unkechaugs existed in Brookhaven, including enclaves in Old Field and on Strong's Neck.

Lynda R. Day points out that it was natural for African Americans and Native peoples to form attachments because they often found themselves enslaved or indentured in the same White households. After King Philip's War, many Native men had either been killed or captured and enslaved elsewhere in the colonies or West Indies. Subsequently, there was a shortage of Native men on Long Island. Also there was a paucity of Black women on Long Island since the eighteenth century because the colonists had brought over from Africa and the West Indies many more Black men than women.

Some historians have noted that depending on the region of Long Island and the time period, it was sometimes illegal for settlers to enslave Native Americans to avoid violent conflicts. If a union was formed, and the mother was Native and the father Black, their children would be born free. So in the eighteenth century, certain Black men would have had an added incentive for marrying Native women.

Yet another reason that the two groups intermarried, according to Day, is that eighteenth-century Native people on Long Island's reservations, the Shinnecock Reservation (between Hampton Bays and Southampton) and the Unkechaugs' Poospatuck Reservation (in Mastic, Brookhaven), frequently took in enslaved African American runaways.

Early photos taken on the Shinnecock Reservation show tribal members with mixed ancestry. Day writes that African Americans and Native people became so culturally intertwined that they made baskets of the same style. Both groups ate a dish called "samp" made from corn and beans. Both groups possessed great knowledge of native plants and their curative properties. And using spears and hooks made from bone and wood, they excelled at whaling and fishing.[39]

THE ARCHAEOLOGY OF NINETEENTH-CENTURY FAMILIES OF COLOR ON LONG ISLAND

In 2015, archaeologist Christopher N. Matthews completed excavations of two Three Village properties associated with nineteenth-century people of

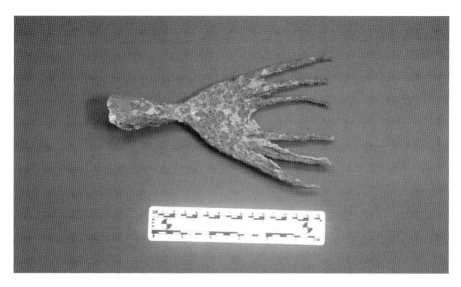

Spearhead excavated in 2015 by archaeologist Christopher Matthews at the Silas Tobias site in Old Field. In a small house once standing on this site, members of the Tobias family, free people of color, lived on the west shore of Conscience Bay. *Christopher N. Matthews.*

Fragments of clay pipes from the Silas Tobias site. *Christopher N. Matthews.*

color. At the Silas Tobias site along the west shore of Conscience Bay in Old Field, generations of Tobiases lived from the 1700s to 1881. At the Jacob and Hannah Hart site at Lake and Main Streets in Setauket, the Hart family resided on the land by 1888 and remained until the 1940s.

The thousands of artifacts that Matthews uncovered at the Silas Tobias site, all from Mount's lifetime, include the remains of two eel spearheads made of wrought iron. Contents of refuse middens indicate that the Tobias family ate fish, shellfish, turtles, and water birds in addition to deer and other land animals. On the site, Matthews also uncovered fragments of a "jew's harp"—a small instrument played between the teeth and plucked with the fingers. A slate pencil (used for writing on a slate tablet), fragments of clay pipes, and commercially manufactured ceramic dishes offer more clues about the lives of the people of color on Long Island in Mount's time.[40]

Mount's Life and Nineteenth-Century Long Island in *Eel Spearing at Setauket*

Mount's memory of fishing with an older man named Hector left such an indelible impression on him that he undoubtedly had Hector in mind as he brushed paint across his canvas for *Eel Spearing at Setauket.*

Mount wrote about Hector in an 1847 letter to his friend Charles Lanman, an author, painter, explorer, and politician. Lanman was authoring a book about fishing, and Mount told him:

> An old Negro by the name of Hector gave me the first lesson in spearing flat-fish and eels. Early one morning we were along shore according to appointment, it was calm, and the water was as clear as a mirror, every object perfectly distinct to the depth from one to twelve feet, now and then could be seen an eel darting through the sea weed, or flatfish shifting his place and throwing the sand over his body for safety. "Steady there at the stern," said Hector, as he stood on the bow (with his spear held ready) looking into the element with all the philosophy of a Crane, while I would watch his motions, and move the boat according to the direction of his spear. "Slow now, we are coming on the ground,"—on sandy and gravelly bottoms are found the best fish. "Look out for the eyes," observes Hector, as he hauls in a flat fish, out of his bed of gravel, "he will grease the pan my boy," as the fish makes the water fly out in the boat. The old negro mutters to himself with a great deal of satisfaction, "fine day, not a cloud, we will make old mistress laugh,

William Sidney Mount, *Clam Diggers*, not dated. *The Long Island Museum of American Art, History, and Carriages Collection.*

now creep—in fishing you must learn to creep," as he kept hauling in the *flat-fish, and eels, right and left, with his quick and unerring hand. "Stop the boat," shouts Hector, "shove a little back, more to the left, the sun bothers me, that will do, now young* Master *step this way. I will learn you to see and catch flat-fish. There," pointing with his spear, "don't you see those eyes, how they shine like diamonds." I looked for some time and finally assented that I did—"Well, now don't you see the form of the whole fish (a noble one) as he lies covered lightly in the sand. Very good, now" says he, "I will strike it in the head," and away went his iron and the clear bottom was nothing but a cloud of moving sand, caused by the death struggle....He threw his whole weight upon his spear. "I must drown him first, he is a crooked mouth, by golly." The fish proved to be a larger flounder, and the way old Hector shouted was a caution to all wind instruments.*[41]

Hector may have been enslaved by Jonas Hawkins, Mount's maternal grandfather, in Stony Brook. "The old mistress" in Mount's account is probably Mount's grandmother Ruth Hawkins Mount. In occasional diary entries throughout his life, Mount mentions fishing in the Stony Brook Mill Pond and in Stony Brook Harbor. It seems that Hector wielded his pronged spear from a Hawkins family skiff in gravelly Stony Brook Harbor. Mount's references to the "old negro" and the "young master" come across as racist. However, Mount did recognize Hector's considerable talents as a fisherman.

Though Mount does not mention it in this passage, Hector was likely experienced in smoking techniques that could bring out and preserve the eels' flavor. In all probability, Hector caught enough fish to sell to neighbors or at market. Both free and enslaved people of color in eighteenth- and nineteenth-century Long Island earned money from fishing. Their forays on the water also afforded them some time and relaxation away from their employers' households, where they were more closely monitored.

It's possible that Hector came to Mount's family from the East End of Long Island. The name Hector is rare in Long Island census records. So he may have been the same Hector who was enslaved by General William Floyd of Mastic Beach and later by Theophilus Pierson of Southampton. In 1744, Pierson left in his will that "my negro Hector and my wench Dol and her child are to be sold." It appears that Hector, Dol (a common Native female name), and the child were a family unit. Southampton was, and is, Shinnecock territory—it is the home of the Shinnecock Reservation to this day. The Shinnecock were well known for their excellent skills on the water, which included eel spearing in inlets as well as whale hunting with harpoons from canoes in the Atlantic. Shinnecock and African Americans often intermarried. If Mount's childhood Hector is in fact the same man as the Southampton Hector, it's likely he learned to fish from Native peoples.

3

MARY BREWSTER, PHILENA SEABURY, MATHIAS JONES, AND *DANCE OF THE HAYMAKERS*

THE CREATION OF *DANCE OF THE HAYMAKERS*

Charles Mortimer Leupp was Mount's favorite type of patron, the kind that allowed the artist to choose his own subject matter. Leupp, a wealthy leather merchant in the city of New York, asked simply for a "picture" and agreed to Mount's asking price of $200. The businessman apparently didn't mind that Mount took two years to fulfill his order. Leupp already had a vast art collection, so he may not have cared exactly what variety of painting he'd receive and when.[42]

This was a lucky assignment for Mount, and for all of us today, because it gave the artist freedom to paint what was in his heart: people playing music. Luckier still, Leupp was so delighted with the work, *Dance of the Haymakers* (1845), he gave Mount an extra $25 for it and showed it off to friends and family. His mother-in-law, Isabella Williamson Lee, admired the work and commissioned one of her own. For her, Mount created *The Power of Music* (1847), on a similar theme, and also received an additional $25 to the asking price of $200.

The good fortune continued. Mount showed both paintings at the National Academy of Art to great acclaim. The New York art critics who'd felt lukewarm, at best, toward *Eel Spearing at Setauket* favored *Dance of the Haymakers* and *The Power of Music*, though these paintings likewise included people of color. Art historian Elizabeth Johns points out that the critics found

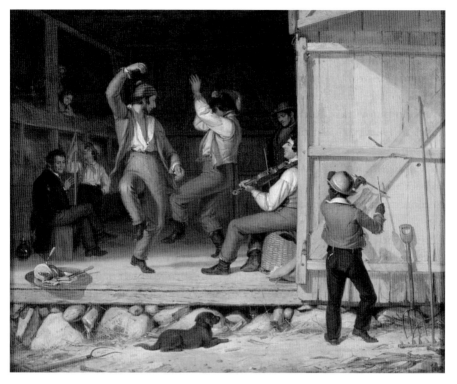

William Sidney Mount, *Dance of the Haymakers (Music Is Contagious)*, 1845. *The Long Island Museum of American Art, History, and Carriages Collection.*

Mount's new works socially acceptable because the compositions separate the Black people from the White people. Racial politics played a large role in the kind of art the all-White American connoisseurs preferred.

Mount's popularity was about to expand beyond the boundaries of the United States and its American sensibilities. In 1848, Carl Wilhelm (known as William) Schaus, a German émigré who'd newly arrived in New York from Paris to open a wholesale art gallery, approached Mount with a propitious offer. Schaus represented Goupil, Vibert & Co., a French art dealership that sold lithographic prints in addition to paintings. In an arrangement that must have seemed to Mount as heaven-sent, he received $100 each for the rights to print *Dance of the Haymakers* and *The Power of Music* and, in time, eight other works.

The firm's distribution range included Europe and the United States and even extended to the Ottoman Empire and Australia. One drawback was that the owners of the paintings had to agree to the works being shipped by

steamer to France to be recreated by an artist onto lithographic stones. The lithographic process, including the transport of art back and forth to the United States, took two to three years. The owners of *Dance of the Haymakers* and *The Power of Music* gave their permission. Perhaps they visited Goupil, Vibert & Co.'s elegant, multistory wholesale gallery and business space at 289 Broadway when they signed their insurance papers. The ample building in the heart of Broadway accommodated a personal residence for Schaus.[43]

As noted earlier, in his dealings with Mount over the next decade, Schaus would commission Mount to paint a series of portraits involving Black entertainers playing the violin, bones, and banjo. Mount's letters and journal entries do not tell us why Schaus took a special interest in seeing Black musicians portrayed in art. But it seems far from coincidental that in Blackface minstrel groups of the time, such as the Virginia Minstrels, four stock characters played the fiddle, the tambourine, the bones, and the banjo. Such a style of music had entered into the American consciousness, to the extent that even a German émigré like Schaus knew of it.

Whatever Schaus's personal taste in artistic subjects might have been, he recognized sales potential for such paintings in the European market.

THE MESSAGE AND STYLE OF
DANCE OF THE HAYMAKERS

Dance of the Haymakers takes us to the joyful evening of a harvest day. In the early morning light, all hands, the head of the household as well as laborers, would have begun cutting the alfalfa or native salt grasses. The farmers dried the grasses in the fields, raked them into piles, and stored them to feed horses and cattle during the cold winter. The painting depicts the workers enjoying the completion of the day's labor by listening and dancing to music in a barn. A fiddler, seated on an overturned basket, plays a lively tune, while two men circle each other with raised arms and knees as they bob up and down.

One with each other and the music, the men move in sync, each keeping an eye on the other and urging him on. It's an exuberant dance and a friendly competition of sorts: Who can outdo the other? The men are "showing their stuff." You can almost feel their ragged, hot breaths, smell the scent of hay, and hear the excited cries and the stomping of feet over the music. A cat, under the raised barn floor, eyes a puppy; like the dancers, each carefully watches the other's next move. They're so interested in each

Top: William Sidney Mount, Studies for *The Power of Music* and *Dance of the Haymakers*, 1845. *The Long Island Museum of American Art, History, and Carriages Collection.*

Bottom: William Sidney Mount, Study for *Dance of the Haymakers*, 1845. *The Long Island Museum of American Art, History, and Carriages Collection.*

other that neither one is going after the ham on a nearby plate, which the human company has on hand.

Just outside the barn, a boy of color raps two sticks together in time with the music. He is not missing out on a chance to participate. Neither are the onlookers in the barn, including a well-dressed older man who is clapping his hands and a woman and girl of color who are watching from the hayloft. People of different ages and races who might not otherwise bond with one another come together in this spontaneous frolic.

The artist's sketches indicate that Mount conceived of *Dance of the Haymakers* and the later *The Power of Music* at the same time; both paintings arose from the same series of figures shown dancing, playing music, and listening. What's fascinating from a cultural perspective is that Mount readily interchanged the ethnicities of the figures in his sketches and studies when completing his final works. For example, in a roughly painted study, a Black boy kicking up his right knee and rising on his left toe became the White hornpiper in the striped hat in *Dance of the Haymakers*. In real life as well in these works, the dancers were not always White and the fiddlers

MOUNT'S WORK REPRODUCED IN PRINT

Earlier in his career, a few of Mount's works had been engraved for limited audiences of subscribers, such as *Farmers Nooning* for the Apollo Association. Other engraved works such as *Bargaining for a Horse* and *The Painter's Triumph* appeared in gift books, in which fictional stories were written to accompany the images. These, too, had a limited and clearly defined market. In the engraving process, the engraver cuts lines into a metal plate in order for these grooves to hold ink. In the lithography process, the lithographer draws a design, usually onto a flat stone (or a metal plate), and then affixes the design by means of chemicals. In our present digital age of instantly and inexpensively mass-produced images, both engraving and lithography would be considered limited and exclusive art forms. In Mount's time, with few printmaking options, lithography leapt ahead as the revolutionary new option that allowed thousands of prints, not just hundreds, to be produced from one stone. Lithographic prints were considered more expendable than engraved prints.

Mount's distribution network expanded to cities in Europe and perhaps beyond. His buyers, too, changed in character from the middle- or upper-class all-American northern and southern purchasers of expensive gift books to middle-class buyers in the northern states and throughout Europe.

were not always Black, and even if the people of color assumed positions in the sidelines, all participated in proximity. Mount's recording of informal musical gatherings shows us that Long Island society, at least on occasion, wasn't rigidly segregated.

Mount's open barn composition resembles a theater stage. He used the same theatrical framing device in *The Power of Music*. Mount's knowledge of lower Manhattan and its theaters contributed to his outlook both as an artist and as a musician. When Mount attended a theater performance in the city of New York, he sketched actors on a proscenium that closely resembled this open-doored barn.

MODELS IN *DANCE OF THE HAYMAKERS*: MOUNT'S FRIENDS AND FAMILY

Mount chose his second cousin, fellow musician and sometime Stony Brook neighbor, Shepard "Shep" Smith Jones, as the model for the fiddler in the painting. Mount depicts the holding and playing of the fiddle with the accuracy of one who played himself.

Jones, a talented fiddler who was much sought after at social occasions, was also a wealthy farmer and landowner, a merchant and businessman, and holder of various public offices. He and Mount were close. Thanks to the discovery of a lithographic print of the image inscribed by the artist to Jones, we are told the fiddler's identity and the music he was playing. Mount's handwritten sheet music for "Shep Jones Hornpipe" was found between the canvas and matte of the print's frame.

It follows that the two men at the center of the painting are dancing a hornpipe, a traditional dance of the British Isles often associated with sailors. Ship captains adopted it because it does not require a partner, could be done in a small space, and gave the men lots of exercise.

Mount's biographer Edward Payson Buffet interviewed Shepard Jones's son, Henry Floyd Jones. Buffet further identifies the true-life models in the painting, all local people. The dancers are, at left, Tom Briggs, and at right, Wesley Ruland. The spectator behind the fiddle is Horace Newton, a Stony Brook resident and wheelwright. The man seated on the box at the left is Billy Biggs. Buffet mistakenly thought the boy with the flail was Jedediah Williamson. He later identified him as Joe Jayne, a relation to Shep Jones.

The barn in the painting is often cited by historians as the one on East Farm in Head of the Harbor, St. James/Smithtown. At the time Mount

Above: This barn on the property of East Farm (now Harmony Vineyards) may have been Mount's setting for both *Dance of the Haymakers* and *The Power of Music*. *Jonathan Olly.*

Right: Interior of East Farm barn. *Jennifer Kirkpatrick.*

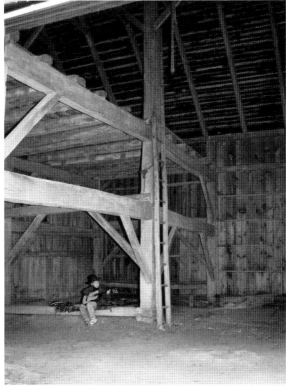

created the work, this beautiful farm overlooking Stony Brook Harbor was owned by Lewis Mills. Mills was another distant cousin of Mount's, though Shep Jones later lived on the property.

The Models of Color in *Dance of the Haymakers*

Mary Brewster

"The colored woman on the mow [the hayloft] with her daughter beside her lived at the Seaburys," Buffet wrote. He said she was called "Aunt Mary"; often women of color in a White household, regardless of age, were given the title of "aunt." According to an unverified source, Buffet wrote, the daughter's name was "Hulda." Both mother and daughter wear head coverings, possible indicators of their status as workers.

As previously noted, Mount's sister, Ruth Hawkins Mount Seabury, and her husband, piano manufacturer Charles Seabury, lived in Stony Brook across the street from the Hawkins-Mount House. The 1840 federal census lists a "free colored person, female, age 10–24," in Charles Seabury's household. (Individual names of dependents were not given in that census year.) This woman of color, age twenty-four or twenty-five at the time of the census, may have been Mary Brewster (1815–1850).

Historians have noted the somewhat unusual fact that Mary was buried in Stony Brook in the Hawkins-Mount cemetery for people of color while her husband (Adam Strong Brewster, 1816–1885) resided in Smithtown at the time. Some historians propose (though there is no proof) that Mary worked as an indentured servant, which would explain why she lived apart from her husband. But there's no record of her residing with the Mounts. It makes more sense that she was the "Aunt Mary" living across the street with the Seaburys. Curiously, the 1850 census shows her living with her husband in Smithtown, near Mills Pond, the same year as her passing. Perhaps by then she'd been released from her indenture (assuming she had been indentured in the first place).

Mary died at age thirty-five, possibly during childbirth or from an illness. The fact that the Seaburys interred her on the Hawkins-Mount property isn't surprising; Ruth Mount Seabury had grown up in the Hawkins-Mount House and lived close by. Someone, apparently a Mount or a Seabury, chose to bury Mary in the same small cemetery as Anthony Hannibal Clapp—a place of honor.[44]

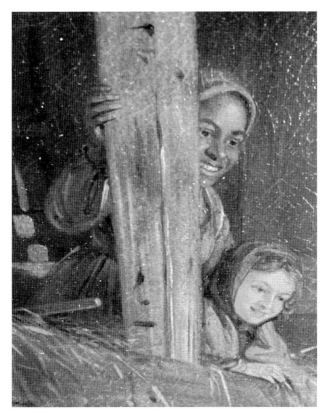

Left: William Sidney Mount, Detail from *Dance of the Haymakers (Music Is Contagious)*, 1845. Mary Brewster and Philena Seabury are possibly the figures shown in the hayloft. *The Long Island Museum of American Art, History, and Carriages Collection.*

Below: Mary Brewster's broken tombstone. *Jennifer Kirkpatrick.*

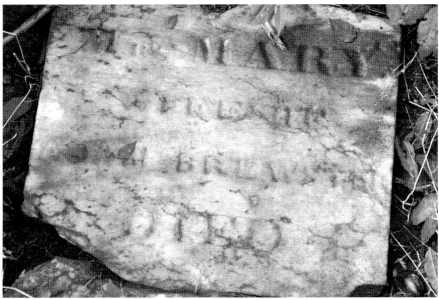

Philena Seabury

The Mary Brewster story has another fascinating twist. Buffet says that the girl in the haymow in *Dance of the Haymakers*, pictured with her mother, is "mulatto" and lived at the Seaburys. Note how light the skin of the girl is compared to that of her mother. The Charles Seabury household in the 1850 census enumerates a previously unmentioned individual, Philena Seabury, age ten, "mulatto," listed after the children of Charles and Ruth. She's not designated as a servant. If she had been one, the census taker would have filled out the column listing professions. It follows that Philena (or Hulda) is the daughter of the female "free colored person" noted as living in the household ten years earlier—Mary Brewster, recently deceased.

Who was Philena's White father? Could he have been one of the Seaburys? Or one of the Mounts? With no further records to go by, it's an unsolvable mystery.

By the time the next census was taken—ten years later, in 1860—Charles Seabury had died and Philena was gone from the household. The name Philena doesn't appear at all in the Brookhaven census in 1860 or later. Did she die? Move? Then why aren't there records of her dying or living elsewhere? Light-skinned biracial people who "passed" for being White sometimes changed their names and disappeared far away into communities where no one would recognize them. It is possible that Philena did the same.

Mathias Jones

Henry Floyd Jones identifies the boy of color who plays percussion outside the barn with two sticks (possibly polished cattle bones) as Mathias, an apprentice to Henry's father, Shep Jones. He was probably Mathias Jones, who was born in Brookhaven in 1830.[45] At the time Mount painted *Dance of the Haymakers*, Mathias would have been fifteen, a plausible age for Mount's model.

Mathias likely grew up in the household of Shep Jones's father, Daniel Floyd Jones (1793–1842). And one or more of Mathias's parents or grandparents may have been born on the estate of Shep Jones's grandfather Benjamin Jones (1754–1823).[46] Both of these Stony Brook households included multiple people of color, according to census reports. It makes logical sense that Shep Jones hired workers associated with his family.[47]

The former Seabury residence, Stony Brook, was once the home of Mount's sister, Ruth Mount Seabury, and her husband, Charles Saltonstall Seabury, a piano manufacturer. *Jennifer Kirkpatrick.*

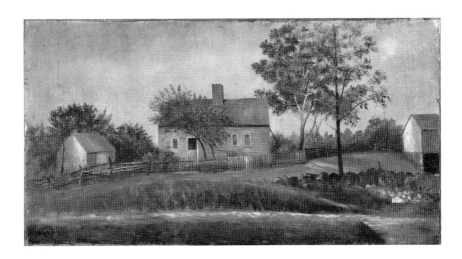

Evelina Mount, *Longbotham House, Stony Brook*, not dated. Mount's niece made this painting of the house where Shepard "Shep" Jones once lived with his in-laws. *The Long Island Museum of American Art, History, and Carriages Collection.*

THE MUSICAL CULTURE OF NINETEENTH-CENTURY LONG ISLAND

Musicologist Christopher J. Smith identifies the boy as a skilled percussionist by the way he's holding the sticks, palm up and palm down. Percussion instruments, including drums, rattles, and clappers, date to ancient times in Africa, Smith says, as do stringed instruments that became the models for banjos and zithers. By Mount's time, percussion instruments had entered the lives of Long Islanders of all racial backgrounds.

Smith also makes the case that by the mid-nineteenth century, tribal dances from Africa and the Caribbean combined with Celtic step dances in a new American synthesis. Not only did African-Caribbean music enter the mainstream of American culture, but African-Caribbean body movements did as well. The free and easy way that the men move in *Dance of the Haymakers* is similar, Smith points out, to people of color dancing juba. Those White men, if they'd been strictly following the style of the sailors' hornpipe, would be folding their arms and holding their backs very straight. The barn dancers, in contrast, move their upper bodies freely. They are not stiff and constrained like the White dancers in *Rustic Dance After a Sleigh Ride* (1830).

Mount's sheet music for fiddle often included stress marks to indicate where participants clapped their hands, stomped, or played along with percussive sticks or bones. They may have also called out words during these dances. As noted previously, the noisy nature of the barn dances prompted Mount to invent his new kind of hollow-backed violin, "The Cradle of Harmony," that would allow the fiddle to be heard over the commotion. Christopher Smith emphasizes that, as with dancing, tribal African and Creole music and practices synthesized in the 1700s and 1800s with Celtic traditions to form a new kind of music. The "shout and echo" that was typical of African music entered Northeast culture, transported by waterways from the American South, where African American music originated from enslaved peoples. In time, jazz and many other varieties of music would evolve from these combined sources.[48]

4

ABNER MILLS (1836) AND *FARMERS NOONING*

THE CREATION OF *FARMERS NOONING*

Mount's painting *Farmers Nooning* (1836), a scene of young men and a boy resting from their morning's labor of cutting hay, brings us to a nineteenth-century harvest day. The reclining figure of color looks happy and relaxed, as if he could be having a good dream. A young White boy wearing a tam-o'-shanter playfully tickles his ear with a piece of straw. Two young White men sit nearby under the shade of a tree, while a third lies recumbent on his stomach, kicking up his feet. The man sitting against a tree sharpens farm tools for the afternoon of work ahead. A scythe hangs overhead from the branch of the tree.

The painting features a number of realistic, well-rendered everyday details that show us much about the period. A rake, missing a prong, leans against the hay bale, while the handle of another rake sticks up behind the bale. The large earthenware jug would typically contain cider, the Long Island farmer's affordable drink of choice. The handles of two knives jutting out from the lunch pail suggest it holds a hunk of cold meat, like the ham hock on the plate in *Dance of the Haymakers*, which the men have been eating.

Mount did not relate in his journals or letters why he chose the subject of this painting. Nor did Jonathan Sturges, the New York and Fairfield merchant who commissioned the painting, record any notes about it. Usually, Mount's wealthier urban clients gave him the leeway to choose his subject matter.

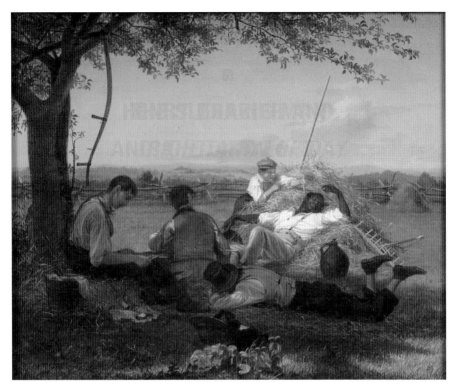

William Sidney Mount, *Farmers Nooning*, 1836. *The Long Island Museum of American Art, History, and Carriages Collection*.

At face value, Mount offers us a pleasant, nostalgic memory from his childhood. Scholars familiar with Mount's political views and those of his contemporaries give *Farmers Nooning* an entirely different interpretation.

THE MESSAGE AND STYLE OF *FARMERS NOONING*

Art historian Elizabeth Johns tells us that *Farmers Nooning* conveys a veiled warning of the dangers of abolitionism. At first glance, racial tensions seem absent in this scene. Was Mount implying that the Black man is lazy because he's asleep? That interpretation does not seem accurate; the Black man is not the only worker who is reclining. All indicators suggest the man has been at the arduous work of cutting, raking, and bundling the itchy and fragrant grasses since early morning. It's appropriate that he and all the other laborers rest.

The telltale clue to this being a painting about abolitionism is the little boy wearing the tam-o'-shanter, a traditional Scottish woolen cap with a headband and pompom. According to Johns, the tam-o'-shanter symbolizes the English and Scottish antislavery groups who funded American abolitionists. The ear tickling, she says, was an expression that held connotations of someone being deceived or duped. The abolitionists "filled the naïve listener's mind with promises," as Johns interprets Mount's possible message. Furthermore, Johns states, the ear-tickling image might have been intended as a warning of what could happen if enslaved people were freed—they might refuse to do their jobs. Or worse, they could riot.[49]

The sleeping man in *Farmers Nooning* looks anything but violent, and again, the mood of the painting is one of calm and tranquility. Art historian Deborah Johnson interprets the ear-tickling metaphor in gentler terms than Johns. She describes the Black man as "in a liminal state, suspended between the slumber of slavery and the awakening of emancipation."[50]

William Sidney Mount, Detail from *Farmers Nooning*, 1836. *The Long Island Museum of American Art, History, and Carriages Collection.*

William Sidney Mount, Study for *Farmers Nooning*, 1836. *The Long Island Museum of American Art, History, and Carriages Collection.*

And yet Mount's small oil study for the work features an arguably menacing image of a standing man, probably a White man, sharpening a scythe. Certainly, Mount was aware of violence over racial matters within the city of New York. He painted *Farmers Nooning* two years after military forces put down a weeklong anti-abolitionist riot. Rioters attacked businesses, private homes, and churches, including the Chatham Street Chapel, very near to where Mount's uncle Micah Hawkins had produced his comic opera in 1824–1825.

Mount's writings clearly show that he was wary of, if not absolutely opposed to, the abolitionist cause. And throughout his career, Mount did not shy away from politics in his art. He encrypted political references into a number of his works, including *Cider Making* (1841) and *Ringing the Pig* (1842). Whether he was being cautionary or glib, it's likely that Mount was making a stand against abolitionism in *Farmers Nooning*.

THE MODEL OF COLOR IN *FARMERS NOONING*

Edward Payson Buffet tells us that the Black man who reclines on his back on a pile of hay, his left arm above him in a casual sleeping position, is "Tobe" (which could be a reference to a member of the Tobias family in Old Field). And then in another article, after receiving further correspondence from his readers, Buffet states the man was Abner Mills.[51]

Though the models for the White characters in this work are not documented, the young men and the boy might be the sons of Mount's sister, Ruth Seabury. Mount painted the work while he was living with his widowed mother in Stony Brook, with Ruth and her family as close neighbors. Mount got along well with both his sister and her many children.

ABNER MILLS

It's likely that Mount knew Abner Mills (circa 1815–1913?), his purported model for *Farmers Nooning*, for more than a decade. Buffet indicates that Abner posed for him a second time as his model for *California News* (1850), fourteen years later.

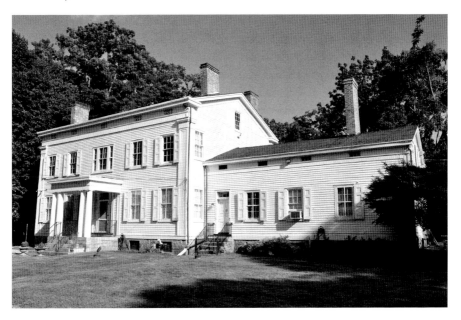

The Mills Pond House (now the Mills Pond Gallery), St. James. *Jennifer Kirkpatrick.*

Top: Cider-Making House at Mills Pond, photographed in 1977 before it was demolished. *Zachary N. Studenroth.*

Bottom: William Sidney Mount, *Study for Cider Making*, not dated. *The Long Island Museum of American Art, History, and Carriages Collection.*

The details of Abner's life are skeletal. He was born around 1815 on the Mills Pond estate in Smithtown. At that time, the house was owned by William Wickham Mills I (1760–1825), the half brother of Mount's grandmother Ruth Mills Hawkins. The estate's holdings would grow exponentially over

time with its ornamental gardens, extensive fruit orchards, a large cider-making house, and immense cattle farm.

Abner's father, Robbin Mills (1782 to after 1860; called "Short Robbin") was thirty-three when Abner was born, and his mother, Eunice (1794–1850), was twenty-one. He had three much-younger siblings, brothers Samuel and Abraham and a sister named Nellie. He also had two older half brothers, Alonzo London and Robbin Mills Jr. Robbin Jr. would be Mount's model for the later *The Power of Music* (1847) and the father of Reverend Robbin Mills, the first minister of Stony Brook's Bethel Church.

Abner spent at least the first thirty-five years of his life in Smithtown. According to the 1850 census, when Abner was thirty-five, his wife was named Catharine (b. 1813), age thirty-seven, and they had four daughters ranging in age from two to twelve.

The New York State Census of 1865 shows a vastly different family makeup. Abner, still a farmer in Smithtown at age fifty-one, has a wife named Sarah, who is twenty-five. No children are listed with them.

Census records show that a man named Abner Mills died in 1913 and was buried in Brooklyn. *If* this individual was the same Abner, he was ninety-eight when he passed.

MOUNT'S LIFE AND POLITICS IN NINETEENTH-CENTURY LONG ISLAND

Was Mount *in favor* of slavery? How could an artist who portrayed people of color with such affection and sensitivity endorse the institution? The conundrum is a disturbing one, and every art historian who has ever written about Mount has grappled with it. Perhaps on a personal level Mount opposed slavery. In his diary in 1867, more than three decades after Mount created *Farmers Nooning*, he wrote, "The slavery controversy has been settled. The 'peculiar institution' is dead and buried, and only lunatics could desire to exhume its putrescent remains."[52]

Mount painted *Farmers Nooning* prior to the Civil War, while Andrew Jackson was president. Many Jacksonian Democrats, including Mount, took the position that the legality of slavery should be decided not by the federal government but on a state level.

It may seem odd that Mount would have taken such a stance when all the people of color he knew—and cared about—were free. As mentioned

Tamer Wren

Abner Mills and his older half brother Robbin were not the only models of color to be associated with the Mills Pond estate. In 1830, William Sidney's brother Shepard Alonzo Mount created *Tamer*, one of the loveliest portraits of a person of color ever made by a White artist in the nineteenth century. The woman in the painting was Tamer Wren (1794–1851?). As previously mentioned, Shepard Mount, a talented artist in his own right, had a successful career as a portraitist.

On a simple wooden panel, just fifteen inches high, a young woman looks out at the viewer with a slight smile that's conveyed with her eyes, her lips, and the gentle roundness of her cheeks. The woman appears so alive that we almost imagine her in front of us, at the moment perhaps in which the artist has paid her a compliment and told her to hold still for her portrait. The three-quarter view is an intimate one.

Shepard Mount's wide, rough brushstrokes give the work an air of informality and spontaneity, and his color scheme, composed mostly of dark and lighter browns, cream and white, convey a feeling of calm. The colors blend harmoniously. The artist used finer brushstrokes to animate Tamer's face. Subtle pinkish highlights on her forehead, nose, cheek, lips, and chin, and in the corner of her eyes give her features life and dimension.[*]

Tamer (alternate spelling of Tamar), later known as Tamer Wren, was born in slavery in 1794 in the household of John Smith of Smithtown. When Tamer was four, she and her twin brother, Abraham; two-year-old sister, Maria; and father, Captain, were sold to a pair of Smithtown brothers, William and Richard Blydenburgh. At age eight, Tamer was separated from the rest of her family and sold to yet another buyer before being purchased, at around age twelve or thirteen, by William Wickham Mills I.

Emancipated in 1824 at age twenty-nine, she continued to work for the Mills family as a free woman when William Wickham Mills II, known as Wickham (1797–1865), inherited the house and property in 1825. William Sidney Mount painted portraits of Wickham Mills and his wife, Eliza Ann Mills, in 1829. A year later, in 1830, Shepard painted Tamer. The simplicity of the wood panel suggests that the painting was an act of friendship, either for the Mills family or for Tamer herself.

Though William Wickham I and Mary had only one living biological child, Eliza Ann, William I became the guardian to a host of others when one of his brothers died. These children may or may not have lived at Mills Pond. What's

[*] The painting *Tamer* by Shepard Mount, 1830, 15½ inches by 12 inches, oil on panel, is published in Johnson, *Shepard Alonzo Mount*, 35.

Wash House at Mills Pond, where Tamer Wren may have done laundry for the Mills family. The building is shown here in 1977 before it was torn down. *Zachary N. Studenroth.*

known for certain is that William II, another nephew and the heir to the estate, came to live with the family around 1809 at the age of twelve.

Eliza Ann was seven years younger than Tamer. Wickham was a year younger than Tamer. The lives of these three children remained inextricably intertwined as they grew up. Wickham and Eliza Ann eventually married, and Wickham inherited the estate. Tamer would toil for Wickham and Eliza Ann, as she had done for Eliza Ann's parents. Probably, Tamer served as one of the caretakers for Wickham and Eliza Ann's nine children.

Tamer had at least one child of her own. In 1823, at around age twenty-eight, Tamer gave birth to a free daughter, Maria Rosco Wren. The father of the child, Tamer's husband, was likely a free Shinnecock man named Simeon Wren (1775–1835) or Charles Wren (dates unknown). Simeon was about twenty years older than she. In 1830, when Tamer's portrait was made, she was about thirty-five. Her daughter, Maria, was seven. Five years later, in 1835, Simeon Wren died at the age of sixty. Both Charles and Simeon Wren were buried in the Mills family cemetery.

In 1837, Tamer served as a defendant in a court trial, *The People v. Glory Ann Smith*, in which Tamer testified against another free Black servant accused of arson. Glory Ann Smith, nearly thirteen, had admitted to Tamer that she had set Wickham and Eliza Ann's house on fire. The girl had stolen a key to a back room not often in use, set fire with a candle to curtains on the underpart of a bed, then locked the door to the room. Glory Ann evidently thought the fire would go out by itself. If she "had thought the house would have burned, she would not have done it," she said.[†]

[†] *The People v. Glory Ann Smith*, Case #9 from File #330, County of Suffolk County Clerk's Office, Riverhead, Long Island, New York.

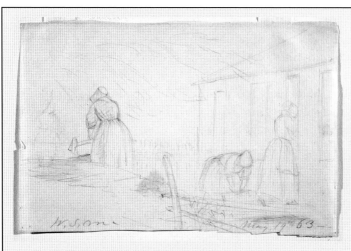

William Sidney Mount, *Wash Day*, 1863. *The Long Island Museum of American Art, History, and Carriages* Collection.

The trial report did not include Glory Ann's motive for arson or what happened to her after the trial. The fire evidently destroyed so much of the house that in the following year, 1838, William Wickham II began building a new dwelling, the Greek Revival mansion that is still in existence today.

Nothing else about Tamer's life was recorded by the Mills family. It's probable that she spent the remainder of her days sweeping out fireplaces and washing clothes for Wickham and Eliza Ann and their children. A cemetery record stating that "Tamer, a negro woman" is buried in the Mills family cemetery seems to confirm this. But the inscription, now very weathered, reads that Tamer passed on "November 27, 1851 age 77 and 3 mos."[‡] There is a puzzling error here. Based on the date of her first childhood bill of sale, she would have been fifty-six when she died.[§]

[‡] Historian Jonathan Olly concludes that Tamer did indeed live to be seventy-eight. Using census data, he poses a scenario that Tamer left the Mills family prior to 1850 to marry widower William Johnson of Smithtown. Johnson is enumerated in the 1850 Brookhaven federal census as a "mulatto" laborer born in Virginia in 1798 and working in the Seabury homestead. If Tamer Wren is the same person as the Tamer Johnson listed in the federal census of 1850 and the New York State Census of 1865, she was the mother of five children, and her second marriage lasted for at least thirty years.

[§] There were at least two Tamars (or Tamers) in the Smithtown area during Tamer Wren's time. "Tamar, a colored woman," died of "Dropsy" at the age of sixty-seven on February 24, 1830, according to records of the First Presbyterian Church of Smithtown. This woman could have been Tamer Wren's mother (Olly, *Long Road to Freedom*, 53–55; also see "Mills Family Cemetery" folder in the Richard H. Handley Long Island Room, Smithtown Library).

earlier, the State of New York enacted a gradual emancipation law in 1799. Most enslaved Long Islanders were manumitted prior to that date. By 1836, when Mount created *Farmers Nooning*, the people of color in Stony Brook and Setauket were not only free but also in some cases landowners.

Historian and author Isabel Wilkerson in her groundbreaking book *Caste: The Origins of Our Discontents* makes the interesting point that before the Civil War, White people in the states that had already abolished slavery tended to be even more prejudicial than their southern counterparts. It was harder, Wilkerson surmises, for those northern people to "cross the divide" in recognizing the "power of dehumanization" brought about by the superstructure in which they no longer took part.[53] Perhaps this is because the social setting of the industrialized North, where African Americans led comparatively freer lives, differed from plantation life in the South.

Mount never traveled to the southern states. He never witnessed slavery as it existed there, though certainly he would have read and heard about it. Did Mount assume that it was no concern of his what the policies were in the South? In any case, Mount, who was born under a system of racial hierarchy, clearly viewed segregation, if not slavery, as natural and inevitable.

Wilkerson writes that "caste"—referring to the hierarchies of race—"is insidious and therefore powerful because it is not hatred, it is not necessarily personal. It is the worn grooves of comforting routines and unthinking expectations, patterns of social order that have been in place for so long that it looks like the natural order of things."[54] Whatever Mount's personal beliefs about slavery may have been, he undoubtedly would not have questioned the "patterns of order" that separated the Black and White people in his own Long Island society.

5

ROBBIN MILLS AND
THE POWER OF MUSIC

THE CREATION OF *THE POWER OF MUSIC*

Music connects all people. This was Mount's theme for both *Dance of the Haymakers* (1845) and his accompanying artwork, *The Power of Music* (1847).[55] It's the same theme that Mount's uncle Micah Hawkins expressed on the tombstone of the Black fiddler Anthony Hannibal Clapp: "His artless music was a language universal." The subject spoke to Mount in a personal way as well. These two exquisite paintings convey the fiddler-artist's pleasurable, firsthand experience of being in sync with other human beings while harmonizing or following a beat.

Almost without a doubt, this painting is strongly autobiographical in its concept. As a boy learning to play the violin, Mount would have performed for his grandfather Jonas Hawkins and his uncle Micah Hawkins, among others. And for a brief period in Mount's childhood, at the ages of eight and nine, Mount may have lived in the same household as Anthony Hannibal Clapp, before his death in 1816. Mount might well have fiddled for his uncle and grandfather while Anthony, a knowledgeable bystander, stood at a distance, listening attentively.

The sketches on which Mount based both *Dance of the Haymakers* and *The Power of Music* present a similar composition with variations. Mount experimented with both Black and White people assuming different roles: playing music, dancing, listening. Skilled musicians, or listeners, in

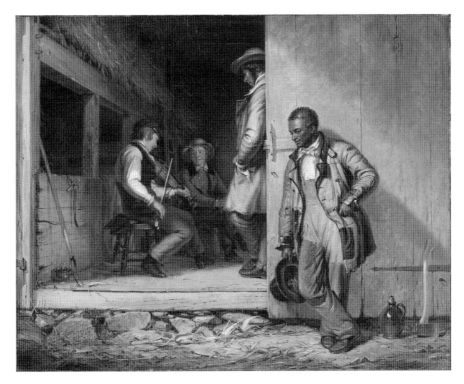

William Sidney Mount, *The Power of Music (The Force of Music)*, 1847. *The Cleveland Museum of Art.*

nineteenth-century Long Island could be of any race—though in Mount's view as seen through his art, not necessarily in actuality, those playing the violin always seem to be male.

THE MESSAGE AND STYLE OF *THE POWER OF MUSIC*

The Power of Music shows a boy fiddling in a barn. The boy's posture suggests that he plays a slow composition rather than a fast-paced jig or hornpipe. With him, two men, perhaps a father and a seated grandfather, look on. A Black man of middle years stands outside the barn, holding his hat and listening attentively. Though the Black man isn't allowed inside, or rather by custom stands apart because of a cultural racial divide, he's part of what is happening. He clearly appreciates the music.

Art and music historians have described the man in the following ways: attentive, yet serene; old, yet whimsical; humble, yet full of knowledge. Some

critics goes as far as to say that the Black listener internalizes the tune being played from the perspective of someone who knows music. Others venture to say that the Black man is possibly the boy's teacher and is taking pride in the boy's skills.[56]

In any case, the Black man's empathetic gaze, rendered with deep emotion, elevates this painting to the level of a masterpiece. Shadows, gradations in tones, and the picture's earthy browns and yellows add to the scene's psychological depth. So, too, do the ways in which the Black man's jacket and pose—one arm cocked, legs crossed—echo those of the standing man, emphasizing the painting's titular theme.

The Black man holds himself apart from the White people; even during this shared moment, we're confronted by the political reality of racial separateness. His overalls look patched and shabby, and he's captured in the moment in which he's set down his axe and jug. Perhaps he's been cutting firewood and has just quenched his thirst. (Or did Mount, as he'd previously done in his 1835 work *Bar-room Scene*, place the jug and axe together as a veiled reference to paying penance for drunken behavior? Town officials often made offenders chop wood.)

As previously mentioned, Mount purportedly depicted the same barn, at East Farm in Head of the Harbor, St. James/Smithtown, in both *Dance of the Haymakers* and *The Power of Music*. This setting, as opposed to a formal parlor, places *The Power of Music*'s White characters in the category of what art historian Elizabeth Johns calls the "Yankee yeomen."[57] Refined as their activity may be, it still takes place near a hayloft. The White people in *The Power of Music* wear finer clothes than the Black man, though only to a slight degree. All the characters are rustics being painted for an urban audience.[58]

The Models in *The Power of Music*

According to Mount's biographer Edward Payson Buffet, the boy performing on the fiddle in the painting is Mount's nephew Charles Edward Seabury, a son of his sister, Ruth Hawkins Seabury. Judging from the musical talent in the Mount family, the real-life youth was probably well versed on the instrument. Another historian suggests that the boy playing the violin is John Henry Mount, son of Mount's deceased brother, Henry. John Henry also appears as a fiddler in Mount's later painting *Catching the Tune* (1866–1867).

Buffet tells us that the seated gentleman in the painting, "Uncle Reuben Mullis," worked for the Seaburys. He appears in the 1850 census as a sixty-five-year-old laborer, born in England and residing in the household of Charles Smith, a neighbor of the Hawkins and Seabury families. The model for the other spectator is Horace Newton, the same Smithtown (and later Stony Brook) resident who Mount portrayed in *Dance of the Haymakers*.

Buffet tells us that Mount's model for the Black man is Robbin Mills (before 1800 to 1881), a free multiracial farmer and half brother of Abner Mills. According to Buffet, "Uncle Vet Tobias" (Abraham Tobias, a Civil War veteran), "who lived with the Mounts in Stony Brook," confirmed the listener's identity.[59]

In keeping with the gray-haired man's likeness, Robbin Mills was a farmer and at least forty-seven years old at the time the painting was made. Not so obvious is that the real-life man wearing the patched overalls was a well-respected property owner. By 1847, Robbin was married to a woman named Hannah (1799–1870), and they had one child, Ann E. Mills (b. 1832). Their second child, the Reverend Robbin Mills, would be born in 1850.[60]

ROBBIN MILLS AND HIS FAMILY AS DOCUMENTED BY DR. SAMUEL THOMPSON

Dr. Samuel Thompson (1738–1811), who knew and employed Robbin Mills as a child, differentiated him from his grandfather and father by the use of nicknames. The story of the four Robbins is particularly interesting and inspiring, because it shows how a once-enslaved family not only became free but also rose to a position of relative wealth and prominence in the community (at least in the short term). Robbin Mills's grandfather "Long Robbin" was enslaved by Dr. Samuel Thompson. Robbin's father, "Short Robbin" (1782 to after 1860), was free but indentured. Robbin Mills, who posed for Mount in *The Power of Music*, was free and owned land in Smithtown and Stony Brook. His son, "Lil' Robbin" Mills, became the honored first minister of the Bethel African Methodist Episcopal (AME) Church in Stony Brook.

The identity of Robbin's mother, and the exact place and time of his birth, remains a mystery. From early childhood until at least 1830, Robbin lived on, or adjoining, the Mills Pond property on North Country Road. (This area, now considered the hamlet of St. James within the town of Smithtown, was referred to simply as Smithtown until around the time of

The Thompson House, Setauket. *Margo Arceri.*

The Thompson House. *Dr. Ira Koeppel.*

Mount's death.) Robbin and his father farmed for Jedediah "Jed" Mills, though both occasionally worked for Dr. Thompson as day laborers. Mount, as a relative of the Mills family, would have known the father and son from visiting Mills Pond.

Dr. Thompson wrote in a journal entry that Robbin's father purchased a house in 1806 for £140 sterling. The doctor's curious reference to "moving the house" indicates that the house or cabin was jacked up from its foundation and put on log rollers before it was set down on an adjoining lot. In this house, it seems, Robbin lived with his father and stepmother, Eunice, and later a host of younger half siblings, including Abner Mills.[61]

ROBBIN MILLS'S MIDDLE YEARS

Though Robbin Mills is listed on the census as a property owner in 1830 near the Mills Pond Farm, he's later recorded as living in a house adjoining East Farm, along Shore Road in Head of the Harbor, St. James/Smithtown. So, Mount pictured Robbin in front of one of East Farm's barns (if indeed that barn was his model) in 1847 when Robbin actually farmed that property.

Sometime after Jed Mills's death in 1828, Robbin began (or continued) working for Jed's son, Lewis Mills, who owned East Farm at the time of the painting. The farm is only a mile and a half away from the Mills Pond estate; Robbin could have walked that distance in thirty minutes. He may have left his family at Mills Pond and farmed both properties, or multiple properties, simultaneously.[62]

Lewis Mills died in 1860, thirteen years after Mount made the paintings. Shep Jones, the fiddler in *Dance of the Haymakers*, then assumed ownership of East Farm. It follows that Robbin stayed on at East Farm with its new owner. He may have already been in Shep Jones's employ for decades, part-time, on one or another of Jones's properties in Smithtown and Stony Brook. Census records also show that by the 1860s, Robbin (perhaps going by the name of Robert Mills) owned lots in both Smithtown and Stony Brook. It would seem, at least on paper, that he frequently moved residences from Smithtown to Stony Brook and back again to Smithtown from 1840 to 1870, when he was in his forties to seventies. But could it be that he simply hung his hat in more than one simple, plank house according to what job needed to be done? There appear to be elements of flexibility in his lifestyle. He chose his employers and where he wanted to live, and he had the financial means to do so.

BETHEL CHURCH

In 1848, just after Mount completed *The Power of Music*, an unprecedented land deal for Brookhaven township—if not all of Long Island—took place. Four landowning men of color—Richard Akeley, Jacob Tobias, Abraham Tobias, and David Tobias—purchased a third of an acre of rocky land at the corner of Christian Avenue and Woodfield Road in Stony Brook from William Bayles. Acting as trustees for the African Methodist Episcopal (AME) Society of Setauket and Stony Brook, Akeley and the Tobiases, who may have been relatives, bought the land for the purpose of building a church and establishing a cemetery. This cemetery was special in that it was not a potter's field like Laurel Hill, the other burying place in the area for free people of color. The members of Bethel, as the church became known, had previously worshipped in segregated sections of White churches in the area. The congregation chose for its first pastor Robbin Mills's son, the Reverend Robbin Mills.

The AME Church at large has longtime associations with abolitionism, Harriet Tubman, and the Underground Railroad. The Stony Brook congregation may not have housed any fugitives from the South, as Stony Brook was many miles to the east of the known Underground Railroad's established routes. But its members,

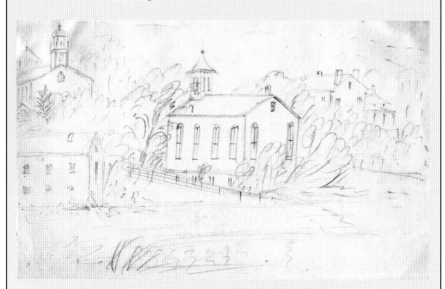

William Sidney Mount, *Churches and Houses*, not dated. The building at center may have been the first Bethel Church before it burned down in the late 1860s or early 1870s. *The Long Island Museum of American Art, History, and Carriages Collection.*

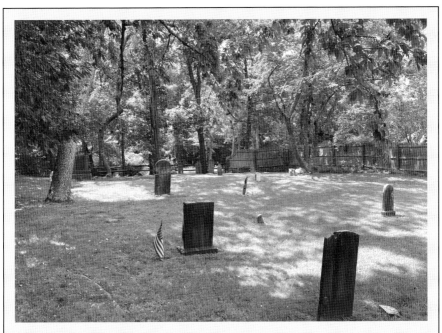

Old Bethel Cemetery in Stony Brook marks the site of the first Bethel AME Church, circa 1848. *Katherine Kirkpatrick.*

like those of all AME churches, no doubt embraced a spirit of reform and activism. To have purchased land from White people and establish the first church of color in the area, in itself, represented a bold action. In addition to holding regular church activities such as baptisms, weddings, and funerals, the Stony Brook parish, like other AME parishes, would have held literacy classes and aided the poor among them.

That there were free people of color in the nineteenth-century Three Villages who were comfortably well off is a certainty. Dr. Thompson referred in his diary to the "Black Gentry" who attended a prenuptial feast that the doctor hosted at his home in 1806 for a White/Native worker, to whom Dr. Thompson and his wife were related—Robbin Ruggles, and Ruggles's fiancée, Charity Smith. According to Dr. Thompson, she was "Nath' Smith's black girl."[*]

Bethel's rectangular and arched headstones, though simple in style, were fashioned from granite and marble, materials that were imported to the area. Clearly the community included individuals who could afford such burials. In

[*] The Journals and Papers of Dr. Samuel Thompson (1738–1811), the Brooke Russell Astor Reading Room for Rare Books and Manuscripts, New York Public Library..

The present-day Bethel AME Church, Setauket, built in 1909. Fires destroyed several previous church buildings. *Jennifer Kirkpatrick.*

contrast, during the two centuries of slavery on Long Island, rocks from fields or beaches usually marked the graves of people of color.

In addition to farmers like Robbin Mills, a local doctor, whalers, fishermen, and seamen formed the congregation. Maritime trades welcomed the disenfranchised. The crews of nineteenth-century Long Island fishing, whaling, and trade ships almost always included Native, Black, and Black-Native workers. Some became farmers after using the money they'd earned at sea to buy land. There were also Native and Black-Native landowners, part of a "maroon community" in Old Field, who remained on the land their ancestors had inhabited for millennia.

Sometime in the late 1860s or early 1870s, fire consumed Bethel's first church building. In 1874, AME trustees Charles Jones, Adam Brewster, and Joseph Tiebout purchased half an acre at Christian and Locust about half a mile east of the original site, where they built a new church building. The original site was then used solely as a cemetery. After a fire destroyed the second church structure in 1909, Bethel's members erected a new building in the same year.[†]

† Nicholson-Mueller and Tobias, "Old Bethel Cemetery." According to a Newtown, New York register of Thursday, September 28, 1874, a new African Methodist Episcopal Bethel Church was dedicated at East Setauket on Sunday (September 24) at 1:30 p.m. with the Reverend W.N. Bowen as pastor.

William Sidney Mount, *Two Men Leaning on Hoes*. The Long Island Museum of American Art, History, and Carriages Collection.

One account indicates that Robbin was well liked and conveyed a distinguished presence. According to Jonas Newton of Stony Brook, "Uncle Rob[b]in Mills" wore a "frock coat and tall silk hat," and "the old gentleman is an embodiment of conservatism and dignity."[63]

In 1870, Robbin's wife, Hannah, died. The following year, Robbin donated an acre to Bethel Church, where his son served as the minister.

Robbin Mills's Final Years

Robbin Mills's personal story mirrors both the successes and the hardships of many people of color on Long Island in the mid-nineteenth century. The 1880 Brookhaven census reveals that at seventy-eight, Robbin was a "laborer" and a "pauper," living in a "farm house" for the poor and insane in Smithtown. This poor farm could have been located on what is now Mills Pond Road, close to the Mills Pond House. Run by a seventy-six-year-old White woman, Martha Harlow, who is listed as owner, the farm had four other residents beside Martha and Robbin Mills, two Black and two White. Another record tells us that Shep Jones paid the poor farm

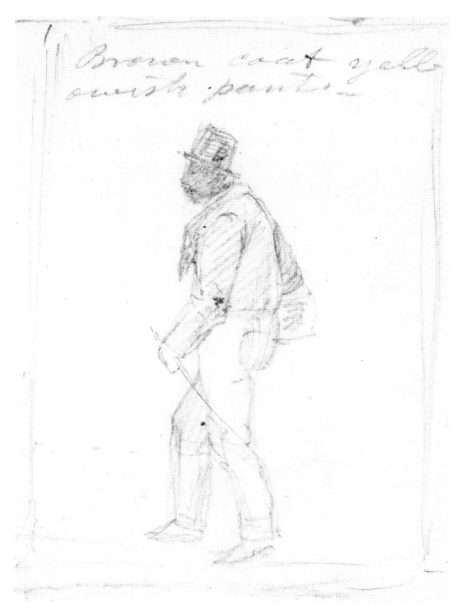

William Sidney Mount, Detail from *Sheet of Twelve Sketches*, not dated. Robbin Mills is said to have worn a "frock coat and a tall silk hat." *The Long Island Museum of American Art, History, and Carriages Collection.*

seventy-five cents a day for Robbin Mills's care. Robbin would die in 1881 around the age of eighty-one.

It's a sad mystery how Robbin Mills, once a landowner of multiple properties, ended up in a poorhouse.

LIFE OF A FREE FARMER OF COLOR IN NINETEENTH-CENTURY LONG ISLAND

The dominant crop on Long Island in Robbin Mills's time was corn, followed by wheat. Farmers also commonly grew oats, rye, barley, potatoes, beans, and peas.

When planting the fields in early spring, Robbin likely harnessed Dr. Thompson's oxen or Jedediah Mills's horses to a wooden plow, though it's possible that after 1837 one of them purchased a steel plow. Come harvesttime in summer, Robbin would have severed the corncobs from their stalks with a small knife, as one of Mount's farmer paintings shows, and then tossed them into a horse-drawn wagon. Farmers waited until the wheat turned golden in early July to reap the crop with a grain cradle, a kind of scythe with finger-length spikes. Farmhands were paid by the bushel, and Robbin, assuming he was strong and able-bodied, would have harvested up to one hundred bushels a day.

Long Island farmworkers like Robbin began their chores around sunrise, rested at noon, and took dinner around sunset. All year round, they fed animals and shoveled manure in addition to working the fields in the spring, summer, and fall. They built and repaired many fences; by law, property owners needed to enclose their animals and keep their fences in good order. In May on the Thompson farm, Robbin likely sheared sheep. Shearing the fleece from 115 bleating sheep with hand clippers must have been quite a production. Later, when the weather turned cold and other food supplies ran out, farmers like Robbin butchered pigs and some of the cattle and sheep for meat.[64]

Woodcutting must be added to Robbin's roster of chores. It's no surprise that axes appear in a number of Mount's paintings, including *The Power of Music*. Nineteenth-century boys and men, especially those of color, chopped and split mountains of wood until their hands were rough and raw. A manor like the Mills Pond House required about forty cords of firewood a year to heat the house and provide for its residents' cooking needs.

Left: William Sidney Mount, *Two Scenes of Men Haying*, 1863. *The Long Island Museum of American Art, History, and Carriages Collection.*

Below: William Sidney Mount, Study for *Ringing the Pig*, not dated. *The Long Island Museum of American Art, History, and Carriages Collection.*

Opposite: William Sidney Mount, *Horse and Buggy*, pencil on paper, 1857. *The Long Island Museum of American Art, History, and Carriages Collection.*

Did Robbin, like the character he portrayed in the painting, listen to or play fiddle music? If he had, such entertainment by the light of the fire in the evenings would have served as a welcome break after a hard day of labor.

6

ABNER MILLS (1850)
AND *CALIFORNIA NEWS*

THE CREATION OF *CALIFORNIA NEWS*

California News (1850) illustrates the excitement of the California gold rush of 1849 as a varied group of eight people in a rural post office gather around a man reading from a newspaper. Without hearing the words, we can guess the story. In the faraway West, miners unearth gleaming gold nuggets and make their fortunes. The news stirs up feelings of wonder, curiosity, and adventure among the Long Island folk. How could it not? The notion of becoming rich overnight fuels the imaginations of everyone in the room—whether a person of color or White, young or old, male or female, wearing a gentleman's top hat or the soft, wide-brimmed leather hat of a farmer. All the characters in the painting appear upbeat, some startled. The young woman, who looks on with shining eyes and clasps her hands together in a rush of emotion, seems positively giddy.

The newspaper that is being read aloud is the *New-York Daily Tribune*. And in fact, it was the copublisher of this publication, Thomas McElrath, who commissioned Mount to make the painting. In addition to his ownership of the *New-York Daily Tribune*, McElrath was a lawyer and state legislator.

MESSAGE AND STYLE OF *CALIFORNIA NEWS*

Mount included a number of background details to clue us into the story of the forty-niners. Two posters advertise vessels that carried eager prospectors to San Francisco in 1849: the leaky *Sabina*, a former whaler, which sailed

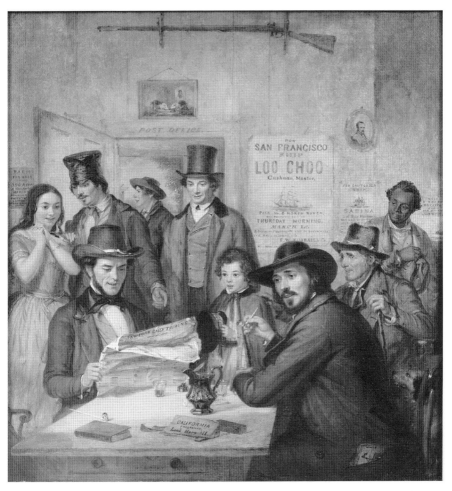

William Sidney Mount, *California News*, 1850. *The Long Island Museum of American Art, History, and Carriages Collection.*

from Sag Harbor, and the sturdier *Loo Choo*, a merchant ship, which operated out of New York Harbor. Their perilous routes took the adventurers more than seventeen thousand miles to San Francisco in five months around Cape Horn.[65] A third poster tells prospective miners where they can outfit themselves. A fourth poster advertises 350 acres of land; it seems that a hopeful farmer, dazzled by the dream of gold, had already decided to sell his holdings to try his luck out West.

Other details in the painting place the events of the gold rush into a larger context of westward expansion. The gun hanging over the doorway

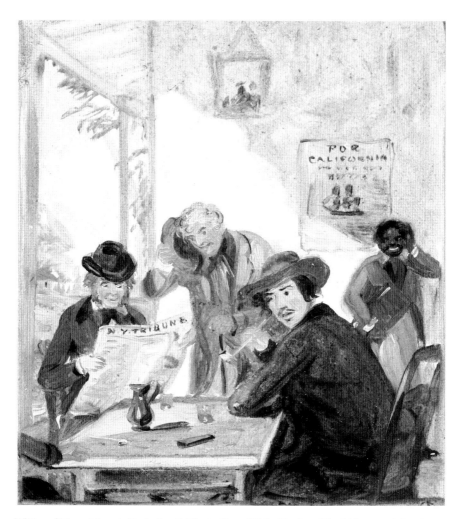

William Sidney Mount, Study for *California News*, 1850. *The Long Island Museum of American Art, History, and Carriages Collection.*

references the Mexican-American War. The portrait of the man sometimes cited to be President James K. Polk remains unidentified. In the painting, the small framed picture over the doorway of two hogs eating their slops possibly symbolizes America's imperialist greed in amassing land. On the other hand, the pigs could be a metaphor for the miners' greed for gold. The image of the hogs is a tiny replica of an actual work by Henry Mount, Mount's oldest brother.

Mount's palette for this painting emphasizes the color brown in all its many varieties—burnt umber, taupe, tan, beige, buff, mahogany, walnut,

and the chocolate brown of the coat of the man closest to the viewer. The rich, earthy tones help equalize the figures in this rather full composition. The skin of the Black man isn't particularly eye-catching, since all else around him is brown.

And yet, the Black man assumes a certain isolation at the corner back of the room. He's not one of the front, central characters. He's not seated (but neither are most of the figures), and his clothes are not fancy (but neither are the clothes of most of the characters). Does the person of color portrayed in the painting look as if he had the time and the money to journey West in search of gold? Do his options appear limited, as opposed to those of some of the White men in the room? His status is debatable.[66]

THE MODELS IN *CALIFORNIA NEWS*

The man holding the pipe, his face turned toward us, is likely a self-portrait of Mount. Alternately, it could be his brother Shepard, who looked like him. The book in the man's coat pocket appears to have a picture of a ship on it. Perhaps we're seeing one of the sketchbooks that Mount liked to carry with him.

Edward Payson Buffet provides the identities of all but two of the models in the paintings; most are Mount's family members. The girl in the picture is Maria Seabury, Mount's niece, the daughter of his sister, Ruth Seabury. The young man with the mustache, who is wearing a rather odd-looking tall hat, is Maria's brother Tom Seabury. The little boy standing at center is Mount's nephew William Shepard Mount, one of Shepard's sons.

If Mount was poking fun at the characters' attitudes toward the discovery of gold, he was, in effect, poking fun at himself and several of those dearest to him. As art historian Deborah Johnson suggests, Mount may have shared a private joke, lost to us now, in putting these people together in one work. Perhaps Mount's family members were all as enamored of the idea of gold being discovered as the characters in the painting. A color study Mount made for the painting shows that he originally set the scene on

William Sidney Mount, Detail from *California News*, 1850, a close-up view of Abner Mills. *The Long Island Museum of American Art, History, and Carriages Collection.*

the porch of the Hawkins-Mount House. In 1850, when Mount created *California News*, he lived with his sister, Ruth, at the Seabury residence across the street and would have frequently walked over to his former home. It's easy to imagine that many family conversations would have revolved around the exciting events happening in the West.

Buffet identifies the man in the beaver top hat as Shaler Hawkins, a Stony Brook sea captain and distant cousin to Mount. The seated old man, clutching his walking stick, is Philip Longbotham, Shep Jones's father-in-law. The man of color at far right is Abner Mills.[67] As mentioned earlier, Mount had painted him as the sleeping man in *Farmers Nooning* (1836).

ABNER MILLS'S FAMILY STORY IN 1850

In 1850, Abner Mills was a thirty-five-year-old farmer in Smithtown, a landowner, and the head of a family unit that included his father, "Short Robbin," and his mother, Eunice. The 1850 census lists him as "farmer" as opposed to "laborer," a distinction often given to landowners and heads of households.[68] The other family members listed in the census are his wife, Catharine, age thirty-seven; and daughters Ruth, twelve; Huldah, nine; Eliza, six; and Alina, two.

Abner evidently supported his parents as well as his wife and children. It's a signifier of the times that a free Black family is now a multigeneration household; a century, or even fifty years earlier, the practice of slavery denied many Black families the ability to care for their own young and old family members under the same roof.

By 1850, the first publicly funded "common schools" had begun to emerge in the northern states. Perhaps to address the concerns of educational reformers, the census included questions regarding literacy for every person over twenty. Parents Robbin and Eunice are noted as unable to read and write. Since Abner and Catharine are *not* referenced as illiterate, they must have been educated. Abner's and Catharine's daughter Ruth, age twelve, is the only one of his children listed as being in school.[69]

What happened next to Abner is extremely unclear. As mentioned earlier, records show that in a census fifteen years later, Abner has a wife half his age named Sarah, and there are no other people by the name of Mills living with them. Apparently, Catherine died and Abner married a widow who already had children of her own. The surname of those children was "Jones."

Above: The servants' wing at the Mills Pond House. If the farm workers on the property were ever permitted to visit the servants in the house, they would have used this back entrance. *Katherine Kirkpatrick.*

Left: Inside the servants' wing at the Mills Pond House. *Katherine Kirkpatrick.*

MOUNT'S LIFE AND NINETEENTH-CENTURY LONG ISLAND IN *CALIFORNIA NEWS*

Many in the northern states felt that America should not have entered into the military conflict known as the Mexican-American War (which Mexicans call "The American Intervention"). Deborah Johnson points out that the editors of the *New-York Daily Tribune* expressed their clear opposition to the conflict in their editorials. Judging from the attitudes conveyed in his newspaper, Mount's patron Thomas McElrath also opposed the war. The Whig party opposed the invasion, not only on the basis of unprovoked military action but also because the Whigs objected to America extending the practice of slavery by adding more "slave states." Meanwhile, Mount, a Democrat, favored western expansion.

How the controversy concluded is obvious to us now. After the Mexican-American War ended in 1848, the United States nearly doubled in size as it added huge tracts of western lands. Subsequently, California became a state. The broadside in the foreground of the painting, printed with the words "California emigrants, Look Here!!!" alludes to the largest migration in the history of the United States. All because of the gold rush, 300,000 people settled in California.

Opposite: The Cider-Making House on the once vast Mills Pond property where Abner Mills likely worked. *Zachary N. Studenroth*.

Above: Barns at Mills Pond. *Zachary N. Studenroth*.

Surely these events were much discussed in Mount's time. Postmasters, such as Samuel Ludlow Thompson III of Setauket (who took over after Jonas Hawkins), would have been the very first people in Stony Brook and Setauket to hold the inky pages of Manhattan newspapers in their hands. It's a realistic scenario that in a rural post office, like the one pictured in *California News*, someone with the rare privilege of owning a daily newspaper would have been reading aloud to his neighbors.[70]

7

HENRY BRAZIER AND
RIGHT AND LEFT

THE CREATION OF *RIGHT AND LEFT*

William Schaus, Mount's lithography agent, admired Mount's 1849 painting
of a White violinist, *Just in Tune*, very much. Seeking images to reproduce
for the European print market, Schaus urged Mount to stay on the theme
of music and to paint "a negro." This request prompted Mount to create
his magnificent portrait of a fiddler of color, *Right and Left* (1850). The work
became the second of four themed portraits of minstrels; *The Banjo Player*
(1856) and *The Bone Player* (1856) completed the series. Mount referred to
these paintings of dapperly dressed musicians as "fancy pictures."

THE MESSAGE AND STYLE OF *RIGHT AND LEFT*

Right and Left represents a radical departure from the typically cartoonish
way Black fiddlers were represented in nineteenth-century art. The work
shows a profound evolution in the way Mount himself portrayed a Black
violin player twenty years earlier in *Rustic Dance After a Sleigh Ride*. Here is a
fine art portrait in the psychologically rich, ennobling style of European Old
Masters. The painting is also remarkable in its musical accuracy—the way
the fiddler holds and fingers his instrument is true to life.

Mount titled *Right and Left* to carry a double meaning. First, "right and
left" is a square dance term, used by callers today as well as in Mount's time.

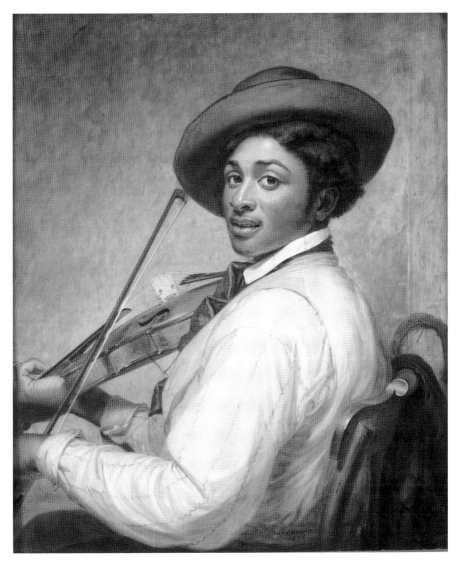

William Sidney Mount, *Right and Left*, 1850. *The Long Island Museum of American Art, History, and Carriages Collection.*

Picture the leader of the dance calling "right, left, right, left" as the dancers pull by each other, shaking hands with each new partner in a line. Second, Mount's title draws attention to the fact that his dapper young multiracial fiddler is left-handed. His left hand holds the bow while his right hand fingers the strings. The instrument may have been strung especially with this accommodation in mind. (Eventually, when the painting was copied

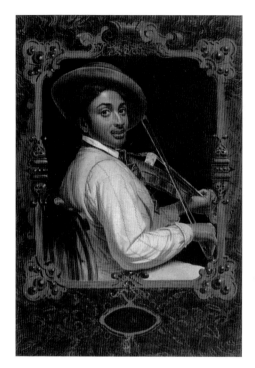

Jean-Baptiste Adolphe Lafosse's lithograph of *Right and Left*, 1852. Mount was annoyed that the lithographer flipped the image of his left-handed fiddler, making him right-handed. *The Long Island Museum of American Art, History, and Carriages Collection.*

for lithographic use, the lithographer flipped the fiddler as a mirror image, making him right-handed—much to Mount's chagrin.)[71]

In addition to the painting's title, other clues also tell us that the subject of the painting is a minstrel. The fine clothes he wears, including his hat, waistcoat, cravat, shirt, and the coat draped over his chair, indicate that the man plays music in a professional, itinerant context. The horseshoe hung on the wall beside the fiddler further symbolizes travel or the variable luck of a performer's life.

THE MODEL OF COLOR IN *RIGHT AND LEFT*

Edward Payson Buffet indicates in a roundabout way that a "yellow" fiddler named Henry Brazier served as Mount's model for *Right and Left*. In a discussion on the perceived evils of dancing by conservatively religious people, he mentions that in a place "the cognizant call…Fiddler's Green… long ago dwelt Harry Brazier, a yellow man [who] with his bow ministered to the social joys of the reprobate throughout the countryside." Buffet notes a spot called Fiddler's Green in Kings Park, near Smithtown (though there

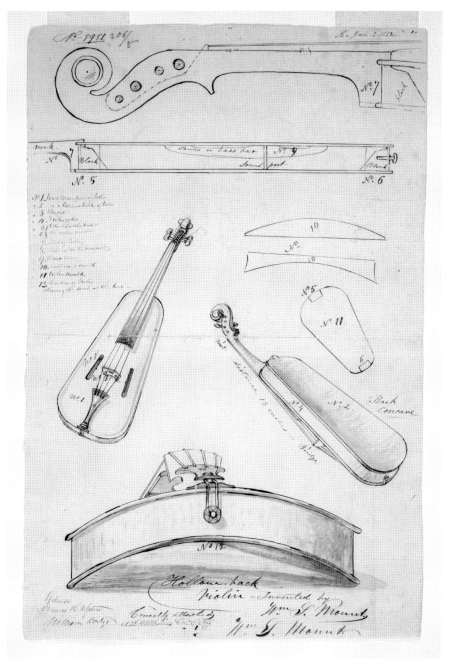

William Sidney Mount, Design drawing for "Cradle of Harmony" violin patent, 1852. *The Long Island Museum of American Art, History, and Carriages Collection.*

William Sidney Mount, *Tuning*, 1867. Pencil on paper. 3¹³/₁₆ x 6⅜ inches. *The Cleveland Museum of Art.*

were greens of the same name in Brooklyn, Manhattan, and Huntington, all places where census reports say a man named Henry Brazier lived).

In the same article, Buffet refers to the model for *Right and Left* only as a "yellow fiddler,"[72] by which he likely meant Black-White. Buffet says the model "fiddled near Smithtown." So, unlike a number of Mount's models who may have simply posed with musical instruments, Mount chose an actual musician.

It follows that the fiddle, strung especially for a left-handed person, may have belonged to the model. The fairly light-skinned man in the painting looks to be at least twenty years old and less than forty. Sure enough, the census of 1840 enumerates a free "colored" man and landowner in Smithtown named Henry Brazier (1817–1895) who would have been thirty-three at the time of the painting. His profession is described as farmer. This, of course, doesn't preclude the possibility that Henry Brazier was also a musician.

That census also tells us that Henry's neighbors were White families, including several branches of the Smiths. Three branches of the White Mills family resided in the general vicinity. Mount could have met Henry through any of these people, all distant cousins. It's intriguing to think that Mount may have met Henry through a musical venue. Did Henry play the fiddle on an occasion where Mount was one of the clapping, foot-stomping participants?

William Sidney Mount, *Group of Men Fiddling and Dancing in Front of Jayne Store*, 1867. *The Long Island Museum of American Art, History, and Carriages Collection.*

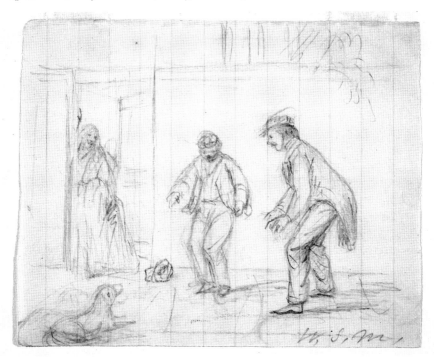

William Sidney Mount, *Two Men Dancing*, not dated. *The Long Island Museum of American Art, History, and Carriages Collection.*

Henry Brazier, a Varied Life on the Move

Born around 1817 in Smithtown, of an unknown father and a woman described as Hannah Caesar "Indian" (circa 1800 to after 1870), Henry was part Native. His mother was Unkechaug.

Henry spent most of his childhood in Huntington but had moved back to Smithtown by age eighteen. He obtained seaman's papers at twenty-one, so it's likely he spent time in his twenties working on ships. His declaration port is listed as the city of New York. The papers detail his height as five foot, three inches, and his race as "B" for Black.

Henry married Esther Cato (1815–1850), who was Native or part-Native and born in Mastic, Long Island. It's possible that Henry and Esther lived in Mastic for a time, in addition to Smithtown. They had at least one child together, Grace Ann Brazier (1845–1906), born in Mastic.

Esther died at age thirty-three in 1850, the same year Mount painted *Right and Left*. Grace Ann was only five.[73]

Census records indicate that Henry, a "day laborer" (if indeed he is the same Henry Brazier), lived in West Cornwall, Connecticut, and later, with his profession as a "driver," lived in Brooklyn.

Finally, a New York State death index notes that Henry Brazier died on March 7, 1895, at the age of seventy-eight in Southold, Long Island.

Mount's Life and Nineteenth-Century Long Island in *Right and Left*

Dancing to music, both informally in barns and formally at private parties, served as the most popular form of social activity within Mount's circle. Musicians of color, such as Anthony Clapp[74] and perhaps Henry Brazier, accompanied the dancers as readily as White musicians. The Black man fiddling at one side of the room in *Rustic Dance After a Sleigh Ride* illustrates this reality. Other people of color, like the coachmen and the man with the bellows, could at times be onlookers, though not dancers (or at least, not in the same room or barn space).

White dancers in formal settings followed an elaborate system of protocol. The dance teacher Nelson Matthewson, active on Long Island in Mount's time and a competitor to Mount's brother Robert Nelson Mount, published the following "Rules and Regulations" for his dance school:

1. No person or persons will be admitted into this school unless subscribers without permission of the teacher 2. The scholars will observe their honor in entering & leaving the hall during school hours 3. No lady will be permitted to leave the Hall in school hours without being accompanied by another lady 4. No gentleman will be permitted to sit with the ladies in school 5. No gentleman will be permitted to sit with his legs crossed or leaning against any other gentleman 6. No pushing pulling or loud talking by either sex will be permitted 7. No lady must refuse to dance with one gentleman & dance with the next that shall offer in the same sett. 8. No gentleman will be permitted to insist on any lady's dancing who wishes to be excused by pulling or any other means 9. No gentleman will be allowed to spit on the floor where the ladies dresses will be liable to be soiled 10. No gentleman will be permitted to dance in boots or overcoat or any fantastical dress whatever on penalty of being expelled from the school 11. The hours of tuition will be from 2 o clock until 5 P M for ladies and from 6 until 9 in the evening for Gentlemen.[75]

This 1841 letter from William Sidney Mount to his brother Robert Nelson Mount, a dance instructor, includes dance music. *The Long Island Museum of American Art, History, and Carriages Collection.*

Nineteenth-century American images of ballroom dancers show women wearing gloves and enormously wide gowns held up by multitiered crinoline petticoats. Men, too, wore gloves and often wore top hats. Mount's country women, as shown in *Rustic Dance*, dressed more simply and informally. Both the music in Mount's personal collection and the correspondence that he and Robert Nelson shared when Robert Nelson traveled as a dance master in Georgia indicate that the Mounts engaged in lively dances such as the quadrille, the cotillion, and the reel. These dances, according to one historian, called for free-flowing dresses and simply cut trousers that allowed for greater freedom of movement. Setting the quick pace, both Black and White fiddlers played a repertory that included African American as well as Celtic tunes.[76]

Today, the subject matter of paintings such as *Rustic Dance* and *Right and Left* appears quaint and innocent. Yet some nineteenth-century Baptist, Methodist, or Presbyterian onlookers would have viewed Mount's musical scenes as bordering on risqué. And to some urban audiences, an image of a Black fiddler would have reminded them of a kind of rude, racist theater that was just coming in vogue in the city of New York—the Blackface minstrel show. One of the stereotypical nineteenth-century American prejudices against people of color was that they were sensual, if not explicitly sexual. The European market, for which *Right and Left* was primarily created, was more broad-minded.

8

BEN CATO AND *THE LUCKY THROW*

THE CREATION OF *THE LUCKY THROW*

A young man of color smiles as he cradles a featherless goose. The lithograph's title, *The Lucky Throw*, indicates that this character has won the goose as a prize in a gambling game. We see his coins on the table. The boy wears a stylish but tattered blue jacket that has black lapels and is torn under one arm. His red and white neck scarf complements the red, white, and black checked border of his tam-o'-shanter.

Mount's original painting, *Raffling for a Goose* (circa 1849), is now lost. Aside from an 1849 sketch that may not be of the same model, Jean-Baptiste Adolphe Lafosse's 1851 lithograph, copied from Mount's painting, is all we have to go by. The rather jarring, pervasive blue coloration of the print, including the bluish tint to the boy's skin, demonstrates the limitations of the medium. Of course, Mount would have used a more varied and subtler palette in his art. The three-quarter portrait format, and the boy's pose as he cradles the goose and looks to one side, are typical Mount. We see almost the same pose in *The Bone Player*. Substitute the bones for the goose, and the tam-o'-shanter for the minstrel's wide-brimmed leather hat, and the works look similar.

A lifeless goose with its large, webbed toes and talons up in the air provides a different tone to the more serious portrait of a bone player. Lithography agent William Schaus, who also commissioned the minstrel-themed pictures, asked Mount to paint a "Negro" holding something "silly." Mount's diary

Jean-Baptiste Adolphe Lafosse, *Raffling for a Goose (The Lucky Throw)*, 1851, after William Sidney Mount's painting of 1849. *The Long Island Museum of American Art, History, and Carriages Collection.*

entry of September 15, 1850, makes the following notation under a list of "Pictures for Wm. Schaus Esqr": "One picture Negro—African—head life size—laughing, showing his white teeth and holding something funny in his hand—*Goose, duck, or squirrel*, etc. Size 25 x 30—it is painted."[77]

THE MESSAGE AND STYLE OF *THE LUCKY THROW*

What the nineteenth-century audience thought of as comic is quite different from what is generally thought of as comic today. Is this work designed to be a joke at a Black person's expense?

Art historian Elizabeth Johns writes that in comparison to *The Power of Music*, which Mount painted three years earlier, *The Lucky Throw* is a "stunning deflation"—a one-dimensional caricature as compared to a dignified portrayal of a person of color.[78] She points out that similar caricatures of Jim

Crow figures portrayed as foolish, unintelligent, yet happy-go-lucky served to reinforce the myth of the "good old times of slavery" to the American public.

What's more, Johns asserts, Mount's picture carries an anti-abolitionist message. As we saw in *Farmers Nooning*, the presence of the tam-o'-shanter would signify to a mid-nineteenth-century American audience that this is a painting about abolitionism. This audience was well acquainted, she says, with the idiom "sound on the goose," which meant loyal to a political stance. In this case, Johns says, the issue at hand was allowing individual states to be "slave states" or not. Her interpretation of Mount's work is that "the Black has won 'the lucky throw,' ironically, the throw of the Compromise of 1850." The "Compromise," a series of bills that overturned the Missouri Compromise of 1820, meant that once again new states had a right to decide whether to allow slavery.

Was Mount suggesting that the Black person was the "lucky goose," no longer manipulated by Republicans who were trying to advance their own causes? Or did the goose represent the Republican Party? Was Mount illustrating his belief that the Democrats' stance of allowing new states to decide on the issue of slavery would prevent war?

In their scholarly article "Sound on the Goose: A Search for the Answer to an Age-Old 'Question,'" physicist Emmett Redd and historian Nicole Etcheson point out that the idiom of "sound on the goose" was popular in 1850 specifically among the proslavery Missourians who founded Kansas.[79] So perhaps the meaning of Mount's goose relates to Kansas's statehood, won as a prize by those founders who coveted the undeveloped western land and the lack of restraint to use it as they pleased.

Though the exact meaning of Mount's artwork is far from clear, all the interpretations hold racist undertones.

THE MODEL OF COLOR IN *THE LUCKY THROW*

Edward Payson Buffet tells us that the model for Mount's raffle winner was Ben Cato (1830–1900), who worked as a laborer for Mount's second cousin Shep Jones. According to Buffet, Ben survived a harrowing accident. While transporting straw on a raft of thatch in Stony Brook Harbor, part of the raft detached, and Ben was nearly sent adrift into Long Island Sound on an outgoing tide.

Buffet tells another story about the brass buttons, imprinted with tiny images of prancing horses, shown on the jacket of Mount's model. Buffet

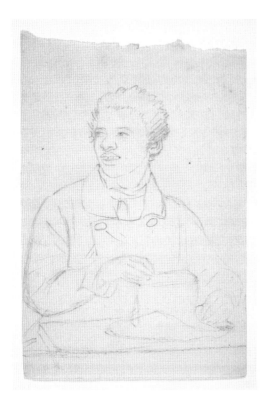

Left: William Sidney Mount, Study for *The Lucky Throw*, 1849. *The Long Island Museum of American Art, History, and Carriages Collection.*

Below: William Sidney Mount, Study for *Raffling a Goose (Tavern Scene)*, not dated. *The Long Island Museum of American Art, History, and Carriages Collection.*

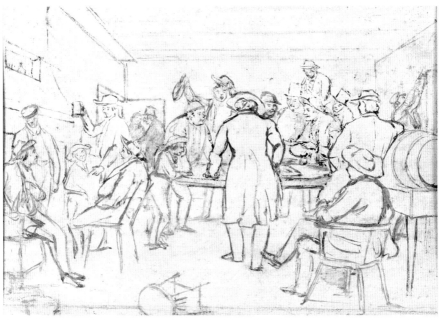

concludes that Ben Cato's outfit must have been a cavalry uniform (whether it was from the War of Independence, the War of 1812, or the War with Mexico, he did not say). A button from the coat, he says, was found in the barnyard of the Hawkins-Mount homestead.[80]

According to the 1840 federal census, a family of "free colored" people, listed under the name Judas Cato, lived in Stony Brook. The family consisted of two males between the ages of ten and twenty-three, and one male and one female, both between the ages of thirty-six and fifty-five. It seems likely that the younger males listed are Ben and a brother.

MOUNT'S LIFE AND NINETEENTH-CENTURY LONG ISLAND IN *THE LUCKY THROW*

The taverns of nineteenth-century Manhattan, and likely Long Island, held raffles for turkeys and geese to keep their customers lingering in dark, smoky rooms and spending more of their wages on ale and cider. A British bar tradition transported to the Americas, participating in raffles was never an activity to benefit churches or schools. According to the Bowery Boys New York City History website, "Raffles were widely seen in saloons, a jovial excuse for men to get liquored up and throw their money in for a chance at a moderate prize. In essence, it was gambling most fowl."[81]

Mount's 1837 painting *The Raffle* or *Raffling a Goose (Tavern Scene)*, an earlier work on the same theme as *The Lucky Throw*, shows a group of men leaning toward another man who holds an upside-down top hat. The featherless trophy lies on the table before them. The hat holds raffle tickets. In the case of *The Lucky Throw*, the hat would have held coins. The title of this later painting suggests a coin-toss bet rather than a raffle. In some iterations of the age-old game of heads or tails, players bet on multiple coins in a single toss.

The artist's *Bar-room Scene* (1835) depicts a shabbily dressed man, upside-down tankard in hand, dancing for others in a drunken revelry. Any scene involving drinking would have struck a moralistic chord for many nineteenth-century viewers. Mount himself rarely drank alcohol, and his diaries contain multiple cautionary reminders to himself that drinking was a vice. His abstinence may have been related, at least in part, to his brother Robert Nelson's alcoholism. Mount did not mention barroom raffles in his letters or journals, but chances are he might have considered them to be tawdry.

ANDREW BREWSTER
AND *THE BONE PLAYER*

The Creation of *The Bone Player*

The Bone Player (1856) shows an elegantly dressed man with a broad-brimmed hat, a knotted red silk scarf, a fancy shirt with designs on the collar, and a brown jacket with darker lapels. He holds "bones," or clappers, between his fingers. He smiles; his goatee and earring give him a slightly exotic look. It is a lively painting and one of Mount's best. As in *The Banjo Player*, another work in Mount's minstrel series for William Schaus, the subject of the bone player is meant to be a performer. The jug and the glass in the background suggest he might be in a tavern. Perhaps the box with the keyhole is the musician's carrying case.

Schaus wrote to Mount on September 1, 1852, requesting that the artist make paintings of a variety of subjects, including a "Negro playing the banjo and singing" and "Negro playing with bones."[82] As mentioned previously, the mostly European buyers of Schaus's lithographic prints from commissioned artwork had different tastes than Americans.

In response to the letter, Mount answered that he "liked the tone" of Schaus's words and was ready to negotiate. Mount alluded to the unusual nature of Schaus's request. Apparently, there were people in Mount's life (whether friends, family, patrons, or other artists) who had urged Mount not to make portraits of people of color.

Mount wrote to Schaus on September 9, 1852:

I will undertake those large heads [three-quarter head and shoulder views of Black minstrels] *for you, although I have been urged not to paint any more such subjects. I had as leave paint the characters of some negroes as to paint the characters of some whites, as far as the morality is concerned. "A negro, is as good as a White man—as long as he behaves himself."*[83]

Interestingly, Mount brings up the subject of morality. Whoever took offense to Mount's subject matter seemed to believe that painting Black people was not only unseemly but, in some way, unprincipled as well.

Though he readily agreed to his agent's terms ($200 to paint each picture, plus a $100 reproduction fee), Mount nevertheless was extremely slow to get to his easel for Schaus. A year and a half later, on March 8, 1854, Mount wrote to Schaus, "The pictures you desire me to paint are not commenced. I have not been well enough. To paint understandingly the mind must be clear."

Another two years later, on March 26, 1856, Mount wrote to Schaus, "It affords me great pleasure to state that I am engaged [in] painting The *Bone Player* for you.…I will not say any thing about the painting, as your own eye will tell you better than a description from me."[84]

THE MESSAGE AND STYLE OF *THE BONE PLAYER*

Bone players move their hands in a graceful back and forth motion across their chests. With the quick movements of the wrists, the bones clap together. Talented folk performer Dom Flemons, a founder of the Carolina Chocolate Drops with Rhiannon Giddons and Sule Greg Wilson, demonstrates the complex rhythms that can be played on such a simple instrument. Similar to castanets, the carved bone or wooden clappers make *clickity-clack* sounds that resemble a tap dancer's strikes on a hard floor. In Mount's time, the instruments were usually made of cattle bones.

Musicologist Christopher J. Smith in his analysis of *The Bone Player* points out that once again Mount got his details right. The bones in the painting—five or so inches in length, etched with designs and curved like barrel staves—seem, almost without a doubt, to have been based on a real-life example. Mount's model assumes the posture and finger movements of an actual musician, Smith tells us. That loose grip in which he holds

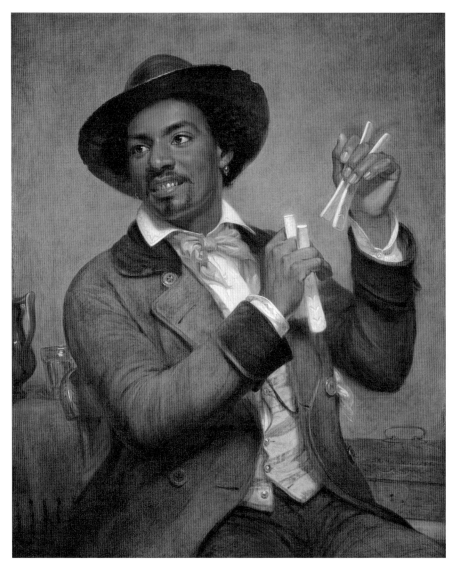

William Sidney Mount, *The Bone Player*, 1856. *The Museum of Fine Arts, Boston.*

the instrument on either side of his middle fingers is evidence of authentic performance technique.

As is the case for Mount's other minstrel-themed paintings, the precision with which Mount rendered the bone player's hand positions led to much scholarly conjecture about his model. Both musicologists and art historians question whether Mount's model could have been a traveling minstrel.

Christopher J. Smith speculates that Mount may have encountered a Black musical troupe (made up of fiddle, bone, tambourine, and banjo players) either on Long Island or in the city of New York. Though there's no documentary evidence that such troupes existed as early as the 1840s and 1850s, Blackface (White impersonating Black) performers such as the Virginia Minstrels were coming into popularity at that time.[85] It makes sense that the Blackface musicians, however skewed and racist their imitations were, took inspiration from actual groups composed of people of color.

It's certainly an intriguing and plausible idea that Mount listened to the lively beat of a Black bone player accompanying a fiddler or a banjo player in a smoky tavern. But once more, Edward Payson Buffet uncovers Mount's façade. The model for *The Bone Player* was Setauket farmer Andrew Brewster (1809 to after 1860).[86]

THE MODEL OF COLOR IN *THE BONE PLAYER*

Andrew Brewster was the younger brother of Rachel Brewster, who might have been Mount's model for *Eel Spearing at Setauket*. They were among five children born to Nell Brewster in the Brewster House in Setauket. Readers will recall that this dark-shingled colonial home is the subject of Mount's *Long Island Farmhouses* and that Mount's brother Robert Nelson Mount lived next door.

Andrew had recently turned forty-seven when Mount completed *The Bone Player* in 1856. The man in the painting looks to be about that age. Mount was only two years older than Andrew. They'd probably known each other since they were young children.

The census of 1850 tells us that Andrew and his wife, Aner—a "mulatta" woman five years younger than he—lived in Robert Nelson Mount's house (or possibly in the adjoining Brewster House). Andrew is described as Black and a "laborer." They apparently had no children. Nor does the marriage appear to have been a long one, as Aner is not listed along with Andrew in the following census, 1860; she may have died young.

Robert Nelson Mount's assets in that year, according to an agricultural census, included 3 horses, 2 milk cows, 2 other cattle, 4 swine, 28 bushels of wheat, 75 bushels of Indian corn, and 150 bushels of oats. The Brewsters would have hired day laborers to assist their regular workers, especially during planting and harvesting.

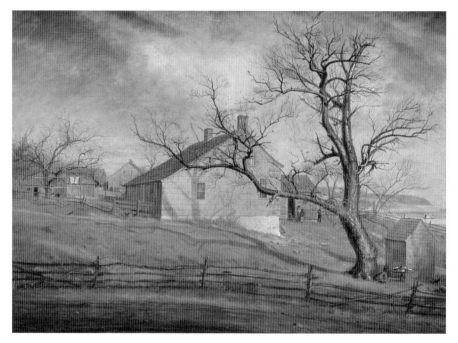

William Sidney Mount's *Long Island Farmhouses*, 1862–1863, is a portrait of the Joseph Brewster House in Setauket. *The Metropolitan Museum of Art, New York.*

The main room in the Brewster House. *Jennifer Kirkpatrick.*

136

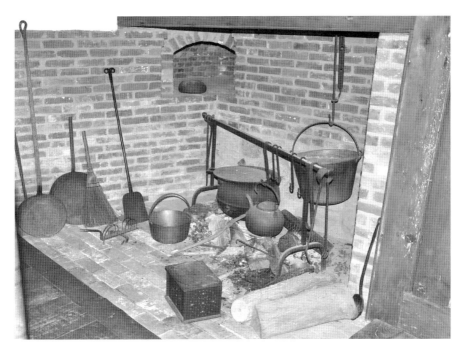

The Brewster House hearth. *Jennifer Kirkpatrick.*

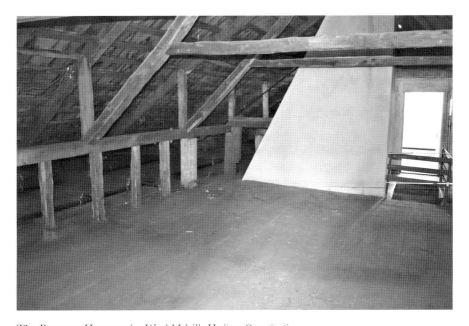

The Brewster House attic. *Ward Melville Heritage Organization.*

It's plausible that Andrew could play the bones. Robert Nelson Mount acted as a dance master and fiddler on a professional basis while farming; Andrew might have performed on an instrument as well. The White members of both the Mount and Brewster households made music a priority in their lives. And we know that William Sidney Mount alone had a collection of multiple violins, a flute, and a number of penny whistles. It would not have been hard for Andrew or anyone in the household to make a set of bone instruments out of readily available cattle bones.

This particular set is engraved with fancy designs. Is it possible that Mount, purchasing a set of bones in lower Manhattan for the purpose of his painting, introduced the Brewster/Robert Nelson Mount household to the instrument?

Though it's unlikely Andrew would have had the time, energy, or financial means to tour in a minstrel troupe, he may have played the bones on informal occasions, just like the boy with the rhythm sticks in *Dance of the Haymakers*. His musical talent is another mystery about Andrew, who disappears from census records after the year 1860.[87]

MOUNT'S LIFE AND NINETEENTH-CENTURY LONG ISLAND IN *THE BONE PLAYER*

On April 3, 1856, Mount wrote in his diary, "I finished the bone player this day." He described painting the canvas with "venetian red" and when letting that dry, creating the subject's skin color by "running over" the red paint with a thin layer of blue to "cool it down."[88] Three days later, just long enough for the oil to dry, Mount announced in a letter to William Schaus that he would be coming into the city with the painting on the following day. The artist added that upon his return to Stony Brook, "I shall take board down in the village for the sake of exercise and change. Some people incline to get saucy if you board with them too long—particularly a young Lady that's been brought up in a boarding school."[89]

This rather fascinating reference may be to Mount's sister in-law Elizabeth Hempstead Elliott Mount (1816–1858), Shepard's wife, who was thirty-eight at the time. She wasn't young, but she was younger than forty-seven-year-old Mount. A likeness of her made by Shepard in 1838 presents her with two rosebuds in her hair and wearing an elegant, shimmering periwinkle blue gown that looks expensive. In the 1850s, when Mount painted *The Bone Player* and *The Banjo Player*, he lived in his family's

homestead, today known as the Hawkins-Mount House, with Shepard and Elizabeth and their four children. The widow of his eldest brother, Henry, Mary Bates Ford Mount (1803–1887) and her six children, also lived there. Mount took the attic room for his studio and sleeping quarters. Even a twenty-room house would have seemed crowded to Mount, considering the number of people who lived in it, about a dozen at any one time.

Shepard traveled frequently to paint portraits, leaving an embittered Elizabeth at home with their children in the shared family house—a situation that, she wrote to her husband, brought her "ridicule and contempt of early acquaintances" whom she'd known before marriage. Shepard once wrote a sardonic poem to a "Lord Mount Joy" (William Sidney?) with the words "the girl I adore by another embraced," and several years followed in which William Sidney and Shepard did not get along well.[90]

On May 24, 1856, just over a month after Mount completed *The Bone Player*, he wrote in his diary that he'd finished *The Banjo Player*. After such long delays in beginning the works, Mount apparently found himself on a creative streak. He further noted that he'd completed *The Bone Player* in seven days (fourteen sittings, two sittings a day "forenoon and afternoon") and *The Banjo Player* in eight days (sixteen sittings, two sittings a day).

After those sessions of painting so intensely, and perhaps arguing with his sister-in-law intensely as well, Mount spent much of the following seasons sketching outdoors and journaling about health issues. On October 31, 1859, he gave himself the advice, "Keep away from your relations and Stony Brook—as much as possible."[91]

GEORGE FREEMAN AND
THE BANJO PLAYER

THE CREATION OF *THE BANJO PLAYER*

There's music in the painting. We can almost feel the banjo vibrating and hear its deep, twangy, fast-paced melody. The young man in Mount's *The Banjo Player* (1856) holds himself and his instrument with a supple grace as he moves his fingers. His cheerful expression engages us. The performer appears to be participating in an activity he loves.

Mount, who immersed himself in the popular folk music of his day, must have relished his assignment from his lithography agent, William Schaus, to create an image of a Black man with a banjo. With Mount's particular interests and skills, *The Banjo Player* seems exactly the kind of painting the artist would most enjoy making.

The painting is successful on many levels. Mount's agent chose a universally appealing subject matter, as people everywhere love music. And Mount picked a model who seems to have a fun-loving personality. The painting's tones of reds and browns give the work warmth. The figure's three-quarter pose (as opposed to a full-length or head-and-shoulders view) feels exactly right; the close-up view is an intimate one. Mount's technical mastery and his attunement to detail shines in this painting. But beyond all of these artistic merits, it is the young man's sense of joyfulness that makes *The Banjo Player* one of Mount's most enduring artworks.

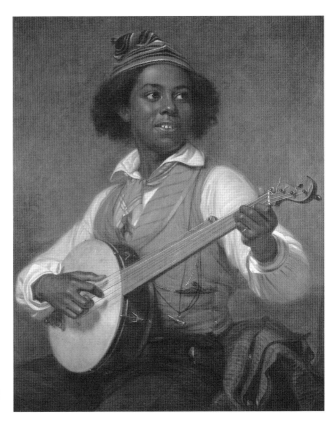

William Sidney
Mount, *The Banjo
Player*, 1856. *The
Long Island Museum of
American Art, History, and
Carriages Collection.*

THE MESSAGE AND STYLE OF *THE BANJO PLAYER*

Musicians tell us that Mount depicted his banjo player's technique, and the instrument itself, with complete accuracy. Christopher J. Smith identifies the banjo as an expensive instrument manufactured by the William Boucher Banjo Company of Baltimore. It has a calfskin head mounted over thick wood, an open back, and gut strings. Smith describes the sound on this instrument as "full, plucky, and percussive."[92]

Smith points out that the banjo player is fingering several strings at once, while his thumb sounds the banjo's shorter, drone string that sounds the same note continuously. Smith describes the player's fingering technique, striking the strings downward, as an "Afro-Caribbean" stroke (later referred to as "clawhammer"). Various musicians have gone so far as to imagine what the banjo player could be playing. We know that Mount enjoyed African American folk tunes. "Possum Up a Gum Stump" (or "Possum Up a Gum Tree") was one of a number of African American tunes in the sheet music

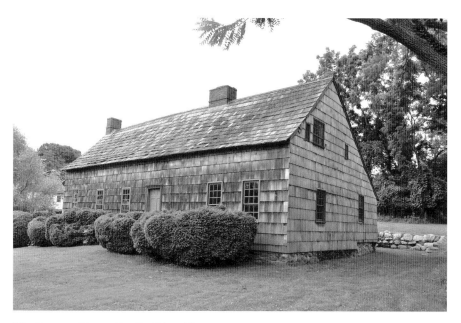

The Brewster House. *Jennifer Kirkpatrick.*

This excerpt from the Brookhaven, New York section of the 1850 U.S. census lists George Freeman, Andrew Brewster, and Andrew's wife, Aner. *National Archives and Records Administration.*

collection that Mount inherited from his uncle Micah Hawkins and added to for the rest of his life.

Dressed in a dapper manner, the banjo player wears a pink silk cravat and a matching waistcoat with panels of a similar fabric. The dark silk handkerchief tucked into his pocket, his gold watch chain, and the ring he wears on his finger further suggest affluence. Some art scholars say that his coat, tucked behind him, and his striped cap indicate a lifestyle on the road. Others suggest that his cap shows he's a coachman (Mount's coachman in the earlier *Rustic Dance After a Sleigh Ride* also wears a red cap). The shiny piece that hangs from around the young man's neck is a bugle mouthpiece. Coachmen used bugles as we would use a car horn today, to warn others of a vehicle's approach.[93]

Was Mount's model a minstrel, a coachman, or both?

THE MODEL OF COLOR IN *THE BANJO PLAYER*

Edward Payson Buffet tells us the model was twenty-one-year-old Setauket farmhand George Freeman (1835–1880). He was indentured to John Brewster, who lived in the main house seen in *Long Island Farmhouses*.

George Freeman was born in the Brewster House. His mother, Caroline, a biracial free person, worked for John Brewster as a servant. She left the household, however, soon after George's birth. With her husband, a free Black man named Charles Freeman, she settled in the Ridge area of Eastern Long Island, near Shoreham and Wading River.

The census record for 1850 indicates that by age fifteen, George returned to the place of his birth to work for his mother's former employer. Caroline Freeman must have had a good opinion of John Brewster in order to entrust her teenage son to him. The particulars of Caroline's parentage remain a mystery—could her father have been a Brewster? Perhaps John Brewster agreed to apprentice George because he felt his family owed Caroline a favor.

George is listed as part of the Robert Nelson Mount household only once, in this 1850 record. Of course, the census was taken only every ten years, so it's possible that he could have worked for John Brewster for almost that long.

Edward Payson Buffet interviewed Robert Nelson's son, John Mount, for his serialized biography in the *Port Jefferson Times*. John Mount was eight at the time George posed as *The Banjo Player*. Buffet related John Mount's memory:

He [George Freeman] *was bound out to R.N. Mount's father-in-law, John Brewster, in whose home…William* [Sidney] *Mount was a frequent visitor. Mr. John B. Mount well remembers that his Uncle William arranged with his grandfather to let George go to Stony Brook a certain number of times to sit for the picture. The artist had taken quite a fancy to the colored boy. George's parents lived in that section of the Island called The Ridge, and his articles of indenture, which still exist, were drawn up by Gen. John R. Satterly of Setauket.*[94]

After George left the Brewster household, he married a young woman from Setauket, "Hannah M.R." (1836–1928). By 1868, when their first son, Apollos George, was born, the couple lived in Mattituck, within Southold township. Two years later, they had a second son named Irving.

George died in 1880 at the age of forty-five in the city of New York. That year's census records list him as living in a Black neighborhood of Chelsea in Manhattan, married but not living with his wife. Hannah remained in Mattituck, Long Island, and lived to age ninety-one. George and Hannah were both buried in Mattituck.

GEORGE FREEMAN'S LIFE WITH THE BREWSTERS AND THE MOUNTS

George Freeman's responsibilities for the Mounts and John Brewster would have involved hoeing, weeding, threshing, planting and harvesting corn, building fences, and shoveling manure. The farm had cattle, poultry, and pigs. He'd have fed and butchered animals, chopped and stacked firewood.

It's likely that Mount dressed up George in borrowed clothes for the painting, just as he dressed up Andrew Brewster for *The Bone Player*. At forty, Andrew would have been George's superior as a laborer. George's clothing would have been functional, not fancy. Mount illustrates what nineteenth-century Long Island farmers were wearing in numerous paintings. They donned white cotton or linen shirts, sometimes with vests and jackets, loose-fitting brown wool trousers with or without suspenders, and thick leather boots. They wore brimmed hats of straw or felt.

Perhaps George wore Robert Nelson's dress-up clothes for his engagements as a dance instructor. Or perhaps Mount himself owned the formal wear. *The Painter's Triumph* (1838), believed to be a self-portrait, shows him in a colorful yellow vest under his plain jacket and a scarf around his neck. It's

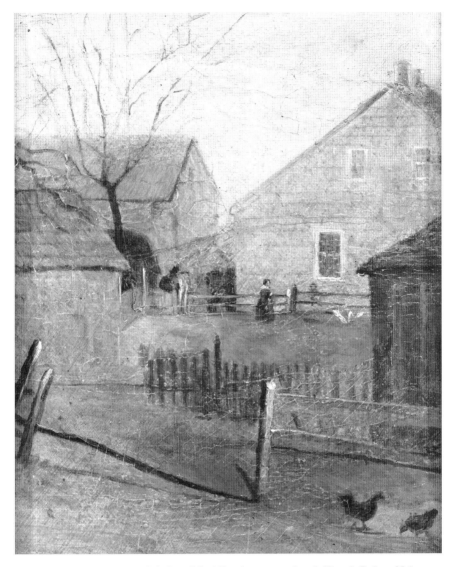

William Sidney Mount, *Detail for Long Island Farmhouses*, not dated. Here is Robert Nelson Mount's house, looking toward the Brewster House. *The Long Island Museum of American Art, History, and Carriages Collection.*

possible that Mount had a gold pocket watch like the one in *The Bone Player.* Though Mount was not as wealthy as his patrons, he regarded himself as a gentleman and projected that image.

John Mount incorrectly (or patronizingly) recalled twenty-one-year-old George to be a "boy." Other details, however, are correct. In 1856, Mount,

who moved about a great deal, had mostly boarded with his brother Shepard Alonzo Mount and Shepard's family in Stony Brook. Presumably, George walked the distance of about three and a half miles from Setauket to the Hawkins-Mount House. We know from Mount's May 1856 diary entry that he completed *The Banjo Player* in eight days and sixteen sittings. The young farmer sat for Mount twice a day, for how many hours at a stretch we do not know. Nor do we know if Mount paid George (or John Brewster). It seems likely that once there, the model spent the day with Mount. Perhaps during their breaks, they shared meals of bread and cheese and played the banjo and fiddle. Shepard Mount's four children, a girl and three boys, must have delighted in the unusual appearance of George dressed up in pink-and-red finery.

John Mount's memory that "the artist had taken quite a fancy" to George is in keeping with the cheerful tone of the painting. It's interesting to contemplate what the young farmer thought of the finished portrait. He may have felt the exercise of posing in fancy garb to be an honor or a joke: *What will these White folks think of next?* He seemed good-natured enough to go along with the artist's choices for his clothing.

The painting did not remain on Long Island for long. Within weeks of its completion, Mount traveled to the city of New York by steamboat with the work and met with William Schaus, and then the painting was shipped to Paris. There, another artist copied the image onto lithographic stones that would be used in the printing process. At least two years later, by the time the painting arrived back in the city of New York—where its owner, merchant and art collector Charles Mortimer Leupp, claimed it—a few thousand lithographic prints of the image were circulating in cities in Europe and America.

Many buyers would have considered George's image strikingly unusual; some of the European buyers might never have seen a man of color in person. Some of them would have only heard of Black people, or actors pretending to be Black people, playing music in comic theater productions in the city of New York.

It's interesting to speculate whether or not George knew of the image's popularity. Did he ever see one of the lithographic prints? Though it's a pleasant idea to think that Mount gifted George with a print of himself, chances are he may not have. Aside from the question of whether or not Mount would have given an expensive print to a farmhand, Mount may have received just one copy. It's also possible that the copies from the one-time print run disappeared into the hands of waiting buyers so quickly that Mount himself couldn't have purchased more prints if he'd tried.

One thing we can almost say for sure: George took away a joyful memory of foregoing farm work to spend eight days in Mount's company. What an interesting time that must have been for them both.

MOUNT'S LIFE AND NINETEENTH-CENTURY LONG ISLAND IN *THE BANJO PLAYER*

Was George a banjo-playing farm laborer? Could the banjo have belonged to him? It seems unlikely that an indentured farmhand would own such an expensive instrument. However, he might well have played the banjo. Many men of color in every walk of life, including the enslaved, played music. Fiddles were ubiquitous in nineteenth-century Long Island, and though banjos were less common, the instruments began to appear on the island with increasing frequency by the 1850s, when Mount made the painting.

Still, the presence of this top-of-the-line banjo remains a mystery. If either William Sidney Mount or Robert Nelson had played a banjo, chances are there would be a mention of it in their letters and journals, or one might have turned up in their personal effects when they died. There's no mention of John Brewster owning a banjo, either, but he could have afforded one more easily than any of the Mount brothers. And we know from William Sidney Mount's accounts that John Brewster loved music and dancing. William once wrote in a letter to Robert Nelson, "I expect you can imagine seeing him [John Brewster] hauling away of an evening on a fiddle his knees keeping time with his music." In another letter, Mount related that upon hearing fiddle music, John Brewster left his supper and came dancing over from next door.[95]

So, from what we know of John Brewster, he was the type of man who would have loaned an expensive banjo to George, just for the pleasure of having the whole household listen to the music. A banjo player might also have come in handy for Robert Nelson Mount at his dance events, in which dance teachers, working in a competitive milieu, sought to outdo each other by presenting all that was new and innovative in the field of music. It's conceivable that Brewster purchased an expensive instrument with his son-in-law's business in mind. Due to the local popularity of pianos, John Brewster may have owned one of these as well.

John Brewster was not only a musical man but also, it seems, a generous one; all signs indicate that he supported the Mount family next door, owned their house as well as his own, and paid the numerous live-in and

Above: William Sidney Mount, *Cow Lying Near Fence*, 1867. *The Long Island Museum of American Art, History, and Carriages Collection.*

Opposite: William Sidney Mount, *Long Island Farmyard*, not dated. *The Long Island Museum of American Art, History, and Carriages Collection.*

day laborers who worked on their joint property. Mount's writings indicate that Robert Nelson Mount, financially struggling and an alcoholic, was a disappointment to his wife, Mary, and no doubt, a disappointment to her father, who evidently picked up the slack for Mary, her husband, and their two children. In his diary, William Sidney Mount describes an incident in which the artist implores Mary to go to the Walter & Carlton liquor seller in Setauket and tell the man not to serve Robert Nelson.[96] It had come to the artist's attention that on one cold winter morning, after his morning's dram near the liquor store, Robert Nelson had passed out on the street and would have frozen to death if someone had not dragged him back inside the store. Mary angrily replied to Mount that she would not speak to the seller, for "the sooner her husband run down the better for all she cared."

To Robert Nelson's credit, he was the only member of the talented, musical Mount family to try to make a living as a musician. Apprenticed as a harness maker at a carriage manufacturer in his teenage years, Robert Nelson soon turned to fiddling and teaching dance. His classes each lasted for about six weeks, and then he would move on to teaching in a new area with different clients.

Unfortunately for Robert Nelson, Long Island had an abundance of dance masters. Apparently motivated to pay off debts, he left Mary and their young daughter, Sarah, at home while he traveled in the South, mostly in Georgia, for four years between 1836 and 1840. During this time, William Sidney Mount and Robert Nelson exchanged frequent letters. As well as offering his brother advice ("be careful to keep your hair short") and enclosing the latest dance tunes from Long Island and Manhattan, William Sidney provided updates about Mary and Sarah.

When Mount painted *The Banjo Player* in 1856, Robert Nelson had long since returned to Setauket and taken up farming. He and his family still lived next door to John Brewster, who was by then a widower. Mary and Robert Nelson now had a second child, John Brewster Mount, noted earlier.

The charming colonial dwelling that we know today as a museum was the setting for much bustling drama.

11

THE SLEEPING MAN
AND *THE DAWN OF DAY*

The Creation of *The Dawn of Day*

A rooster stands atop a sleeping Black man in a field. *The Dawn of Day* (1867) is Mount's most controversial work and his most overtly polemical. Mount also referred to the painting on his sketches and in his journals as *The Break of Day* and *Politically Dead*. Mount's own description of the painting is that of a dead man. However, the man's pose, knees up, one foot turned a little to the side, head resting on his hat, suggests a man asleep. If taken only on surface value, the painting, with its red, brown, and golden hues, lit by bright sunlight, evokes a feeling of peacefulness. Except that the brightly feathered cock that stands on the man's chest seems oddly out of place.

Mount painted *The Dawn of Day* less than a year before his death on November 19, 1868. By that time, Abraham Lincoln had been assassinated and Southern Democrat Andrew Johnson served as president. Mount was living in the home of his brother Robert Nelson Mount in Setauket (next door to the Brewster House) and had set his portable art studio about two miles away in Port Jefferson. Mount walked to it daily with his lunch.

At the time Mount made the painting, he was losing his vision. As several art historians have noted, the figures he painted in his last few years, particularly in *Catching the Tune* (1866–1867), bear a certain sameness. The lack of definition suggests Mount no longer employed models but worked from memory. Though he may have used a model for *The Dawn of Day*, it's

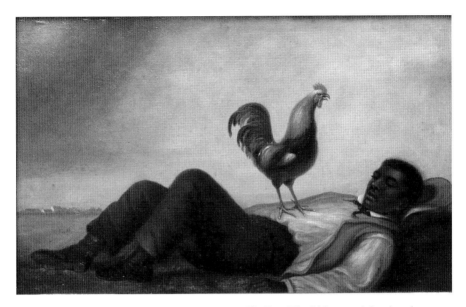

William Sidney Mount, *The Dawn of Day*, 1867. *The Long Island Museum of American Art, History, and Carriages Collection.*

just as likely he did not; in any case, no documentation exists to tell us who the model was, if there was one. Neither the 1860 nor the 1870 federal census lists any people of color as residing within Robert Nelson Mount's homestead.

THE MESSAGE AND STYLE OF *THE DAWN OF DAY*

Mount based the painting on a banner he'd created on cloth. This work no longer exists. In a public notice of November 11, 1867, Mount writes of the banner, "We the undersigned thought proper to commemorate the recent Democratic victories by having a drawing, representing *A Rooster standing upon a dead Negro. The Break of Day*." (the italicized emphasis is by Mount).

Mount goes on to say that on a piece of white muslin, two feet, four inches, by four feet, four inches, he completed the work in oil on November 8. The committee made up of "the undersigned"—four names were listed at the bottom of the notice along with his own—wished for "the Cock to crow from time to time." The banner was to be displayed in Port Jefferson, Stony Brook, and Setauket.

William Sidney Mount, Study for *Catching the Tune (Three Views of Man Whistling)*, 1866. *The Long Island Museum of American Art, History, and Carriages Collection.*

William Sidney Mount, Sketch for *Politically Dead*, 1867. *The Long Island Museum of American Art, History, and Carriages Collection.*

The four individuals Mount lists at the bottom of the document, besides himself, are Walter Jones Jun.[ior], Water [Walter?] Smith, Joseph Wm [William] Underhill, and John Henry Smith. Mount's journal tells us that Jones's store was one of the locations where the banner was hung. Captain Underhill boarded in Robert Nelson Mount's house at the same time Mount did. The names of Robert Nelson, Shepard, and other family members are noticeably absent from Mount's list. Perhaps they did not agree with, or wish to involve themselves, with Mount's political activities.[97]

Mount does not detail which victory he was referring to; it may have occurred at the convention of district Democrats from the town of Brookhaven (to which Mount was elected the following year). Mount may alternatively have been referring more generally to President Andrew Johnson's opposition to giving citizenship to the formerly enslaved. Johnson's backward policies, denying civil rights, were viewed by Democrats like Mount as the means by which the southern "slave states" would return to the Union. In the conservative Democrats' way of seeing things, the least said about the formerly enslaved individuals' rights, the better. Making peace, according to Mount, meant giving a rest to the postwar controversies over voting and other rights for Black people.

Art historian Alfred Frankenstein explains, "[*The Dawn of Day*] shows a cock crowing on the chest of a sleeping black man, and it symbolized the idea that, from the point of view of a conservative Democrat like Mount, the black man in America was no longer a live political issue."[98]

Mount repainted and framed the banner's image on sturdy canvas sometime in the year 1867. His correspondence indicates he'd hoped to both sell it and display it at the National Academy. He also aspired to the image becoming a lithograph. It's another odd twist in the story that Mount was convinced that businessman August Belmont of Belmont Stakes horse racing fame was going to purchase the painting. Belmont had been chair of the Democratic National Committee from 1860 to 1872. "I no longer have any room left in my Gallery for new paintings," he wrote to Mount in March 1868.[99] Considering that he owned opulent mansions in North Babylon, Long Island, as well as in Newport, Rhode Island, this reason seems a thinly disguised excuse to refuse a painting he did not like.

After Belmont's refusal of the painting, Mount decided not to try to include it in the annual National Academy show. In a letter to Belmont on March 30, he wrote: "On sober second thought I have concluded not to exhibit the painting at present."[100] The painting was never sold. Nor did any lithographer purchase rights to reproduce it.

MOUNT'S LIFE AND NINETEENTH-CENTURY LONG ISLAND IN *THE DAWN OF DAY*

Many American citizens considered the Democrats' position of that time as shortsighted and cruel. Long Islanders were no exception. The banner evidently created such a stir that it became the subject of a *Long Island Star* newspaper editorial, in which a Republican editor denounced it. That article is lost to us, though Mount's published rebuttals in two other newspaper pieces exist as copies in Mount's journals. The editor of the paper mistakenly thought the Black man represented the Republican Party. It's easy to see how the editor could have been confused; by the 1840s, the rooster had become the emblem of the Democratic Party, but in this case, Mount reversed the meaning.

Mount provided the following explanation in one of his rebuttals (December 9, 1867):

> *The painting represents the Negro Politically Dead. Radical Crowing will not awake him. It is the Radical Republican—Rooster—trying to make capital out of the Negro, but, is about used up for their purpose; which is glorious news for the whole country. The African needs rest.*

Later in the letter, Mount wrote:

> *If the Negro represents the Republican party (which the Editor of the Star states), he will be sure, in his death struggle, to steal the old cock for his last meal.*[101]

Despite the confusing aspects of this painting's meaning, then as now, it's clear that Mount took Andrew Johnson's and the conservative Democrats' view that giving rights to people of color interfered with the country's progress.

Today, Andrew Johnson is viewed as one of the worst presidents in history: backward and intolerant in his policies to deprive people of civil liberties and illegal in his dealings with hired officials. He was, in fact, impeached. During his watch in what is known today as the Reconstruction era, the Ku Klux Klan rose, unsuppressed, to prominence in the South.

Andrew Johnson's presidency did not last long. Soon there would be a Republican in charge. The following November, a little less than a year after

William Sidney Mount, *Sheet of Seven Sketches*, 1866. Several of Mount's sketches, including the one shown at center ("thinking of future prospects"), relate to politics of the Civil War era. *The Long Island Museum of American Art, History, & Carriages Collection.*

Mount painted *The Dawn of Day* and just weeks before Mount's death on November 19, Johnson lost the Democratic nomination to Horatio Seymour. Republican nominee Ulysses S. Grant defeated him. As president, Grant ratified the Fifteenth Amendment, which gave voting rights to men of color, and signed the Civil Rights Act of 1875 to protect all citizens in their civil and legal rights.

Reconciling Mount

Whenever the question of slavery came up in politics, Mount chose the leaders who did not embrace equality. He endorsed Andrew Jackson and Andrew Johnson, two of the most racist American presidents of all time. He fell into the pitfalls of racist thinking in his life and perpetuated racist thinking and inequality in some of his artworks.

At the same time, we can appreciate Mount for his considerable artistic merits. This complex and talented man brought forth a number of magnificent paintings such as *The Power of Music*, *The Bone Player*, and *The Banjo Player* that were absolutely ahead of their time in conveying people of color with realism, sensitivity, and a sense of humanity.

We can also appreciate the paintings for their historical value and their usefulness in serving as windows into the lives of the people whom he portrayed. It is a rare and wonderful gift to have pictorial records of people who would be otherwise lost to us because they did not have status, wealth, or power. And because of Mount's detailed craftsmanship, his ability to portray realistically and accurately based on firsthand observation of models, the images possess a high degree of authenticity. The people in the paintings must have looked in life just as Mount portrayed them.

Thanks to Mount, we have pictures of and can remember for all time, eel-spearing Rachel, likely Rachel Brewster or Rachael Youngs Tobias; Andrew Brewster and George Freeman of the Brewster House in Setauket; and Henry Brazier, Abner Mills, and Robbin Mills of Smithtown. We may have visual records of Ben Cato and Mathias Jones, and likely have pictures of Mary Brewster and Philena Seabury, however fragmentary. Thanks to Shepard Mount we have the portrait of Tamer Wren. Because of one of Mount's letters, we know about the intrepid Hector. And because of Mount's letters and the epitaph written by Micah Hawkins, we can remember Anthony Hannibal Clapp.

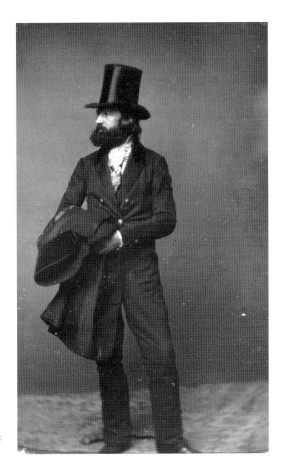

Mathew B. Brady, Portrait of
William Sidney Mount, circa
1853–1860. *Library of Congress Prints
and Photographs Division.*

Mount's art tells us stories of the time and leaves us with memories of the people themselves. His art inspires us, while also prompting us to ask questions. Knowing the identities of the sitters helps us not only remember and acknowledge people of color from Long Island's past but also better understand the racial inequalities in our present time.

NOTES

Introduction

1. The authors of this book have chosen to follow the American Psychological Association (APA)'s style guide for bias-free language, updated in 2022, when using racial and ethnic identifiers. Like the APA, we capitalize "B" in Black when identifying groups that comprise the African diaspora in America and "W" in White when writing about people of European Ancestry. See https://apastyle.apa.org/style-grammar-guidelines/bias-free-language/racial-ethnic-minorities. The term "mulatto," offensive to many, is presented in this book only in its historical context in regard to nineteenth-century census records and other documents.

2. Johnson, *William Sidney Mount*, 77–78.

3. Ibid., 42.

4. Roger Wunderlich, "William Sidney Mount's Split Personality: Artistically Forward, Politically Backward," in the Three Village Historical Society [hereafter TVHS], *William Sidney Mount*, 41–43.

5. Edward Payson Buffet's 1923–1924 serialized biography of Mount in the *Port Jefferson Times* exists today only as articles pasted into scrapbooks. We cite here the page numbers from the TVHS's volume. Additionally, we give the "chapter" numbers (in Roman numerals) that Buffet assigned to each article.

6. The hamlet of St. James, part of the town of Smithtown, did not exist in Mount's time.

7. For a full discussion of Ward Melville, see Matthews, *Struggle for Heritage*, 25–193.

William Sidney Mount (1807–1868): A Biography

8. Mount, a fiddler, owned an extensive music collection. In 1976, a musician named Gilbert Ross used one of Mount's three extant violins to play music from Mount's manuscript collection; the recording, called *The Cradle of Harmony: William Sidney Mount's Violin and Fiddle Music*, is available for purchase from the Smithsonian Institution and excerpts from it can be listened to online at no charge. See https://folkways.si.edu.

9. Thomas Mount manumitted an enslaved man named Harry on April 6, 1813; Mount co-owned Harry with Jonas Hawkins Jr. This is listed in the Records of the Town of Brookhaven (1888), 171–72. Perhaps Harry served Ruth Hawkins prior to her marriage, then subsequently moved with her to the Mount household.

10. The household of Jonas Hawkins in the 1810 census included one enslaved and two "all other persons" (non-White people). Anthony Clapp might have been included in the "all other" category.

11. Frankenstein, *William Sidney Mount*, 19.

12. Benjamin Franklin Thompson, born in 1784, the noted historian of Long Island and a son of Dr. Samuel Thompson, became a close friend and patron of Mount (Cathy Nelson, "William Sidney Mount and the Thompson Family," in TVHS, *William Sidney Mount*, 30). Benjamin's cousin Martin E. Thompson, a New York architect, likely referred Mount to the National Academy.

13. Mount journal 0.72606, 123, Long Island Museum, as cited by Johnson, *William Sidney Mount*, 95n47.

14. Art historian Elizabeth Johns asserts that Manhattan businessmen liked paintings of farmers because they gave them a comfortable feeling of superiority. The images of Yankee life reminded them of their place during an uncertain time of sweeping changes. For more on the subject of businessmen taking an interest in agricultural scenes, see Johns, "An Image of Pure Yankeeism," chap. 2 in *American Genre Painting*, 24–59, and Johns, "Farmer in the Works of William Sidney Mount," 257–81.

15. Johnson, *William Sidney Mount*, 134.

16. For more information about Mount's interest in spiritualism, see Robert W. Kenny, "Mount's Spirit Guides," in TVHS, *William Sidney Mount*, 23–28; Brosky, *Haunted Long Island*, 91–100, 145–53; Frankenstein, *William Sidney Mount*, 285–97.

17. Buffet, "William Sidney Mount" [hereafter biography series] "Chapter I: Determinative Factors," 96.

18. Frankenstein, *William Sidney Mount*, 262.

19. Long Island Museum, *Sheet of Twelve Sketches*, not dated, 1977.022.0323, and *Sheet of Seven Sketches*, 1866, 1977.022.0320.

20. Frankenstein, *William Sidney Mount*, 357.

Sketches of Five Households

21. Kline, *Three Village Guidebook*, 145–48.
22. Ibid., 67–69. See also Adkins, *Setauket*, 13. Additional genealogical information was supplied to the authors by John T. Strong.
23. Harris, "Lives, Loves, and the Laments." See also Historic American Buildings Survey, "Mills Pond House."
24. Kline, *Three Village Guidebook*, 78–80.
25. Ganz, *Colonel Rockwell's Scrap-book*, 156–57.

Chapter 1. *Anthony Clapp and* Rustic Dance After a Sleigh Ride

26. Johnson, *William Sidney Mount*, 24.
27. Johns, *American Genre Painting*, 105–6.
28. Frankenstein, *William Sidney Mount*, 91.
29. Reference to "Cane's seat," which still survives today, is from a *Long Island Forum* article by Kate Strong in August 1944.

Chapter 2. *The Rachel of* Eel Spearing at Setauket

30. It's difficult to pinpoint the exact location in which William Sidney Mount painted *Eel Spearing*. Over a century ago, when houses were few and Strong's Neck was mostly felled of trees, St. George's Manor could have easily been seen from both Conscience Bay and Setauket Harbor.
31. Buffet, biography series, "Chapter XXIII: 1846—Early Recollections of Eeling," 107.
32. Though it's true that fine arts painting in the mid-1800s rarely included people of color, John Singleton Copley and others preceded Mount in depicting Black people as subjects. See McElroy et al., *Facing History*.
33. Johns, *American Genre Painting*, 119.
34. The daughters of Pierro Young(s) (1781–1832) and Eunice (1788–1863) were Rachael (1805–1866), Tamar (1807–1873), Cealia (b. 1810), and Ellen "Nell" (1815–1905).
35. The family members listed together in the 1850 Brookhaven U.S. Census are Eunice Smith, fifty-eight; Alice Smith, forty-three; Jacob Tobias, forty-three; Rachael Tobias, forty-one; Hanna Tobias, twenty; David Tobias, sixteen; Samuel Tobias, fifteen; Silas Tobias, eleven; Abraham Tobias, eight; Isaac Tobias, three; and Charles, an infant.

36. The eighteenth-century Brewster family Bible, as copied by LeRoy Smith in 1911, states, "November ye 3 day 1799 Rachel Nels Daughter was Born. February 20th 1802 Nels daughter was Born Fanna by name. Dec 18 1805 Nels Daughter Rox was Born. February 18, 1809 Nels son Andrew was Born."

37. Rachel Brewster's tombstone in Laurel Hill Cemetery reads: "Rachael Brewster Born January 22, 1796 Died July 10, 1879." Neither her birth nor her death dates on the tombstone precisely match the information given in the family Bible and census records. The epitaph, unlike these other sources, spells her name as "Rachael."

38. There's a third Rachel who has often been cited in articles and books as Mount's model: Rachel Lucretia Tobias. However, she was born in 1836, so she would have been a child of nine at the time Mount made the painting. This Rachel has also been confused with both Lucretia Tobias, born in 1830, who resided with the Roe family in Oyster Bay, and a Rachel Hart IV (1842–1902), another Brookhaven resident. According to Hart family tradition, Rachel Hart worked for a Selah Strong as his housekeeper. She was likely employed by Selah Brewster Strong II (1841–1931), the son of Selah Brewster Strong I (1792–1872) and Cornelia Udall. This Selah Strong was the brother of Judd Strong (Thomas Shepard Strong II)—the little boy in the painting.

39. Day, *Making a Way to Freedom*, 89–91.

40. For more details of the two archaeological excavations mentioned, see Matthews, *Struggle for Heritage*.

41. Frankenstein, *William Sidney Mount*, 120–22.

Chapter 3: Mary Brewster, Philena Seabury, Mathias Jones *and* Dance of the Haymakers

42. Frankenstein, *William Sidney Mount*, 105 and 471.

43. Penot, "Perils and Perks of Trading Art Overseas."

44. Connections between Mary Brewster and William Sidney Mount abound. Mary's husband, Adam Strong Brewster—born in the Brewster House in Setauket—was the son of Rachel Brewster, who may have been Mount's model for *Eel Spearing at Setauket*. Adam was also the brother of Andrew Brewster, who, according to Edward Payson Buffet, was Mount's model for *The Bone Player*. In Smithtown, Adam lived next door to Robbin Mills, Mount's model for *The Power of Music*. Other neighbors included Abner Mills, Mount's model for *Farmers Nooning* and *California News*, and Tamer Wren, whose portrait was painted by Mount's brother Shepard.

45. A farm laborer named Mathias Jones (1859–1938) is listed on several Brookhaven census reports. The name Mathias is rare in nineteenth-century Long Island, so it

follows that the Mathias of *Dance of the Haymakers* (born in 1830) could have had a son with this same name. The Mathias born in 1859 lived in West Hampton for a time and settled in Smithtown.

46. In 1810, Benjamin Jones, who had four people listed in his household (unnamed), lived next door in Stony Brook to a man simply recorded as "Robbin"—Robbin Mills? In 1821, Benjamin Jones manumitted an enslaved man named Mingo, who is listed in Brookhaven records as "under forty-five Years and of Sufficient Ability to provide for and Maintain himself." Perhaps Mingo was Mathias's father?

47. Buffet, biography series, "Chapter XXII: 1845—Dance of the Haymakers (Music Is Contagious)," 107, and "Chapter XXVI: Mount and His Friend Thomas Cole," 108. Also see Elizabeth Kahn Kaplan, "Ties of Family, Friendship, and Music: William Sidney Mount and Shepard Smith Jones" in TVHS, *William Sidney Mount*, 13–18.

48. Smith, *Creolization of American Culture*, 1–27.

Chapter 4. *Abner Mills (1836) and* Farmers Nooning

49. Johns, *American Genre Painting*, 33–38.

50. Johnson, *William Sidney Mount*, 38–43.

51. Buffet, biography series, "Chapter XIII: 1837—Farmers Nooning and Raffling the Goose," 101–2; "Chapter XXIII: 1846—Early Recollections of Eeling," 107.

52. Johnson, *William Sidney Mount*, 106n207; William Sidney Mount, "Journal/Address Book," 1, Smithtown Library.

53. Wilkerson, *Caste*, 29.

54. Ibid., 70.

Chapter 5. *Robbin Mills and* The Power of Music

55. For an in-depth study of *The Power of Music*, see Robertson, "*Power of Music*."

56. Johns, *American Genre Painting*, 119–22; Johnson, *William Sidney Mount*, 61–62; Smith, *Creolization of American Culture*, 194–95.

57. Johns, "An Image of Pure Yankeeism," chap. 2 in *American Genre Painting*, 24–59.

58. In the chapter "Standing Outside the Door" in her book *American Genre Painting* (114–36), Elizabeth Johns discusses the marginalization of people of color in nineteenth-century American art. She makes the astute point that the "outside the door" portrayal of Black people in genre paintings normalized, reinforced, and even galvanized the tendency for White people to segregate and denigrate

people of color. Art, drawn from life, influenced life in return, Johns writes. Genre art tended to help cement social hierarchies. *The Power of Music* both reinforced and challenged the position of people of color in society. While the Black man literally stands outside a door, he is portrayed with sensitivity and humanity. His image is also treated with more importance that those of the other people in the painting.

59. Buffet, biography series, citing Henry Floyd Jones in "Chapter XXIV: Mount's Most Famous Picture—*The Power of Music*," 107–8. For further details of identification of people in the painting, see Kaplan, "Ties of Family," TVHS, *William Sidney Mount*, 13–18.

60. Biography of Robbin Mills, see "Robin (sic) Mills: a brief history by Bruce Robertson, 1995," correspondence between Vera Toman and Bruce Robertson located in "Mount, W. S., Paintings, Afro Americans" folder in the Richard H. Handley Long Island Room, The Smithtown Library, Smithtown, New York.

61. The Journals and Papers of Dr. Samuel Thompson (1738–1811), the Brooke Russell Astor Reading Room for Rare Books and Manuscripts, New York Public Library.

62. Ganz, *Colonel Rockwell's Scrap-book*, 156–57. The authors also consulted the scrapbooks and correspondence of Leighton H. Coleman III.

63. Buffet, biography series, "Chapter XXIV: Mount's Most Famous Picture—*The Power of Music*," 108.

64. In addition to the population censuses, the U.S. government conducted so-called nonpopulation censuses that provided data on agriculture, mortality rates, and other issues. One of these, the 1850 U.S. Selected Federal Census, states that Dr. Samuel Thompson owned 200 "improved" (land that was cultivated or built upon) and 300 "unimproved" acres. Thompson's assets included 7 horses, 11 cows, 2 oxen, 18 other cattle, 115 sheep, 20 pigs, 300 bushels of wheat, 100 bushels of rye, 800 bushels of corn, and 200 bushels of oats. Meanwhile, the Mills family of Smithtown owned 50 "improved" and 430 "unimproved" acres, 3 horses, 3 cows, 3 pigs, 2 bushels of beans and peas, 20 bushels of "Irish" (White) potatoes, 6 bushels of barley, and 33 bushels of buckwheat. The large cattle operation owned by the Mills family is oddly not mentioned in this report, nor is Shepard Jones's farm.

Chapter 6. Abner Mills (1850) and California News

65. See the Library of Congress's digital collection "California as I Saw It: First Person Narratives of California's Early Years, 1849 to 1900, 'The Forty Niners,'" https://www.loc.gov/collections/california-first-person-narratives.

66. Johnson, *William Sidney Mount*, 67–69.

67. Buffet, as cited by Kaplan, "Ties of Family," TVHS, *William Sidney Mount*, 18.

68. Census details from 1850 tell us that Abner's neighbors include his much younger brothers, Samuel, age eighteen, and Abraham, age fifteen. Described as farmers, they live in the household of a White man named Henry Wells; perhaps they are indentured.

69. The 1850 census tells us that the Abner Mills family lived next door to the family of Lewis Mills, son of Jedediah Mills, on whose land Abner's father once lived. Perhaps the Jedediah Mills family set up a school for the families who worked their land? Or perhaps Quakers in Smithtown saw to it that Abner and others in his family learned to read.

70. When Mount painted *California News*, a letter from Stony Brook could be delivered to California in a targeted three to four weeks, first transported from the city of New York to the Isthmus of Panama by a steamship contracted by the U.S. Navy, then transported by pack animals fifty miles to the coast, and then carried by another steamship to San Francisco. A year later, in 1851, the department experimented with its first overland route, in which stagecoaches transported mail to Salt Lake City and from there by individual carriers through the Sierra Nevada Mountains to Sacramento. By the time of Mount's death in 1868, speedy locomotives transported the mail between coasts. See United States Postal Services, "The United States Postal Service: An American History," https://about.usps.com/publications/pub100.pdf.

Chapter 7. Henry Brazier and Right and Left

71. Johnson, *William Sidney Mount*, 73.

72. Buffet, biography series, "Chapter V: Colored Fiddlers and Micah Hawkins," 98.

73. In 1860, the U.S. census lists a Henry Brazier as living in West Cornwall, Litchfield County, Connecticut. He's a day laborer in the household of William C. Rogers, a merchant. A city of New York directory in 1866 shows Henry Brazier, "laborer," as a resident of Spencer and Flushing Avenues in Brooklyn. Another city of New York directory, in 1870, lists Henry with the last name of Brasier (alternate spellings are common in records), as a "driver" who lives on Hopkins and Marcy Avenues in Brooklyn.

74. Anthony Clapp died a year before Henry Brazier was born. And yet it may not be a coincidence that multiple members of Henry Brazier's family, including an individual who was either his half brother or a son, were named Anthony. Anthony Brazier (1835–1890), born in Smithtown, could have been the son

of Henry Brazier (1817–1895) and Esther Cato (1815–1850). He was listed as "Indian." Or it's possible that Anthony was Henry's much younger half brother. When the couple lived in Smithtown, their family unit included two younger male relatives and one older man—likely Henry's father and half brothers. Census records reveal that in 1790 a White Quaker family named Brazier lived in Huntington next door to a Black man named "Toney." The name Anthony is a rare one on Long Island in the nineteenth century. A fiddler as renowned on Long Island as Anthony Clapp could have had children named after him. Fond associations with his name could have continued in Long Island's North Shore Black communities long after he was gone. The Clapp residence where Anthony lived in Horseneck, Connecticut, was close to the home of a White family by the name of Brazier. Other White families named Brazier lived in Huntington and elsewhere on Long Island. Did Anthony work for, then accompany, members of a White Brazier family from Connecticut to Huntington? Or perhaps Anthony moved to Long Island to be close to a community of people of color, including a Black family by the name of Brazier? Many families, both White and of color, had members on both sides of Long Island Sound. There had been a considerable amount of migration between the two places since colonial times, even prior to the Revolutionary War.

75. Frankenstein, *William Sidney Mount*, 52.
76. American Antiquarian Society, "An Invitation to Dance: A History of Social Dance in America," https://americanantiquarian.org/Exhibitions/Dance/fashion.htm.

Chapter 8. Ben Cato and The Lucky Throw

77. Frankenstein, *William Sidney Mount*, 162.
78. Johns, *American Genre Painting*, 123–29.
79. Redd and Etcheson, "Sound on the Goose," 204–17.
80. Buffet, biography series, "Chapter XXXI: Mount's Large Comic Portrait Series, Lithographed for Goupil." It's likely that Mount's model Ben Cato was a son of the Judas Cato of Stony Brook enumerated in the 1840 Brookhaven census. However, several other possibilities for the model exist, as the name "Cato" was fairly common among Black-Native families in the Three Villages in the nineteenth century. In 1850, a Black seventeen-year-old named Cato Alexander is described as living next door to another of Mount's cousins, Daniel Alfred Smith (1813–1885). In that same census, Anthony Brazier, age fifteen—possibly the son of Henry Brazier, Mount's model for *Right and Left*—is

listed as a resident worker on Daniel Alfred Smith's farm. Henry Brazier's wife had the maiden name of Esther Cato. Could she have been the mother of Ben Cato? If so, he was Henry Brazier's stepson, and his grandfather was a Native man named Judas Cato.

81. Bowery Boys New York City History, "Turkey Raffles Were 19th Century Versions of Bar Trivia Nights," October 24, 2013, https://www.boweryboyshistory.com.

Chapter 9. Andrew Brewster and The Bone Player

82. Frankenstein, *William Sidney Mount*, 164.

83. Ibid.

84. Ibid., 168.

85. Smith, *Creolization of American Culture*, 142–47.

86. Buffet, biography series, "Chapter XXXI: Mount's Large Comic Portrait Series, Lithographed for Goupil," 111–12.

87. Although Andrew Brewster is no longer listed in the Brookhaven federal census records after 1865, there is a "Brewster Wells," aged fifty-two, of Suffolk County listed as a "ship's joiner" in the New York State Census of 1865.

88. Frankenstein, *William Sidney Mount*, 307.

89. The "young lady brought up in a boarding school" could be either of these sisters-in-law, Elizabeth or Mary, or their daughters. There's no evidence, however, that the Mount brothers had the kind of money to send Elizabeth's daughter Ruth (Tutie), twelve at the time, or Mary's daughters—Julia, twenty-six, Elizabeth, nineteen, and Evelina, seventeen—to boarding school, presumably in Manhattan.

90. Johnson, *Shepard Alonzo Mount*, 47n87–88.

91. Frankenstein, *William Sidney Mount*, 345.

Chapter 10. George Freeman and The Banjo Player

92. Smith, *Creolization of American Culture*, 133–41, 156–57.

93. The banjo player's brass bugle mouthpiece is a curious detail. Is it possible that George drove a coach for the Brewster family, in addition to his other duties? It's unlikely. The Brewsters would have owned a buckboard wagon, or equivalent, for farm work, and perhaps a horse-drawn buggy. A coach would have been an extravagant purchase. The kind of uniformed, stylish coachman Mount evokes appears to have a full-time occupation, such as a stagecoach driver who delivered

mail or conveyed passengers from a railroad station to their homes. Mount was likely drawing on popular stories, or personal experiences, of coachmen who played music on their off hours while waiting for their next assignment. Mount may have read, or heard about, the Black coachman who appears in the 1838–39 autobiography of Charles Mathews, a prominent British comic actor. This coachman directed his horses by different tunes on a fiddle while he fastened the horses' reins around his neck. As Mount was a musician, such a whimsical story would no doubt have appealed to him.

94. Smith, *Creolization of American Culture*, 136 (from page 112 of the scrapbook of Buffet's articles, which Smith consulted).
95. Frankenstein, *William Sidney Mount*, 52.
96. Ibid., 367.

Chapter 11. *The Sleeping Man and* The Dawn of Day

97. Frankenstein, *William Sidney Mount*, 440.
98. Ibid., 201.
99. Ibid., 452.
100. Ibid.
101. Ibid., 441–42.

SELECTED BIBLIOGRAPHY

Adkins, Edwin P. *Setauket: The First Three Hundred Years, 1655–1955*. New York: David McKay Co., 1955.

Brosky, Kerriann Flanagan. *Haunted Long Island Mysteries*. Charleston, SC: The History Press, 2021.

Buffet, Edward Payson, "William Sidney Mount: A Biography." *Port Jefferson Times*, December 1, 1923–June 12, 1924 (fifty-six installments).

Day, Lynda R. *Making a Way to Freedom: A History of African Americans on Long Island*. Interlaken, NY: Empire State Books, 1997.

Frankenstein, Alfred. *Painter of Rural America: William Sidney Mount, 1807–1868*. Stony Brook, NY: Suffolk Museum at Stony Brook, 1968.

———. *William Sidney Mount*. New York: Harry N. Abrams, 1975.

Ganz, Charlotte Adams, ed. *Colonel Rockwell's Scrap-book*: *Short Histories: Dwellings, Mills, Churches, Taverns 1665–1845*. Smithtown, NY: The Smithtown Historical Society, 1968.

Gellman, David N. *Emancipating New York: The Politics of Slavery and Freedom 1777–1827*. Baton Rouge: Louisiana State University Press, 2006.

Harris, Bradley. "Lives, Loves, and the Laments of the People of St. James." Parts 1–4, undated. Mills Pond House, https://www.millspondgallery.org.

Historic American Buildings Survey Heritage Conservation and Recreation Service. "Mills Pond House: Historical and Descriptive Data." Department of the Interior, Washington, D.C. https://www.archives.gov.

Howard, Nancy Shroyer. *William Sidney Mount: Painter of Rural America*. Worcester, MA: Davis Publications, 1994.

Johns, Elizabeth. *American Genre Painting: The Politics of Everyday Life*. New Haven: Yale University Press, 1991.

———. "The Farmer in the Works of William Sidney Mount." *Journal of Interdisciplinary History 17*, no. 1 (Summer 1986): 257–81.

Johnson, Deborah J. *Shepard Alonzo Mount: His Life and Art*. Stony Brook, NY: Museums at Stony Brook, 1988.

———. *William Sidney Mount: Painter of American Life*. New York: American Federation of Arts, 1998.

Kaufman, Marjorie. "Artist's Homestead Restored with Care." *New York Times*, May 2, 1993.

Kendi, Ibram X. *Stamped from the Beginning: The Definitive History of Racist Ideas in America*. New York: Bold Type Books, 2016.

Kline, Howard. *Three Village Guidebook: The Setaukets, Poquott, Old Field & Stony Brook*. Setauket, NY: Three Village Historical Society, 1986.

Lapham, Edward A. *Stony Brook Secrets.* New York: Gotham Book Market, 1942.

Lewis, Robert E., Christopher N. Matthews, and Judith A. Burgess, ALTC Co-Directors. "The Bethel-Christian Avenue-Laurel Hill Historic District: The Preservation of an Indigenous Minority Community in Setauket, Long Island" A Long Time Coming, A Collaborative Public History & Archaeology Initiative of Higher Ground Intercultural and Heritage Association. https://lihj. cc.stonybrook.edu.

Marcus, Dr. Grania Bolton. *Discovering The African-American Experience in Suffolk County, 1620–1860*. Mattituck, NY: Society for the Preservation of Long Island Antiquities and Amereon House, 1988.

Matthews, Christopher N. *A Struggle for Heritage: Archaeology and Civil Rights in a Long Island Community*. Gainesville: University Press of Florida, 2020.

McElroy, Guy C., Henry Louis Gates, Christopher C. French, Corcoran Gallery of Art and Brooklyn Museum. *Facing History: The Black Image in American Art*. San Francisco, CA: Bedford Arts, 1990.

Moss, Richard Shannon. *Slavery on Long Island: A Study in Local Institutional and Early African-American Communal Life*. New York: Garland Publishing Inc., 1993.

Nicholson-Mueller, Vivian, and Simira Tobias. "Old Bethel Cemetery." National Register of Historic Places Registration Form, United States Department of the Interior, National Park Service, September 2017.

Olly, Jonathan M. *Long Road to Freedom: Surviving Slavery on Long Island*. Stony Brook, NY: Long Island Museum of American Art, History, and Carriages, 2022.

Penot, Agnès. "The Perils and Perks of Trading Art Overseas: Goupil's New York Branch." *Nineteenth-Century Art Worldwide: A Journal of Nineteenth-Century Visual Culture* 16, no. 1 (Spring 2017).

Pike, Martha V., and the Museums at Stony Brook. *Catching the Tune: Music and William Sidney Mount*. Stony Brook, NY: Museums at Stony Brook, 1984.

Redd, Emmett, and Nicole Etcheson. "Sound on the Goose: A Search for the Answer to an Age-Old 'Question.'" *Kansas History: A Journal of the Central Plains* 32 (Autumn 2009), 204–17.

Robertson, Bruce. "*The Power of Music*: A Painting by William Sidney Mount." *The Cleveland Museum of Art Bulletin* 79, no. 2 (February 1992): 38–62.

———. Unpublished biographical material regarding Robbin Mills, in "Mount, W.S., Paintings, Afro Americans" folder in the Richard H. Handley Long Island Room, Smithtown Library, Smithtown, NY.

Smith, Christopher J. *The Creolization of American Culture: William Sidney Mount and the Roots of Blackface Minstrelsy*. Urbana: University of Illinois Press, 2013.

Smith, Leroy. Leroy Smith Papers 1910–1955. The Middle Country Public Library, Centereach, New York.

Thompson, Samuel, Dr. The Journals and Papers of Dr. Samuel Thompson (1738–1811). The Brooke Russell Astor Reading Room for Rare Books and Manuscripts, New York Public Library.

Three Village Historical Society. *William Sidney Mount: Family, Friends, and Ideas*. Setauket, NY: Three Village Historical Society, 1999.

Wilkerson, Isabel. *Caste: The Origins of Our Discontents*. New York: Random House, 2020.

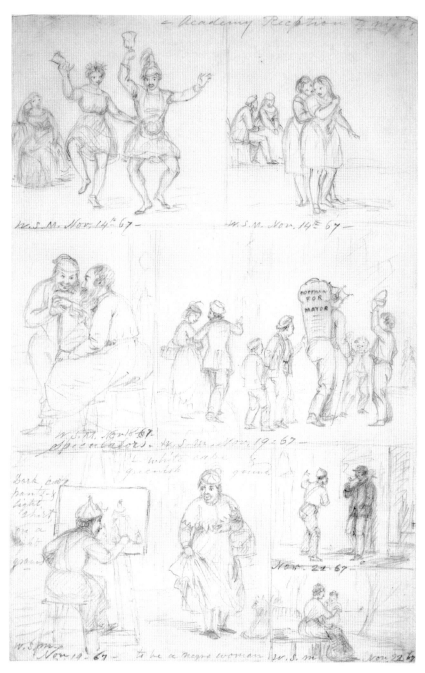

William Sidney Mount, *Sheet of Seven Sketches*, 1867. *The Long Island Museum of American Art, History, & Carriages Collection.*

ILLUSTRATION CREDITS

Cover

Front cover: William Sidney Mount (1807–1868), Detail from *Eel Spearing at Setauket (Recollections of Early Days—"Fishing Along Shore")*, 1845. Oil on canvas. 33⅜ x 50⅝ inches. Collection of the Fenimore Art Museum, Cooperstown. Gift of Stephen C. Clark. Photograph by Richard Walker. N0395.1955.

Back cover: William Sidney Mount (1807–1868), *The Power of Music (The Force of Music)*, 1847. Oil on canvas. 17⅛ x 21 inches. The Cleveland Museum of Art. Leonard C. Hanna Jr. Fund. 1991.110.

Color Insert

William Sidney Mount (1807–1868), *Self-Portrait*, 1832. Oil on canvas. 24⅜ x 20½ inches. The Long Island Museum of American Art, History, and Carriages Collection. Gift of Mr. and Mrs. Ward Melville, 1950. 1976.016.0008.

William Sidney Mount (1807–1868), *The Mount House*, 1854. Oil on canvas. 8 x 10 inches. The Long Island Museum of American Art, History, and Carriages Collection. Bequest of Ward Melville, 1977. 1977.022.0550.

William Sidney Mount (1807–1868), *Long Island Farmhouses*, 1862–1863. Oil on canvas. 21⅞ x 29⅞ inches. The Metropolitan Museum of Art, New York. Gift of Louise F. Wickham, in memory of her father, William H. Wickham, 1928. 28.104.

William Sidney Mount (1807–1868), *Detail for Long Island Farmhouses*, not dated, oil on panel, 5 x 4 inches. The Long Island Museum of American Art, History, and Carriages Collection. Bequest of Ward Melville, 1977. 1977.022.0579.

William Sidney Mount (1807–1868), *Rustic Dance After a Sleigh Ride*, 1830. Oil on canvas, 22⅛ x 27⅛. The Museum of Fine Arts, Boston. Bequest of Martha C. Karolik for the M. and M. Karolik Collection of American Paintings, 1815–1856. 18.458.

William Sidney Mount (1807–1868), *Eel Spearing at Setauket (Recollections of Early Days—"Fishing Along Shore")*, 1845. Oil on canvas. 33⅜ x 50⅝ inches. Collection of the Fenimore Art Museum, Cooperstown. Gift of Stephen C. Clark. Photograph by Richard Walker. N0395.1955.

William Sidney Mount (1807–1868), Study for *Eel Spearing at Setauket*, not dated. Oil on paper. 5 x 6½ inches. The Long Island Museum of American Art, History, and Carriages Collection. Bequest of Ward Melville, 1977. 1977.022.0573.

William Sidney Mount (1807–1868), *The Mower*, 1866–1867. Oil on panel. 9¾ x 14 inches. The Long Island Museum of American Art, History, and Carriages Collection. Museum purchase, 1971. 0000.001.5774.

William Sidney Mount (1807–1868), *Dance of the Haymakers (Music Is Contagious)*, 1845. Oil on canvas. 24⅝ x 29¾ inches. The Long Island Museum of American Art, History, and Carriages Collection. Gift of Mr. and Mrs. Ward Melville, 1950. 0000.001.0019.

William Sidney Mount (1807–1868), *Farmers Nooning*, 1836. Oil on canvas. 20¼ x 24½ inches. The Long Island Museum of American Art, History, and Carriages Collection. Gift of Frederick Sturges, Jr., 1954. 0000.001.1521.

William Sidney Mount (1807–1868), *The Power of Music*, 1847. Oil on canvas. 17⅛ x 21 inches. The Cleveland Museum of Art. 1991.110.

William Sidney Mount (1807–1868), Detail from *The Power of* Music, 1847. Oil on canvas. 17⅛ x 21 inches. The Cleveland Museum of Art. 1991.110.

William Sidney Mount (1807–1868), *California News*, 1850. Oil on canvas. 21½ x 20¼ inches. The Long Island Museum of American Art, History, and Carriages Collection. Bequest of Ward Melville, 1977. 0000.001.0014.

William Sidney Mount (1807–1868), *Right and Left*, 1850. Oil on canvas. 30 x 25 inches. The Long Island Museum of American Art, History, and Carriages Collection. Museum purchase, 1956. 0000.001.2726.

William Sidney Mount (1807–1868), *The Bone Player*, 1856. Oil on canvas, 36 x 29 inches. The Museum of Fine Arts, Boston. Bequest of Martha C. Karolik for the M. and M. Karolik Collection of American Paintings, 1815–1865. 48.461.

William Sidney Mount (1807–1868), *The Banjo Player*, 1856. Oil on canvas. 35¾ x 28¾ inches. The Long Island Museum of American Art, History, and Carriages Collection. Gift of Mr. and Mrs. Ward Melville, 1955. 0000.001.0011.

Jean-Baptiste Adolphe Lafosse (1810–1879), *Raffling for a Goose (The Lucky Throw)*, 1851, after William Sidney Mount's painting of 1849. Colored engraving lithograph. 29 x 23¼ inches. The Long Island Museum of American Art, History, and Carriages Collection. Gift of Mr. Richard M. Gipson, 1951. 0000.006.3657.

William Sidney Mount (1807–1868), *The Dawn of Day*, 1867. Oil on panel. 7¾ x 11¾ inches. The Long Island Museum of American Art, History, and Carriages Collection. Gift of Mr. and Mrs. Ward Melville, 1958. 0000.001.0006.

William Sidney Mount (1807–1868), *Boy Hoeing Corn (Boy With Bridle)*, 1840. Oil on panel. 14⅜ x 11⅜ inches. The Long Island Museum of American Art, History, and Carriages Collection. Bequest of Ward Melville, 1977. 1977.022.0561.

Shepard Alonzo Mount (1804–1868), *The Slaves Grave*, circa 1850. Oil on panel. 5¼ x 9⅛ inches. The Long Island Museum of American Art, History, and Carriages Collection. Gift of the Estate of Dorothy deBevoise Mount, 1959. 0001.003.3927.

Front Matter and Introduction

William Sidney Mount (1807–1868), *Figure Sketch: Black Woman with Hat*, 1831. Pencil on paper. 4½ x 5½. The Long Island Museum of American Art, History, and Carriages Collection. Bequest of Ward Melville, 1977. 1977.022.0674.029.

William Sidney Mount (1807–1868), *Boy Playing Violin*, not dated. Pencil on paper, 4½ x 6⅞ inches. The Long Island Museum of American Art, History, and Carriages Collection. Bequest of Ward Melville, 1977. 1977.022.0209.

William Sidney Mount (1807–1868), *Dancing Couple*, November 25, 1866. 4 x 6⅛ inches. The Long Island Museum of American Art, History, and Carriages Collection. Bequest of Ward Melville, 1977. 1977.022.0131.

William Sidney Mount (1807–1868), *The Mower*, 1866–1867. Oil on panel. 9¾ x 14 inches. The Long Island Museum of American Art, History, and Carriages Collection.

Shepard Alonzo Mount (1804–1868). *Profile of a Woman Smoking*, not dated. Pencil on ledger paper. 9⅛ x 11¾ inches. The Long Island Museum of American Art, History, and Carriages Collection. Bequest of Ward Melville, 1977. 1977.000.0514.350.

William Sidney Mount (1807–1868): A Biography

Charles Loring Elliott (1812–1868), *William Sidney Mount*, 1848. Oil on canvas. 30½ x 20½ inches. The Long Island Museum of American Art, History, and Carriages Collection. Gift of Miss Edith Douglass, Mrs. Mary Rackliffe, and Mr. Andrew E. Douglass in memory of Mrs. Moses. 0005.002.2906.

Samuel Hollyer, engraver. *Catharine Market, New York, 1850*. Lithograph engraving circa 1903. The Library of Congress Prints and Photographs Division. LC-USZ62-93760.

James Brown, *Dancing for Eels: A Scene from the New Play of New York as It Is, as Played at the Chatham Theatre New York*. Lithograph, published by E. & J. Brown, 140 Fulton Street, circa 1848. The Library of Congress Prints and Photographs Division. LC-DIG-pga-05447.

William Sidney Mount (1807–1868), *The Jig*, 1866. Pencil on paper. The Cleveland Museum of Art. Hinman B. Hurlbut Collection. 1946.1706.

Thayer, *The Celebrated Negro Melodies*, Sheet Music Cover showing the Virginia Minstrels performing, 1843. Lithograph. The Library of Congress Prints and Photographs Division. LC-USZ62-42353.

William Sidney Mount (1807–1868), *Self-Portrait with Flute*, 1828. Oil on canvas. 20 x 15¾ inches. The Long Island Museum of American Art, History, and Carriages Collection. Gift of Ward Melville. 0000.002.0027.

The Hawkins-Mount House attic, undated photograph. The Long Island Museum of American Art, History, and Carriages Collection.

One of William Sidney Mount's tiny sketchbooks in the collections of the Long Island Museum of American Art, History, and Carriages Collection. Photo by Katherine Kirkpatrick.

James H. Ward, "Cradle of Harmony" violin, 1851–1852, designed by William Sidney Mount. The Long Island Museum of American Art, History, and Carriages Collection.

New York City—An Afternoon Lounge at Goupil's Art Gallery, Fifth Avenue, drawn by J.N. Hyde, 1872, wood engraving print. Published in *Frank Leslie's Illustrated Newspaper*, July 13, 1872. Library of Congress Prints and Photographs Division. LC- USZ62-120368.

The Setauket Presbyterian Churchyard. Photo by Jennifer Kirkpatrick.

William Sidney Mount's grave at the Setauket Presbyterian Church. Photo by Jennifer Kirkpatrick.

Mount paintings in the storage vault of the Long Island Museum of American Art, History, and Carriages. Photo by Katherine Kirkpatrick.

Sketches of Five Households

Map of the Five Households by Jennifer Kirkpatrick.

Shepard Alonzo Mount (1804–1868), *The Cabin*, not dated. Pencil on ochre paper with colored chalk or crayon. 9⅛ x 11¾ inches. The Long Island Museum of American Art, History, and Carriages Collection. Gift of Mrs. John Kitching, 1971. 1971.008.0002.

The Hawkins-Mount House, 1757, Stony Brook. The Long Island Museum of American Art, History, and Carriages. Photo by Jennifer Kirkpatrick.

St. George's Manor House, 1844, Setauket. Residence. Photo by Jennifer Kirkpatrick.

The Mills Pond House, 1838–1840, St. James. Now the Mills Pond Gallery, the home of the Smithtown Township Arts Council. Photo by Jennifer Kirkpatrick.

Cow Barns at the Mills Pond House in 1977, St. James. Now the Mills Pond Gallery, the home of the Smithtown Township Arts Council. Photo by Zachary N. Studenroth.

The Ward Melville Heritage Organization's Brewster House, 1665, Setauket. Photo by Jennifer Kirkpatrick.

The attic space in the Brewster House, 1665, Setauket. Photo courtesy of the Ward Melville Heritage Organization.

The East Farm Manor House, also known as the Archibald M. Brown Estate, circa 1690, enlarged in 1910, Head of the Harbor, St. James. Now part of Harmony Vineyards. Photo courtesy Leighton H. Coleman III.

Chapter 1

William Sidney Mount (1807–1868), *Rustic Dance After a Sleigh Ride*, 1830. Oil on canvas, 22⅛ x 27⅛. The Museum of Fine Arts, Boston. Bequest of Martha C. Karolik for the M. and M. Karolik Collection of American Paintings, 1815–1865. 48.458.

The large main room in the Hawkins-Mount House, 1757, Stony Brook. The Long Island Museum of American Art, History, and Carriages. Photo by Joshua Ruff.

Shepard Alonzo Mount (1804–1868), *The Slaves Grave*, circa 1850. Oil on panel. 5¼ x 9⅛ inches. The Long Island Museum of American Art, History, and Carriages Collection. Gift of the Estate of Dorothy deBevoise Mount, 1959. 0001.003.3927.

Tombstone of Anthony Hannibal Clapp, circa 1816, red sandstone, carved by Phineas Hill. Red sandstone. 51½ x 26 inches. The Long Island Museum of American Art, History, and Carriages Collection. Melville Collection. 0007.015.2140.

Detail of Anthony Clapp's tombstone, circa 1816, red sandstone, carved by Phineas Hill. Red sandstone. 51½ x 26 inches. The Long Island Museum of American Art, History, and Carriages Collection. Melville Collection. 0007.015.2140. Photo by Katherine Kirkpatrick.

The Hawkins-Mount House, 1757, Stony Brook. The Long Island Museum of American Art, History, and Carriages. Photo by Jennifer Kirkpatrick.

Chapter 2

William Sidney Mount (1807–1868), *Eel Spearing at Setauket (Recollections of Early Days—"Fishing Along Shore")*, 1845. Oil on canvas. 33⅜ x 50⅝ inches. Collection of the Fenimore Art Museum, Cooperstown. Gift of Stephen C. Clark. Photograph by Richard Walker. N0395.1955.

William Sidney Mount (1807–1868), *St. George's Manor*, not dated. Oil on panel. 13¾ x 20½ inches. The Long Island Museum of American Art, History, and Carriages Collection. Bequest of Ward Melville, 1977. 1977.022.0559.

William Sidney Mount (1807–1868), Study for *Eel Spearing at Setauket*, not dated. Oil on paper. 5 x 6½ inches. The Long Island Museum of American Art, History, and Carriages Collection. Bequest of Ward Melville, 1977. 1977.022.0573.

William Sidney Mount (1807–1868), Study for *Eel Spearing at Setauket*, 1845. Pencil on paper. 6¼ x 7¼ inches. The Long Island Museum of American Art, History, and Carriages Collection. Bequest of Ward Melville, 1977. 1977.022.0194.

Rachel Brewster's tombstone in Laurel Hill Cemetery, Setauket. Photo by Jennifer Kirkpatrick.

Spearhead excavated in 2015 by archaeologist Christopher Matthews at the Silas Tobias site in Old Field. Photo by Christopher N. Matthews.

Fragments of clay pipes excavated in 2015 by archaeologist Christopher Matthews at the Silas Tobias site in Old Field. Photo by Christopher N. Matthews.

William Sidney Mount (1807–1868), *Clam Diggers*, not dated. Pencil on paper. 4⅝ x 5¼ inches. The Long Island Museum of American Art, History, and Carriages Collection. Gift of Caroline Miller. 0000.008.4339.7.

Chapter 3

William Sidney Mount (1807–1868), *Dance of the Haymakers (Music Is Contagious)*, 1845. Oil on canvas. 24⅝ x 29¾ inches. The Long Island Museum of American Art, History, and Carriages Collection. Gift of Mr. and Mrs. Ward Melville, 1950. 0000.001.0019.

William Sidney Mount (1807–1868), Studies for *The Power of Music* and *Dance of the Haymakers*, 1845. Pencil on paper. 9 x 5½ inches. The Long Island Museum of American Art, History, and Carriages Collection. Bequest of Ward Melville, 1977. 1977.022.0091.

William Sidney Mount (1807–1868), Study for *Dance of the Haymakers*, 1845. Oil on paper. 6½ x 8 inches. The Long Island Museum of American Art, History, and Carriages Collection. Museum Collection. 2010.000.0561.

Barn on the property of East Farm (now Harmony Vineyards), Head of the Harbor, St. James. Photo by Jonathan Olly.

Interior of East Farm barn (now on the property of Harmony Vineyards). Photo by Jennifer Kirkpatrick.

William Sidney Mount (1807–1868), Detail from *Dance of the Haymakers (Music Is Contagious*, 1845. Oil on canvas. 24⅝ x 29¾ inches. The Long Island Museum of American Art, History, and Carriages Collection. Gift of Mr. and Mrs. Ward Melville, 1950. 0000.001.0019. Photo by Katherine Kirkpatrick.

Mary Brewster's tombstone in the Hawkins-Mount cemetery for people of color, Stony Brook. Photo by Jennifer Kirkpatrick.

The Seabury House, late 1700s, Stony Brook. Residence. Photo by Jennifer Kirkpatrick.

Evelina Mount (1837–1920), *Longbotham House, Stony Brook*, not dated. Oil on canvas, mounted on wood panel. 11⅝ x 22⅛. The Long Island Museum of American Art, History, and Carriages Collection. Gift of Mr. and Mrs. Ward Melville, 1976. 1976.017.0092.

Chapter 4

William Sidney Mount (1807–1868), *Farmers Nooning*, 1836. Oil on canvas. 20¼ x 24½ inches. The Long Island Museum of American Art, History, and Carriages Collection. Gift of Frederick Sturges, Jr., 1954. 0000.001.1521.

William Sidney Mount (1807–1868), Detail from *Farmers Nooning*. The Long Island Museum of American Art, History, and Carriages Collection. Gift of Frederick Sturges, Jr., 1954. 0000.001.1521. Photo by Katherine Kirkpatrick.

William Sidney Mount (1807–1868), Study for *Farmers Nooning*, 1836. Oil on canvas, 4 x 5½ inches. The Long Island Museum of American Art, History, and Carriages Collection. Bequest of Ward Melville, 1977. 1977.022.0555.

The Mills Pond House, 1838-1840, St. James. Now the Mills Pond Gallery, the home of the Smithtown Township Arts Council. Photo by Jennifer Kirkpatrick.

Cider Making House at the Mills Pond House in 1977, St. James. Now the Mills Pond Gallery, the home of the Smithtown Township Arts Council. Photo by Zachary N. Studenroth.

William Sidney Mount (1807–1868), Study for *Cider Making*, not dated. Pencil on paper, 6⅝ x 13½ inches. The Long Island Museum of American Art, History, and Carriages Collection. Bequest of Ward Melville, 1977. 1977.022.0121.

Wash House at Mills Pond in 1977. Photo by Zachary N. Studenroth.

William Sidney Mount (1807–1868), *Wash Day*, 1863, pencil on paper. 4 x 6.063 inches. The Long Island Museum of American Art, History, and Carriages Collection. Gift of the estate of Mrs. Scott Kidder, 1956. 0000.008.4341.014.

Chapter 5

William Sidney Mount (1807–1868), *The Power of Music*, 1847. Oil on canvas. 17⅛ x 21 inches. The Cleveland Museum of Art. Leonard C. Hanna Jr. Fund. 1991.110.

The Ward Melville Heritage Organization's Thompson House, 1709, Setauket. Photo by Margo Arceri.

The Ward Melville Heritage Organization's Thompson House, 1709, Setauket. Photo by Dr. Ira Koeppel.

William Sidney Mount (1807–1868), *Churches and Houses*, not dated, pencil on paper. 4 x 6¼ inches. The Long Island Museum of American Art, History, and Carriages Collection. Gift of the estate of Mrs. Scott Kidder, 1956. 0000.008.4341.29.

Old Bethel Cemetery, Stony Brook, circa 1848. Photo by Katherine Kirkpatrick.

Bethel AME Church, Setauket, 1909. Photo by Jennifer Kirkpatrick.

William Sidney Mount (1807–1868), *Two Men Leaning on Hoes*, not dated, pencil on paper, 4 x 6 inches. The Long Island Museum of American Art, History, and Carriages Collection. Bequest of Ward Melville, 1977. 1977.022.0348.

William Sidney Mount (1807–1868), Detail from *Sheet of Twelve Sketches*, not dated. Pencil on paper. 12¼ x 8 inches. The Long Island Museum of American Art, History, and Carriages Collection. Bequest of Ward Melville, 1977. 1977.022.0323.

William Sidney Mount (1807–1868), *Two Scenes of Men Haying*, 1863. Pencil on paper, 8 x 6 inches. The Long Island Museum of American Art, History, and Carriages Collection. Bequest of Ward Melville, 1977. 1977.022.0092.

William Sidney Mount (1807–1868), Study for *Ringing the Pig*, not dated, pencil on paper. 9 x 13½ inches. The Long Island Museum of American Art, History, and Carriages Collection. Bequest of Ward Melville, 1977. 1977.022.0120.

William Sidney Mount (1807–1868), *Horse and Buggy*, pencil on paper, 1857. 9½ x 12 inches. The Long Island Museum of American Art, History, and Carriages Collection. Gift of the estate of Mrs. Scott Kidder, 1956. 0000.008.4341.48.

Chapter 6

William Sidney Mount (1807–1868), *California News*, 1850. Oil on canvas. 21½ x 20¼. The Long Island Museum of American Art, History, and Carriages Collection. Bequest of Ward Melville, 1977. 0000.001.0014.

William Sidney Mount (1807–1868), Study for *California News*, 1850. Oil on paper. 4¾ x 4½ inches. The Long Island Museum of American Art, History, and Carriages Collection. Bequest of Ward Melville, 1977. 1977.022.0574.

William Sidney Mount (1807–1868), Detail of *California News*, 1850. Oil on canvas. 21½ x 20¼. The Long Island Museum of American Art, History, and Carriages Collection. Bequest of Ward Melville, 1977. 0000.001.0014. Photo by Katherine Kirkpatrick.

The servants' wing at the Mills Pond House, 1838–1840, St. James. Now the Mills Pond Gallery, the home of the Smithtown Township Arts Council. Photo by Katherine Kirkpatrick.

The servants' wing at the Mills Pond House, interior, 1838–1840, St. James. Now the Mills Pond Gallery, the home of the Smithtown Township Arts Council. Photo by Katherine Kirkpatrick.

A structure on the Mills Pond property in 1977, St. James. Now the Mills Pond Gallery, the home of the Smithtown Township Arts Council. Photo by Zachary N. Studenroth.

Barns on the Mills Pond property in 1977, St. James. Now the Mills Pond Gallery, the home of the Smithtown Township Arts Council. Photo by Zachary N. Studenroth.

Chapter 7

William Sidney Mount (1807–1868), *Right and Left*, 1850. Oil on canvas. 30 x 25 inches. The Long Island Museum of American Art, History, and Carriages Collection. Museum purchase, 1956. 0000.001.2726.

Jean-Baptiste Adolphe Lafosse (1810–1879), *Right and Left*, 1852, after William Sidney Mount's *Right and Left*, 1850. Colored lithograph with hand-pointed border presumably by William Sidney Mount. 32¾ x 23 inches. The Long Island Museum of American Art, History, and Carriages Collection. Gift of Ward Melville, 1949. 0000.006.0098.

William Sidney Mount (1807–1868), Design drawing of "Cradle of Harmony" violin patent, 1852. Ink on paper. 17⅞ x 11⅛. *The Long Island Museum of American Art, History, and Carriages Collection.*2020.000.0081.

William Sidney Mount (1807–1868), *Tuning*, 1867. Pencil on paper. 3¹³⁄₁₆ x 6⅜ inches. The Cleveland Museum of Art. Hinman B. Hurlbut Collection. 1946.1711.

William Sidney Mount (1807–1868), *Group of Men Fiddling and Dancing in Front of Jayne Store*, 1867. Pencil on paper. 4 x 6½ inches. The Long Island Museum of American Art, History, and Carriages Collection. Bequest of Ward Melville, 1977. 1977.022.0229.

William Sidney Mount (1807–1868), *Two Men Dancing*, not dated, pencil on paper, 4 x 5 inches. The Long Island Museum of American Art, History, & Carriages Collection. Bequest of Ward Melville, 1977. 1977.022.0347.

William Sidney Mount (1807–1868), Letter to Robert Nelson Mount, 29 August 1841. Ink on paper. 7^{13}/$_{16}$ x 9^{1}/$_{4}$ inches. The Long Island Museum of American Art, History, and Carriages Collection. Museum Purchase. 0.11.3092.13.

Chapter 8

Jean-Baptiste Adolphe Lafosse (1810–1879), *Raffling for a Goose (The Lucky Throw)*, 1851, after William Sidney Mount's painting of 1849. Colored engraving lithograph. 29 x 23 1/$_{4}$ inches. The Long Island Museum of American Art, History, and Carriages Collection. Gift of Mr. Richard M. Gipson, 1951. 0000.006.3657.

William Sidney Mount (1807–1868), Study for *The Lucky Throw*, 1849. Pencil on paper. 29 x 23 inches. The Long Island Museum of American Art, History, and Carriages Collection. Museum purchase, Partial gift from Irene Emerson, 1992. 1992.023.004.

William Sidney Mount (1807–1868), Study for *Raffling a Goose (Tavern Scene)*, not dated. Oil on panel. 8^{1}/$_{4}$ x 12 inches. The Long Island Museum of American Art, History, and Carriages Collection. Melville Collection. 0000.005.0069.

Chapter 9

William Sidney Mount (1807–1868), *The Bone Player*, 1856. Oil on canvas, 36 x 29 inches. The Museum of Fine Arts, Boston. Bequest of Martha C. Karolik for the M. and M. Karolik Collection of American Paintings, 1815–1865. 48.461.

William Sidney Mount (1807–1868), *Long Island Farmhouses*, 1862–1863. Oil on canvas. 21^{7}/$_{8}$ x 29^{7}/$_{8}$ inches. The Metropolitan Museum of Art, New York. Gift of Louise F. Wickham, in memory of her father, William H. Wickham, 1928. 28.104.

The main room in the Ward Melville Heritage Organization's Brewster House, Setauket, 1665. Photo by Jennifer Kirkpatrick.

The Ward Melville Heritage Organization's Brewster House, Setauket, 1665, hearth. Photo by Jennifer Kirkpatrick.

The Ward Melville Heritage Organization's Brewster House, Setauket, 1665, attic. Photo courtesy of the Ward Melville Heritage Organization.

Chapter 10

William Sidney Mount (1807–1868), *The Banjo Player*, 1856. Oil on canvas. 35¾ x 28¾ inches. The Long Island Museum of American Art, History, and Carriages Collection. Gift of Mr. and Mrs. Ward Melville, 1955. 0000.001.0011.

The Brookhaven, New York section of the 1850 United States Federal Census. Page 60. *National Archives and Records Administration.*

William Sidney Mount (1807–1868), *Detail for Long Island Farmhouses*, not dated, oil on panel, 5 x 4 inches. The Long Island Museum of American Art, History, and Carriages Collection. Bequest of Ward Melville, 1977. 1977.022.0579.

William Sidney Mount (1807–1868), *Cow Lying Near Fence*, 1867. Pencil on paper. 4 x 4½ inches. The Long Island Museum of American Art, History, and Carriages Collection. Bequest of Ward Melville, 1977. 1977.022.0070.

William Sidney Mount (1807–1868), *Long Island Farmyard*, not dated. Pencil on paper. 7⅞ x 10 inches. The Long Island Museum of American Art, History, and Carriages Collection. Bequest of Ward Melville, 1977. 1977.022.0139.

Chapter 11

William Sidney Mount (1807–1868), *The Dawn of Day*, 1867. Oil on panel. 7¾ x 11¾. The Long Island Museum of American Art, History, and Carriages Collection. Gift of Mr. and Mrs. Ward Melville, 1958. 0000.001.0006.

William Sidney Mount (1807–1868), Study for *Catching the Tune (Three Views of Man Whistling)*, 1866. Pencil on paper. 4 x 6½ inches. The Long Island Museum of American Art, History, and Carriages Collection. Gift of the estate of Dorothy deBevoise Mount, 1959. 0000.008.4337.32.

William Sidney Mount (1807–1868), Sketch for *Politically Dead*, 1867. Pencil on paper. 3½ x 4½ inches. The Long Island Museum of American Art, History, and Carriages Collection. Museum purchase, 1986. 1986.027.

William Sidney Mount (1807–1868), *Sheet of Seven Sketches*, November 25, 1866, pencil on paper, 12½ x 8 inches. The Long Island Museum of American Art, History, and Carriages Collection. Bequest of Ward Melville, 1977. 1977.022.0320.

Mathew B. Brady (c.1822–1896), Full-length portrait of William Sidney Mount, circa 1853–1860. Daguerreotype. Library of Congress Prints and Photographs Division LC-USZC4-6547.

Back Matter

William Sidney Mount (1807–1868), *Sheet of Seven Sketches*, 1867, pencil on paper, 12¼ x 8 inches. The Long Island Museum of American Art, History, and Carriages Collection. Gift of the Estate of Dorothy deBevoise Mount, 1959.

The Hawkins-Mount House, 1757, Stony Brook, attic. The Long Island Museum of American Art, History, and Carriages. Photo by Joshua Ruff.

A shelf in the Hawkins-Mount House, 1757, Stony Brook, attic. The Long Island Museum of American Art, History, and Carriages. Photo by Joshua Ruff.

INDEX

The Hawkins-Mount House attic where William Sidney Mount set up an artist's studio. *Joshua Ruff.*

A shelf in the Hawkins-Mount House attic painted by William Sidney Mount. Here he kept a record of color samples from his artist's palette. *Joshua Ruff.*

ABOUT THE AUTHORS

KATHERINE KIRKPATRICK grew up in Stony Brook. As a child, she took summer writing and art classes in the Long Island Museum's old schoolhouse, which is catty-corner to the art gallery that houses the largest collection of William Sidney Mount paintings in the world. For her, seeing the Mount paintings is like greeting old friends.

Katherine is the author of eight books, both fiction and nonfiction. Her children's book *Redcoats and Petticoats*, illustrated by Ronald Himler, features Setauket's Culper Spy Ring. Katherine studied English and art history at Smith College and is a painter as well as a writer. She brings to this project her knowledge and enthusiasm for writing, art, William Sidney Mount, and Three Villages History, all passions instilled in her by her late mother, Audrey Kirkpatrick. For more about Katherine, visit https://katherinekirkpatrick.com/.

Vivian Nicholson-Mueller is an educator and historian who has done extensive research on the lives of White, Black, and Native people of pre-colonial, colonial, and post-colonial Long Island. She has focused on Samuel Thompson, a Brookhaven doctor, Revolutionary War figure, and the father of Long Island historian Benjamin Franklin Thompson. Through her research and advocacy, Vivian, along with her cousin Simira Tobias, spearheaded a successful campaign to assign Stony Brook's Old Bethel Cemetery, which was established in the mid-nineteenth century by free people of color, to the State and National Registers of Historic Places.

Vivian is descended from Native and Black people and European colonists who were among the early inhabitants and settlers of Setauket, Stony Brook, and Old Field. One of these, Rachel Brewster, was possibly the model for the woman in *Eel Spearing at Setauket*; and another, Rachel's brother, Andrew Brewster, posed for *The Bone Player*. A third ancestor, Robbin Mills, posed as the pensive figure outside the barn in *The Power of Music*. A fourth ancestor, Silas Brewster, helped transport Mount's coffin to his grave. Through the Smith family line, Vivian and William Sidney Mount share common ancestors.